New Photography in Britain

New Photography in Britain

edited by Filippo Maggia

SKIRA

Cover
Melissa Moore
Plasmic, detail, 2007
C-type print, 76 x 76 cm

Editor
Filippo Maggia

Design
Marcello Francone

Layout
Greco Fieni

Editorial Coordination
Francesca Lazzarini
Eva Vanzella

Editing
Emanuela Spinsanti

Translations
Ben Bazalgette-Staples,
Giliola Rubaldi

First published in Italy in 2008 by
Skira Editore S.p.A.
Palazzo Casati Stampa
via Torino 61
20123 Milano
Italy
www.skira.net

Printed and bound in Italy. First edition
ISBN: 978-88-6130-543-4

Distributed in North America by Rizzoli
International Publications, Inc.,
300 Park Avenue South, New York,
NY 10010, USA.
Distributed elsewhere in the world
by Thames and Hudson Ltd.,
181A High Holborn,
London WC1V 7QX, United Kingdom.

The present book was published on
the occasion of the exhibition *In Our
World: New Photography in Britain* held
at the Galleria Civica di Modena
between 20th April and 13th July 2008

Contents

Filippo Maggia

In Our World: New Photography in Britain

The experiential factor has clearly come to the fore over the last few years as the element that brings together the research of a great number of artists – especially those between the ages of 25 and 40 – who make use of photography all around the world. For we are not talking about images here, but photographs. Photographs that represent a changing reality and its inherent contradictions, its excesses due largely to that all-enveloping shift towards globalisation which has been taking place since the '80s. We may now look upon that decade as a crucial period which merits a far deeper analysis and not simply being pigeonholed as a transitory decade between past wonderment and present bitter truths; a conservative era, yet at the same time, the lighting of that burning fuse of what was literally to explode towards the end of that period.

It represented a state of play which has changed over and over again since then, in different ways and different places, often without a specific purpose if not that of creating a market open to all yet not to the advantage of all. Representations which at times become outright allegories as in the great photographs of Andreas Gursky or Thomas Struth, Thomas Ruff or Thomas Demand, of that German school which was to dominate the scene and the market itself throughout the '90s, right up to the present day, leading us at long last to find ourselves faced with an almost worn out form of photography, exhausted by its continually observing the world around us and recounting it to others. It has come to represent a ceaseless flow of images churned out in front of us, one after the other, before our very eyes.

This is a form of photography on the verge of collapse, self-annihilated, aged by the arrival of the digital image, worn out by the relentless use that has been made of it over recent years. Yet this is a medium which the up-and-coming generations of photographers have brought back to the arena of the self, questioning it and reflecting not so much on its potential as a means of artistic expression, but rather on the aims and objectives that the medium should pursue, and on its actual ability – if there is still any left – to contribute to the perception of the contemporary world, to its definition, yet fully aware that this ability will continue to change over time. This is a form of photography which has no intention of reaching a working agreement with the world of glossy glamour of the last decade, which in its most interesting and innovative aspects, runs for cover and almost hides away, far from both those great, glistening nocturnal cityscapes and those stark, natural daylight shots. For while these may be credited with showing us as yet unknown places, today they no longer make any sense when compared with the works of the very incomplete list of above-mentioned artists. The former representation of the world – which often in fact means nothing more than cities – has become so refined as to constitute merely a decorative element, objects to be displayed in a large minimalist living room behind a long white sofa. Nothing more than a postcard, it is like an open window which, once closed, leaves no trace of its presence.

And thus mindful, albeit at times not consciously, of the experiences rooted in the end of the '70s and the beginning of the '80s, many contemporary photographers

have once more started to talk about themselves, about their own world, standing as the only, thin filter in the translation of the sensations and emotions which they receive from the outside world, metabolise and then piece back together in the form of a narrative, an installation, a video or a film. At any rate, works that find no place other than in their own world. Whether we are able to share in it or not, they offer us a world which is undoubtedly and harshly pure, one designed to make us reflect, ask questions and analyse situations ranging from the personal to the universal, and touching on all the many aspects of contemporary culture to be examined from an artistic stance. With greater clear-mindedness and detachment than the artists of the recent past, like Francesca Woodman or Nan Goldin; without settling for compromises like Robert Mapplethorpe and Peter Hujar; with gaze turned more towards the development of artists like Philip-Lorca diCorcia, Cindy Sherman or Jeff Wall (in a certain sense, pooling and selecting specific elements of acquired knowledge), these current artists come across as a synthesis of self-analysis and then self-regeneration, placing at the centre of their attention not the surrounding reality, but rather the process that brings together hearts and minds when dealing with the world around them.

In this sense, London has now become an important international crossroads towards which so much gravitates, thanks to its specific weight in the arts system and the art market above all. Yet more than anything else, it is interesting to note how London has become an artistic meeting ground but not necessarily a centre of creativity. If we compare it to New York 30 years ago, we note that it is less open, less cooperative, and highly selective: London is synonymous with business, a place where it is easy to be overwhelmed by the number of offers, but then find oneself unable to produce anything. The defence of their own cultural identity, of their origins and life experiences, is the challenge that many young artists have taken up in London, just as they have done in Berlin and New York in the past; searching for a level on which to operate, a chance to grow, a sense of comparison and dialogue. This is a primary need in the battle to survive and develop one's own artistic research, one which is shared by the British, the Japanese, the Germans, the Italians and the Scandinavians alike.

"In Our World: New Photography in Britain", is the upshot of my year-long research, made possible also thanks to the visiting fellowship offered to me by the Royal College of Art in London, into new directions in photography in the UK. I would therefore like to thank the Royal College of Art, London for their kind collaboration in the implementation of this project, and especially the Department of Photography, meaning Olivier Richon, Claire Smithson and the rest of the staff. The selection of works presented here – which concerns artists active over the last 10 years – is clearly only one of the many possible selections to be made, and it is based on my own personal contact with over 70 artists and their works, and my having consulted art reviews, visited galleries, and spoken to a great number of curators and other colleagues over this time. The fact that all the 18 artists who were finally chosen to exhibit their work and contribute to the exhibition

catalogue attended the Master in Photography at the Royal College of Art in London is a complete coincidence on the one hand, but, one might say, entirely logical on the other, given the importance and prestige to which this institution may lay claim. Yet the really interesting thing is the range of different origins of these artists – from Portugal to the USA, from Ireland to Germany, from Switzerland to Ghana, as well as the United Kingdom itself: an aspect which exemplifies the need for ongoing comparison in a shared environment, as well as the ability of each and every one of them to bring their own individual style to their work.

At the beginning of this text, the importance of the experiential element was mentioned, and the great extent to which this is characterising contemporary photographic research. The artist lives in an osmotic relationship with the world around him or her, allowing more or less profound traces of this world to intervene or settle on the lens of his/her perception, ingesting them and then reconstructing them, adopting a variety of different approaches in so doing. Never before has photography been so called upon to act as *the* code with which to translate the many stimuli that endlessly pour forth from reality, yet the mere narration of reality is no longer enough. Everything has been seen, everything has been catalogued by images, in the numerous forms they may take on, thus becoming the only really universal language, albeit one which is often ambiguous and deceptive. And so, all the more reason for this translation not to be generic or superficial. It calls for a background of recognition and study, of skills and investigations which make it possible for the artist to add without overlapping; to offer and propose rather than accumulate. Hence, experience is a key factor in this creative process.

In her work, Becky Beasley analyses the relationship between real objects and their representation as photographic objects. The objects in question are minimal sculptures created by the artist herself which she then interprets through her photography, providing a number of different interpretations and

bringing about a sense of estrangement in the viewer, enveloped by the silence given off by the object and by its image attached to the wall. In an overtly post-minimalist approach, the artist's aim is to produce a representation of a "present absence", one which is able to generate a sense of anxiety, to highlight the sense of the void, and to manage to specify this desire in visual terms. Although the project is seemingly put across in an oneiric language, it is defined in terms of the state of anxiety which it immediately provokes, opening up a number of pathways into the memories and personal histories of every one of us.

The idea of objects which are not what they appear to be, or at least not what we commonly think they are and see them as, is also at the heart of Bianca Brunner's work. The Swiss artist sees the view of reality offered to us by photography as not being necessarily reliable: for this reason, she questions the very notion of the image and its representation. The environments she creates, be they in the studio or in the great outdoors, are deliberately undefined and imprecise; they lack important details and thus force the viewer to fill them in using his/her imagination. In this process, the objects are transformed to the point of becoming infinite, given the many layers of interpretation to be made. Her photography is one which investigates elements of her inner self, her very nature and conceptual origins, while leaving a lot of room for play and subjective interpretations.

Lisa Castagner stages moments of everyday life driven to the point of exasperation in which, despite her drawing on reality, everything seems over the top. Her models are icy, silent creatures, disarmingly expressionless even when there appears to be a relationship between them. Paradoxical scenes show typical moments of British life, in which the role and image of the woman appear to be deliberately subjected to the dominating sense of glamour, in line with the homogenisation process so typical of contemporary society. Yet it is this very aspect that raises doubts and poses questions in the face of a lost, fake and theatrical sense of femininity. In all this, her attention to every last detail is of the utmost

importance, from the gesture to the exact position of the model, right down to the objects chosen to complete the scene. This in its own right constitutes a line of reasoning which seems to entail a clear sense of provocation.

Dreams and visions are portrayed in the photographs of Simon Cunningham. His chaotic research is immediately fascinating as it sweeps aside all forms of certainty, doing away with all points of reference, be they conceptual or symbolic. Whether through his images, his videos or in the little *Duckrabbit* sculpture, the artists invites the viewers to complete the work, to let themselves be drawn in by it, using the most suitable elements to justify it, as if Cunningham wanted to turn his own experience into an invitation to enter his world in order to share in his emotions and sensations.

Annabel Elgar organises a series of *mis-en-scenes* which are both self-aware and painful. They are photographs showing figures from behind or from the waist up in heavily connoted environments: an approaching fire, a wood full of life, a room full of coloured balloons. And yet these are not the symbolic elements that help us to reconstruct the protagonists' experiences: there are tiny details that speak volumes about their weaknesses and fragility, of a looming yet undefined sense of fear. And thus photography reveals the protagonists' inner selves, testifying to the vulnerability of human beings in all their forms.

The real and the imaginary are carefully combined in the works of Anne Hardy. Environments that have fallen into disuse, and which are then reconstructed in the studio before being photographed. Although the human figure is absent, there is clearly a recent history of physical interaction with the space, leaving unmistakable traces of human passing yet without specifying the degree of involvement, preferring to leave this open to the viewer's own personal interpretation. In the creation of these scenes, Hardy expresses all her own intimate reflections on photography, experiencing first hand – for she is the only real interpreter of that world – the relationship between the chosen objects

and the absent subjects, who never actually existed.

Lucy Levene's work is only apparently documentary as the artist deals with the theme of the cultural pressure exerted by one's own social community, in this case the Jewish community, taking the choice of a spouse as a focus – or rather a pretext – for her study. Levene portrays herself side by side with young Jewish men, casually dressed as she is, an element that stresses her underlying conceptual anti-conformism. So too does her gaze, almost annoyed, as she waits for the moment in which to take the shot capturing their hypothetical future together. Here, the experience is that of a life choice, a moment bound up in the history of a people, and a destiny which it is difficult to escape from, but which photography provides a means to challenge.

Then there is the profoundly intimate slide show put together by Gareth McConnell, a genuine visual poem experienced first hand by the artist. "A love poem" as McConnell himself describes it, a story told in images of a part of his own life, showing how things change, how nothing can be as it was before or stop in time forever. "The moment is all", McConnell stresses, and so it must always be lived to the full, for good or bad, in all its intensity. Endowed with a rare sensitivity, harsh and yet delicate, the artist puts all he has into the telling of this tale, warts and all, and encourages us to do likewise, without wasting one second of our lives as they slip away.

Brigida Mendes's research revolves around the theme of representation – meant here as tracing a thin line between fiction and reality – of identity. All the subjects portrayed in her photos are members of her own family: her sister, her mother and her mother's twin sister. Her images, constructed down to the last detail, are not manipulated and nor do they mean to appear so; nevertheless, they immediately induce a sensation of instability and amazement in the viewer, who is unable to understand whether that which is in front of him/her is real or illusory. And this is in fact Mendes's goal: to give her audience a taste of a possible alternative reality, inviting them to adopt a critical view, free of forgone perceptive conclusions.

The recent series of photographs produced by Suzanne Mooney, brought together under the title *Behind the Scenes*, constitute an explicit reference to the way in which we are used to looking at the world. The work features a digital camera suspended in mid-air situated between the real landscape behind it and the viewer, thus showing the framed landscape. A *modus videndi* which we now take for granted, yet which raises many questions linked to the construction of the image, or rather: what exactly are we seeing, selecting, recording? Mooney's work is a conceptual game, an intellectual exercise in which the artist constantly reconsiders the role and the meaning of the various elements that lead to the construction of the image: the camera, the surrounding space, along with the person who then actually takes the shot.

The photographs of Melissa Moore belonging to the *Plasmic* series were taken in a Jacobean mansion, Plas Teg, known among groups of paranormal enthusiasts for its history, full of mysteries and unsolved enigmas. Moore wanders through the rooms without ever showing herself completely, attempting to mould her own body into those elements which might best take on a certain symbolic value. The female figure, despite appearing clearly self-referential, moves in a constant state of metamorphosis, as if stimulated by her surroundings and not threatened by them, thus leading to the creation of new possible enigmas to be resolved, despite the staticity of the photographic image.

Having always been fascinated by the charm and the stimuli provided by popular culture, Harold Offeh is fully aware of being a product of it while at the same time relating to it in a critical fashion. A member of that generation of artists defined in his day by Thomas Ruff as the "children of television", Offeh exploits the language of this medium – the bottomless pit of images – to examine through his video works the issue of communication between different cultures in an attempt to destroy the classic racial stereotypes and the cultural boundaries which to this day keep different populations apart instead of bringing them closer together. His direct experience as protagonist of his own videos has grown recently, involving the audience wherever possible in a game of playful exchanges which turn his research work into outstanding interactive performances.

The cultural identity of a place and a knowledge of the history of that place, and of its anthropological past/present, be it a city (as in his recent video *Hiroshima*) or a bamboo forest (which appears silently in the video *Murmur*) lie at the heart of the investigative process adopted by Kirk Palmer. In fact, the artist sets himself up in front of the chosen landscape to wait humbly before it, until with the passing of time, he finds that special approach, that inner state of awareness, which allows him – through the slow passing of his video images – to access not only the atmosphere, but also and above all the human presence, the memories, the history of that landscape. Through the extremely refined image-composition and editing of his works, Palmer ponders the possible synthesis of a single experience between the artist and his surroundings, and on the existential nature of our relationship with the world.

The outcome of her residency at the UK Fire Service College, the recent series produced by Sarah Pickering draw on the sets and props actually used for training purposes by members of the Fire Service. The relationship between reality and imagination is thus Pickering's key field of study: the opaque surface of the barite paper used for black and white photography as chosen for her *Incident* series constitutes the tangible material which the viewer may touch as if it were ash settled on a charred object, letting us imagine what might have taken place in that environment as we attempt to reconstruct a plausible story. These traces become actual clues in the *Fire Scene* series, with narrative elements which lead us to make suppositions about what to all intents and purposes are real scenes of violence, tragedies brought about by human madness or by pure chance, of a dark or even lethal fate. Pickering's photography always provides us with a form of narration suspended between reality and illusion.

The Glyndebourne Opera House is our destination with Sophy Rickett, to discover

the stage, the backstage and the auditorium, slowly revealing to us all that which is not immediately visible. The presence of "another" reality takes place through the slow raising of the curtains, the hissing lights rising to the point of becoming the sole protagonist. This ritual is repeated again and again, each time providing us with a few more details, until the human figure is revealed, with his series of well-rehearsed motions used to raise and lower the curtains, to show and hide reality, providing the perception, when reality is denied, of something which is not usually grasped. A film which creates a tangible sense of tension in the spectator minute after minute, *Auditorium* ends by revealing everything to us, the absence of the audience, of the orchestra, of the opera on the stage: it's all an illusion.

Esther Teichmann in *Silently Mirrored* strips bare the sentiment of love, of an ancestral love – towards her mother – and a passionate one – for her husband. In her tale, disarming because it is so intensely raw, these two key figures are portrayed piece by piece using different colours: black to dark blue on her lover's skin, and white going on light blue on her mother's skin. The stark fear of losing a loved one painfully underpins the two stories that are told in parallel, until a natural compromise is found in the composition and in the various formats used to present the images, as if they were different fragments of intensity, yet all able to reach down to the bottom of her soul. Heiko Tiemann abandons himself to the world to the point of rediscovering that situation which, through his photography, may provide him once more with that single and vital inspiration, the synthesis of a tension which grows slowly to the point of becoming a primary need. His waiting for this moment leads him to develop a tortuous relationship of psychological interaction with people and places, based on an underlying sense of melancholy with regard to external reality, yet one which at the same time constitutes a necessary passage towards discovering when and where his subject – be it a person or a landscape – becomes vulnerable, i.e. authentic, showing themselves to be what they are in all

respects, fixed in space and suspended in time. His is a meticulous practice, based on his own direct experience and on the traces left by the memories of each passing moment.

Restlessness and attraction, fear and fascination, clumsiness and vivacity are the sentiments aroused by the personae created by Danny Treacy. Brought together in a series under the telling title *Them*, they are the others, or perhaps they're us, or perhaps it's a we which prefers to hide rather than be shown, just as the artist seems to do when he puts together the costumes he wears, letting his imagination breathe life each time into a new protagonist who emerges from the dark to be seen. Put together using items of clothing found in the street or even in the rubbish bins of residential areas, Treacy's clothes are immediately brought back to life and, like aliens waiting for nothing else, move forward to occupy the space, leading to an anarchic circus of perversion and transgression. The other face, the other me, the other reality which hides behind everything around us, be it dead or alive.

Becky Beasley

Born in Portsmouth, UK, 1975.
Lives and works in Berlin.

Beasley's work moves between sculpture and photography and originates in both personal and more universal encounters. Its subject matter is largely composed of autobiographical recollections mediated through literary references. Aesthetically, it engages in her questioning the relationships between handmade objects and their (re-)presentation as photographic objects. The language of her practice is at times oneiric, but bears equal references to surrealism and minimalism. Beasley's work deals with death and anxiety, using elements from the visual and the literary realms to allow her to ponder issues of personal fate and destiny.

A key element in understanding Beasley's work is the concept of the "cadaver" as articulated by Maurice Blanchot in *The Two Versions of the Imaginary*. In Blanchot's writing, the cadaver as understood by Beasley is a hollow absence which nonetheless resembles itself more than ever. Throughout Beasley's works, it appears to play with the documentation and presentation of constructed or assisted realities, such as states of loss, instances of muteness or death. The cadaverous appears in numerous guises, not merely as a photographic concept, but also by transferring photographic qualities – gloss, matt or black and white – onto sculptural objects, transforming potentially minimalist objects into post-minimal props. Beasley's work needs to be assessed from a post-minimal stance defined by the artwork's desire to achieve the status of document of "present absentness". Beasley's project, however, does not fit in seamlessly with the post-minimal program, as her photographic trajectory appears to operate the other way around, attempting to make the document coincide with the artwork. Her work transcends the imperatives of a documentary project altogether, and she uses the potential of photography and minimalist sculpture to be reproduced or doubled as an opportunity to produce slightly different versions of reality, shifting meanings in the process of negotiating content through the photographic process of projection and printing. Her work undertakes an incessant interrogation of the relationships between images and pictorial representations, both as regards her personal stories and those of others, and it is able to touch upon the complexities surrounding the existence of different versions of the same image. It also proposes an uncanny reading of the history of art, literature and personal memoirs by making them resonate through the *sfumato* of her allegorical photographic environment.

Wim Peeters

Education

2000–02
MA in Photography, Royal College of Art, London

1996–99
BA in Fine Art/Art History (1st Class), Goldsmiths College, London

1994–95
Foundation Art and Design, Winchester School of Art, Winchester

Solo Exhibitions

2008
"W", Museum 52, New York, USA (with Kate Atkin)
BolteLang Gallery, Zurich (with Daniel Gustav Cramer)

2007
"Three Notable American Novellas", Laura Bartlett Gallery, London
Index of Maladjustments, in "Future Present", at "Artissima '07". Selected for solo statement by curator and writer Luca Cerizza
"Eleven Years Later", Office Baroque, Antwerp

2006
"Décors du Silence!", Ubu Gallery, Glasgow

2004
"Six Storeys", Millefiori Art Space, Athens

2003
"From the Series: Institute of N", The Bakery (Annet Gelink Gallery), Amsterdam
"Thru darkly night", Whitechapel Project Space, London

Selected Group Exhibitions

2008
Office Baroque Gallery, Antwerp
"Building, Dwelling, Thinking", curated by John Slyce, Laura Bartlett Gallery, London
"In Our World: New Photography in Britain", curated by Filippo Maggia, Galleria Civica di Modena, Italy

2007
"Oh a rhinoceros!", Ubu Gallery, Glasgow
"Ost Property", curated by Julia Spicer and Jon Cairns, Danielle Arnaud Gallery, London
"Black and White", curated by Vita Zaman, ibid Projects, London

2006
"Anatomies of Desire", curated by Eduardo Barroso, Encosta Galeria, Lisbon
"Bloomberg New Contemporaries 2006", Liverpool, London

2005
"Button Up NY", curated by Michael Wilson, DUMBO, New York
"The Instant of My Death", curated by Hannah Collins, Galeria dels Angels, Barcelona
"Fata Morgana", Museum of Photography, Thessalonica, Greece (Cat.)

2004
"PILOT: I", International Art Forum, London

2003
"Animal, Vegetable, Mineral", curated by Francis Summers, Hoxton Distillery, London
"Private Property", curated by Jack Rolo and Paul Corcoran, Private property, East London
"Don't start from the good old things but the bad new ones", Whitechapel Project Space, London
"Flora & Fauna", curated by Harry Pye, The Beehive Pub, London

2002
"Intermission", The Little Theatre, Brighton
"The Show", Royal College of Art, Degree Show, London
"Sledge", curated by Mel Jackson, Jam Factory, London
"Domestic Sphere", curated by Elizabeth Neilsen, The Art House, London
"Meantime", Royal College of Art, London

2001
"Leaving Things", Hockney Gallery, Royal College of Art (with Annabelle Dalby)
"Flip Flop", ERBAN, Nantes
"The Insistent Image", Royal College of Art, London

1997
"Getting Out of Our Box", Words and Pictures event produced by Iain Forsyth and Jane Pollard, launched at ICA, London

Publications

2008
Correspondences (1957–2007), ed. by Anthony Banks, "Succour Journal", Issue 7, London
Of Other Potentialities: The Inhabitable Inhospitable Object, "MATERIAL" Journal, Spring, Los Angeles and London
Future Greats, in "Art Review", Issue 20, p. 106
Kristina Johansen, Book review, *American Letter*, http://sites.a-n.co.uk/interface/reviews
Lúpe Nuñez-Fernández, Review of "Three Notable American Novellas", in "Flash Art International", Vol. XLI, No 258, January–February, p. 85

2007
Martin Herbert, Solo exhibition review "Three Notable American Novellas" at Laura Bartlett Gallery, in "Time Out London", 5–11 December
Lúpe Nuñez-Fernández, Exhibition review "Three Notable American Novellas", in "Saatchi Online Magazine" (www.saatchi-gallery.co.uk/blogon/ 2007/11/laura_bartlett_gallery_relocat.php)
American Letter, Artist's monograph, published by Laura Bartlett Gallery, texts by the artist and John Slyce, London 2007
Future Present, Exhibition Catalogue, text by Luca Cerizza, "Artissima '07", Turin
"MOUSSE Magazine", Milan, Artist's interview, Issue 8, May–June
In which Annette is mistaken for Georges' mother, in *Ost Property*, published to coincide with the exhibition "Ost Property", Danielle Arnaud Gallery, London

2006
Bloomberg New Contemporaries 2006, Exhibition Catalogue, London
Jack Mottram, Review of "Décors du Silence", in "The List", 8–22nd June

2004
Wonders and Miracles – Photography Beyond Representation, Thanassis Moutsopoulos Museum of Photography, Thessalonica, Greece, (Photosynkyria 2005 Catalogue, Greek Edition)

2003
Dark Set Piece, in "Source", Issue 37, Winter

1997–2000
Measurement of Prolixity, Artist's writing, in "Inventory Journal", London
Words and Pictures, Artist's postcard; Limited edition artists multiples box, produced by Iain Forsyth and Jane Pollard, launched March, London

Night Music, 2007
Steel, HDF, wood, acrylic glass, blackboard paint, 125 x 147 x 58.5 cm
Courtesy Laura Bartlett Gallery, London

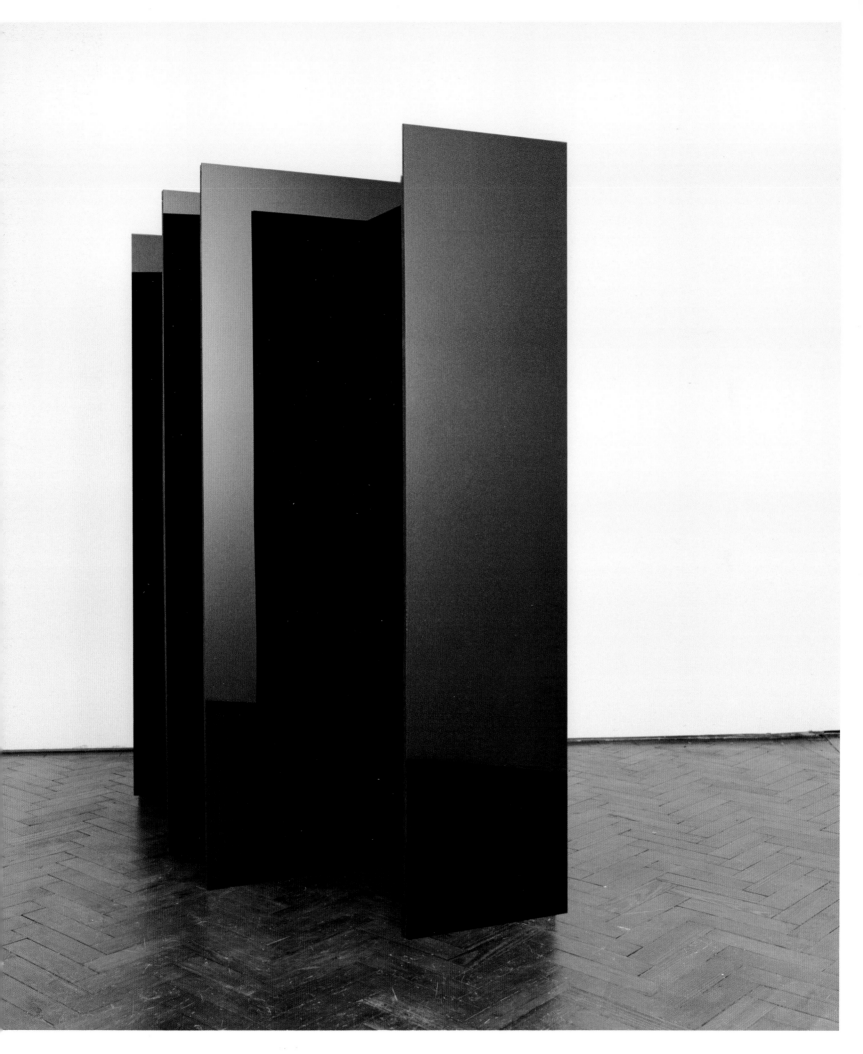

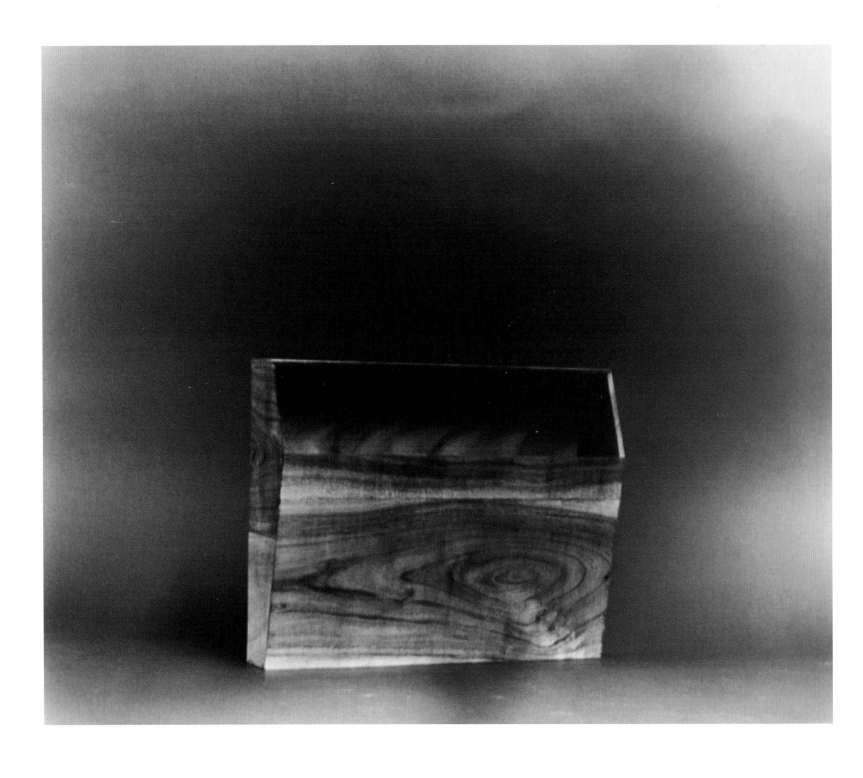

As I Lay Dying (Room 2) (Edition I), 2006
Matt gelatin silver print, 58 x 69 cm
Courtesy Laura Bartlett Gallery, London, and Office Baroque Gallery, Antwerp

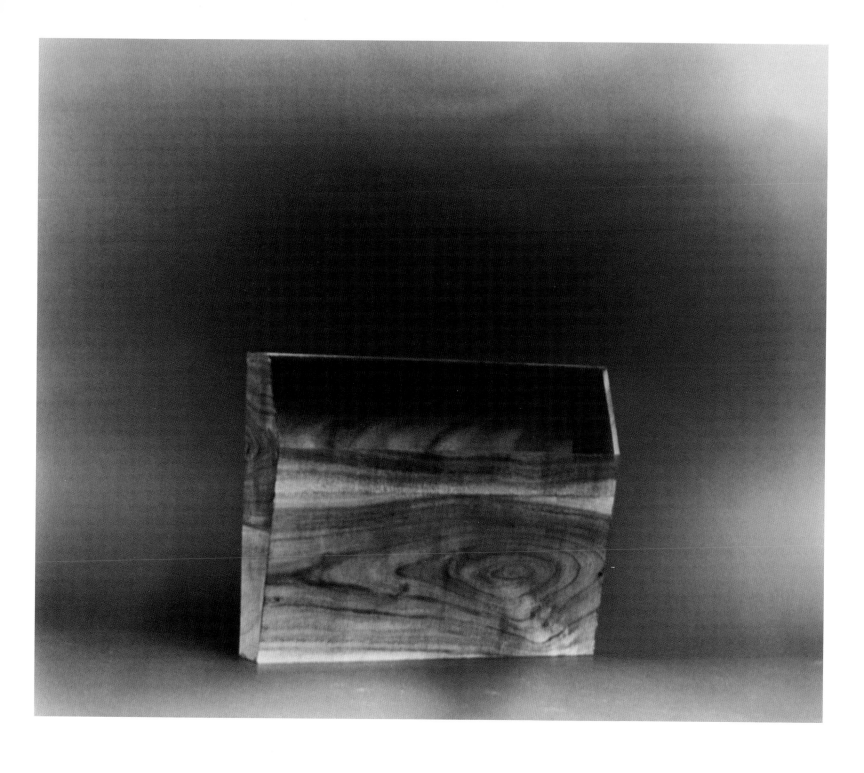

As I Lay Dying (Room 2) (Edition II), 2006
Matt gelatin silver print, 58 x 69 cm
Courtesy Laura Bartlett Gallery, London, and Office Baroque Gallery, Antwerp

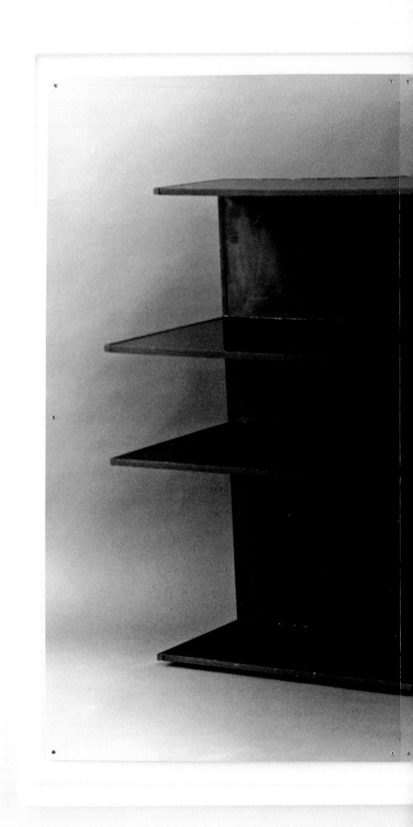

Gloss II, 2007
Matt gelatin silver print,
archival linen tape, eyelets, 168 x 200 cm
Courtesy Laura Bartlett Gallery, London

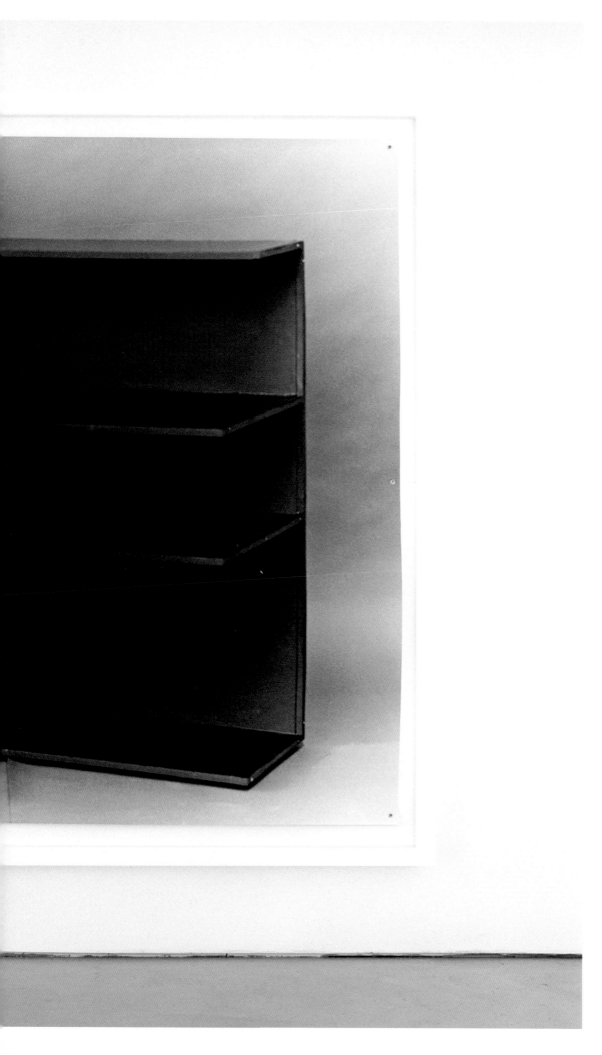

Malcontenta, 2007
Matt gelatin silver print, archival linen tape, eyelets, 224 x 190 cm
Courtesy Laura Bartlett Gallery, London

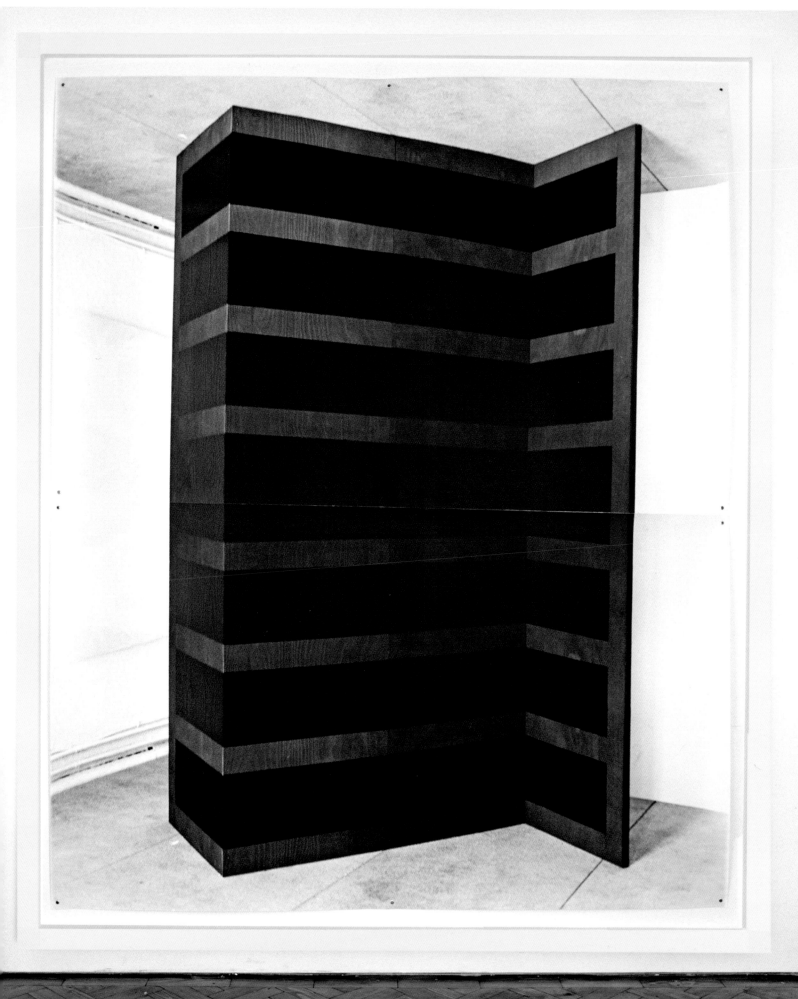

Bianca Brunner

Born in Chur, Switzerland, 1974.
Lives and works in London.

Bianca Brunner challenges the notion of photography as a "realistic" medium mimetically picturing the world. Although she takes actual pictures, the viewer is confronted with an imaginary scenario, which the artist constructs herself before she photographs it. She builds objects out of wood which she sets in scene, either in her studio or in studio-like outdoor environments. The objects have the quality of models, insofar as they are too abstract to be realistic, lacking any details. It appears that they were not built to be used, but rather to be depicted. The abstraction might even go so far as to cause estrangement. It is not evident what the objects represent; they seem to be figures of thought rather than actual things. The uncertainty is aggravated as the camera angle allows us to see only a minor part of the scenario, and we might even begin to speculate about what lies "behind" the scene. What does the background of the picture hide?

All this serves to highlight the imaginary nature of Brunner's pictures – so much so that imagination itself becomes one of their major topics. They deal with the question of what an image is by asking what is needed to construct it. Indeed, the repetitive act of construction (and implied deconstruction) asserts itself as the series progresses. More particularly, *Wood* (2007) emphasises the materiality of the picture. It seems as if the branches in the background (which remain unchanged throughout the series) were "transformed" into a new wooden object with each picture. *Star* (2008) explores the role played by light in the constitution of an image. The silver foil curtain in the background reflects the strong flash light, which is then reflected a second time onto the wooden objects in the foreground, picking out their forms within countless glimmering stars.

Given this preoccupation with the topic of the image, it is not surprising that the constructed wooden objects sometimes come close to comprising "scenes" in a literal sense. We might make out a stage, a stand for an audience for example. Yet these are not the only references the pictures play with. As for *Star*, we might remember the importance that philosophy of art has attached to the concept of "reflection" (from Hegel to Lacan, etc.), or we might consider how important a design item the silver foil curtain was in Warhol's Factory. And for *Wood*, Heidegger's understanding of the work of art as a "clearing" *(Lichtung)* comes to mind – as well as his way of thinking "off the beaten track" *(auf dem Holzweg*, which literally means "on a track in the wood"). Whatever weight the viewer might attach to such references, they indicate that Brunner's pictures, which at first glance might appear formal and rigid, on closer inspection also have a playful, even ironic side.

Tan Wälchli

Education
2005–07
MA in Photography, Royal College
of Art, London
2002–04
BA (Hons) in Photography, London
College of Communication
1996–97
Diploma in Visual Communication,
University of Art, Zurich
1992–96
BA (Hons) in Graphic Design, University
of Art, Zurich

Exhibitions
2008
"In Our World: New Photography
in Britain", curated by Filippo Maggia,
Galleria Civica di Modena, Italy
2007
"The Great Exhibition 2007", Royal
College of Art, London
"Summer Show", Hoopers Gallery,
London
"Photo50 between Mirrors and
Windows", London Art Fair,
selected by the MFA Curating
Programme at Goldsmiths, London
"Arrebato", Cámara Oscura Galería
de Arte, Madrid
2006
"Eleven Contemporaries at Michael
Hoppen", London
"RCA Print Auction", White Space,
County Hall Gallery, London
"ReGeneration: 50 photographers of
tomorrow", Aperture Foundation,
New York
"ReGeneration: 50 photographers of
tomorrow", Pingyao Photographic
Festival, China
"Re-Stage", The Arts Gallery, London
2005
"ReGeneration: 50 photographers of
tomorrow", Galleria Carla Sozzani,
Milan
"Helmhaus Scholarship 2005",
Helmhaus for contemporary Art, Zurich
"ReGeneration: 50 photographers of
tomorrow", Musée de l'Elysée,
Lausanne

2004
"Future Map Visual Art Exhibition",
The Arts Gallery, London
"Degree Show", London College
of Communication, London

Publications
2007
*Reference Book, 2007 Photographic
Practice*, Royal College of Art, London
2006
*ReGeneration: 50 photographers
of tomorrow*, Aperture Foundation,
New York
Re-Stage, University of the Arts,
London
2005
*ReGeneration: 50 photographers of
tomorrow*, London, Thames & Hudson

Awards
2007
The Worshipful Company
of Painter-Stainers Award
The Matthews Wrightson Charity
Trust Award
2006
First Prize, The National Magazine
Company Award

Collections
Aperture Foundation, New York
Musée de l'Elysée, Lausanne
University Art Collection, London

Untitled (3), from the series *Wood*, 2007
C-type print, 100 x 125 cm

Untitled (2), from the series *Wood*, 2007
C-type print, 100 x 125 cm

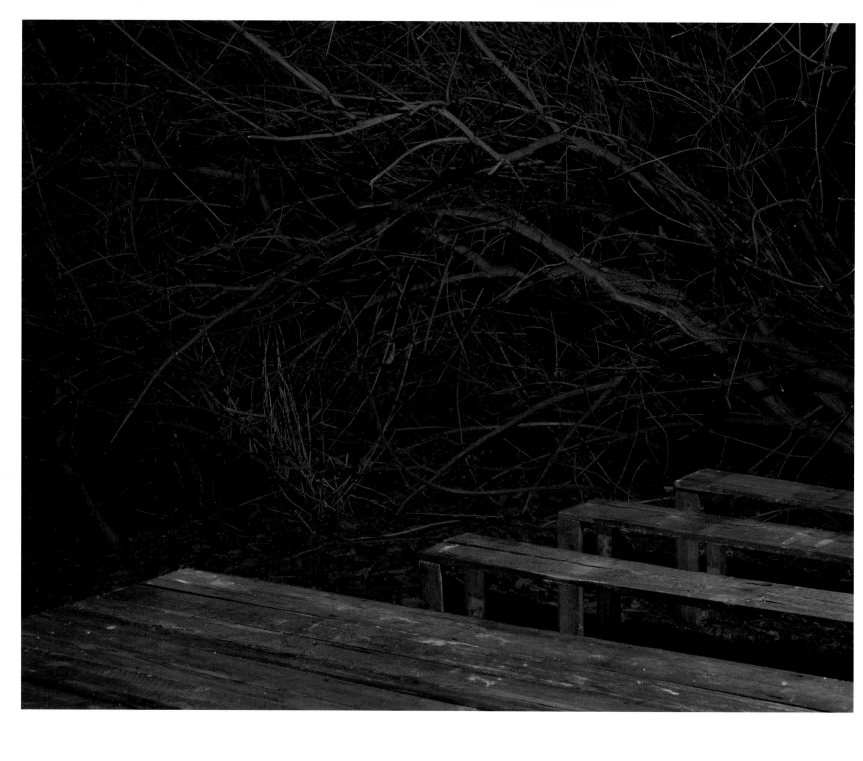

Untitled (1), from the series *Wood*, 2007
C-type print, 100 x 125 cm

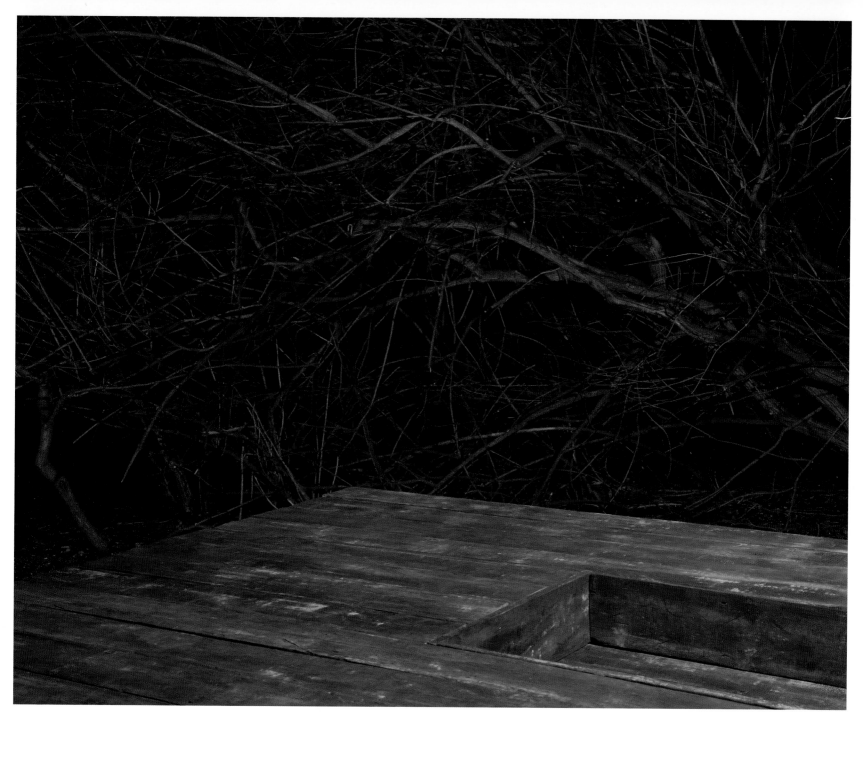

Untitled (4), from the series *Wood*, 2007
C-type print, 100 x 125 cm

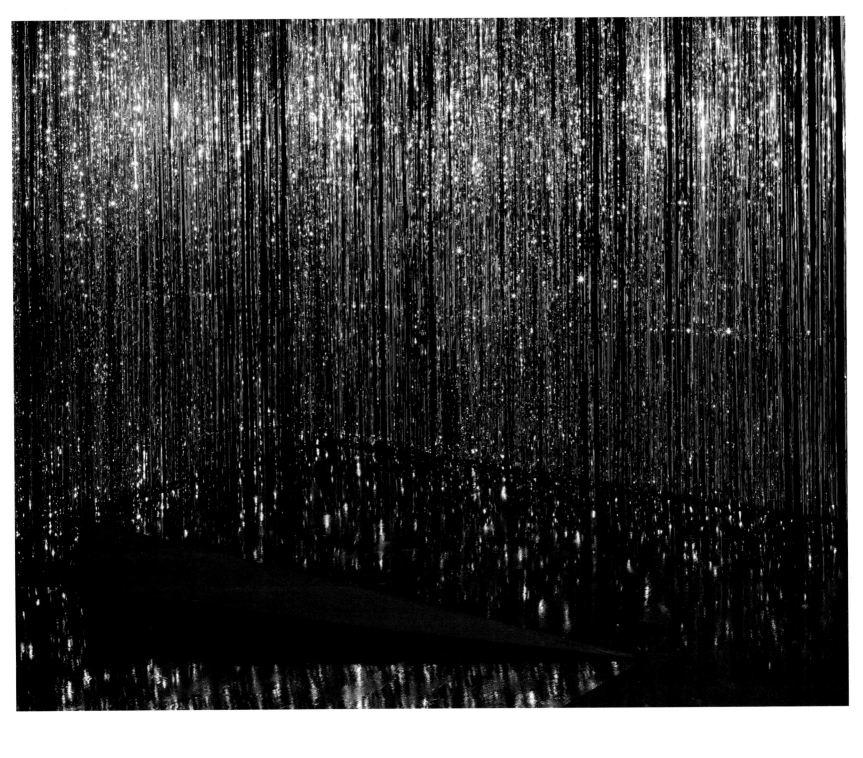

Untitled (1), from the series *Star*, 2008
C-type print, 100 x 125 cm

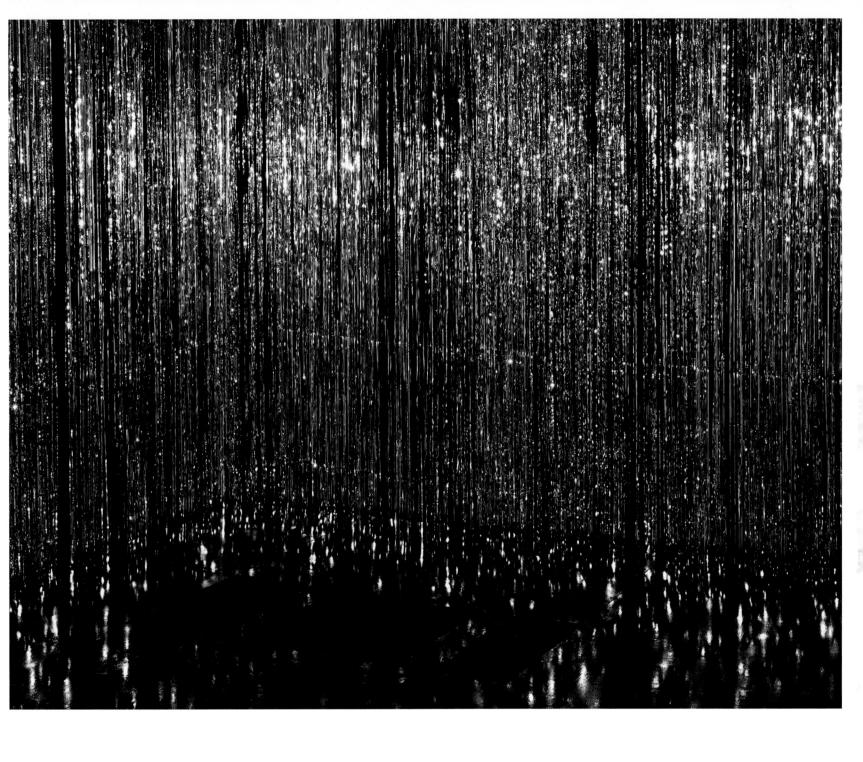

Untitled (2), from the series *Star*, 2008
C-type print, 100 x 125 cm

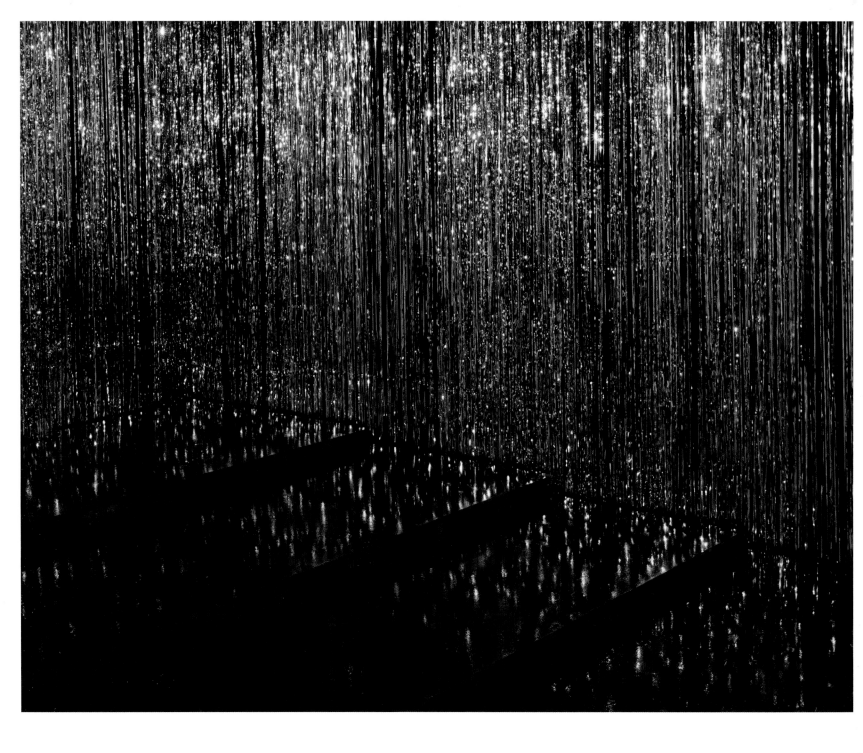

Untitled (3), from the series *Star*, 2008
C-type print, 100 x 125 cm

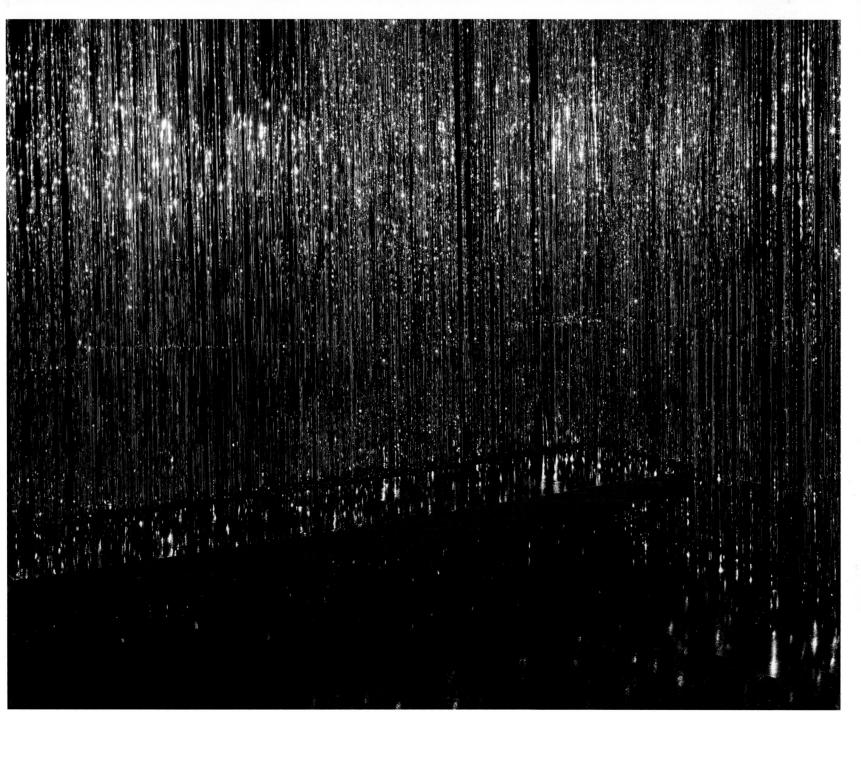

Untitled (4), from the series *Star*, 2008
C-type print, 100 x 125 cm

Lisa Castagner

Born in Banbridge, Northern Ireland, 1975.
Lives and works in London.

In Lisa Castagner's filmic and photographic universe, domesticity and the urban environment take on strangely animate psychic lives. Everyday encounters and gestures are reperformed by carefully groomed models, with a precise aggression that recodes ephemeral instances. In her recent series of photographs – *Treat*, *Break*, *Cure* and *Change* – pairs of women are placed in mundane urban environments. Rather than the blank availability that has characterised much art photography featuring attractive young women, Castagner's protagonists are all too active: from the mock-threat of the assistant wielding a syringe in *Treat* to the echoes of the back-street abortionist in the bristling handfuls of clothes hangers held by the shop assistant in *Change*. In *Cure*, a young woman appears to be trying to hypnotise her companion, who stares disinterestedly at the ring held on a string, perhaps stilled by her cool expression. Both women are dressed in smart, business-like clothes, blending with the bland corporate setting. The headscarf worn by the girl who is apparently being hypnotised and the photograph's title point to a drama that is ironised by the girls' similarities. Here Islamic fundamentalism is raised not as a spectre of difference or threat, but as an immaculately worn headscarf. The office partition that the women are posed against is transformed into a stage set for this ambiguous scene: is this a parody of British-Muslim identities held in tension, or are these actors in a more complex drama that the viewer can only begin to unravel? As in many of Castagner's photographs, the image allows for different levels of engagement, from the decorative, studied arrangement to the symbolically weighted props and gestures.

These exquisitely framed photographs incorporate both staged and documentary photographic traditions, with Castagner explaining how she was thinking about the lack of empathy in Martin Parr's colour documentary work from the 1980s whilst making her recent series. Rather than the grotesqueries of New Brighton or the class-riven politics of social gatherings, Castagner stages her dramas as the literalisation of emotions that are felt every day, captured through their theatrical reperformance rather than an unflattering camera angle or chance composition as in Parr's work. Like Parr however, there is perhaps something peculiarly British about her changing room, treatment suite or office settings, despite their anonymous fittings and standardised furniture. The recurrence of the flower print across the series – already tired whether it is a 1980s print or a contemporary photograph – situate these environments within the corporate landscape of Britain, found in every high street and office block: the homogenisation of experience that aims for glamour whilst remaining tied to utility. The loud consumption of the USA as pictured in pop art and cinematic scenes is not found here, nor is the romanticisation of the cityscape found in the European tradition of photography and cinema. In the brave new world of globalisation, the British urban landscape is still imprinted with the failure of fantasy. Castagner's landscapes speak of a grinding reality of work and leisure that blend seamlessly into one another: from a Botox treatment to a new outfit to the end of a work day that could also be its beginning. Castagner's earlier films and photographs primarily occupy domestic spaces, with the literalised version of imagined events and equivalences drawing on surrealism. However, the anonymous, blank models that appear in these earlier works are not the coquettish *femme-enfants* of Bretonian surrealist art, but are strangely full and empty at the same time. It is as if the evacuation of the body that took place in certain versions of feminist art theory in the 1980s has been taken literally, and the corpse of the female model is brought back to life, Frankenstein style, bearing the spectral legacy of her/its death. The equation of the female body with domestic objects is found in the film *Nap*

(2002), which offers many of the keys to Castagner's symbolic vocabulary. The sequence of events is simple: a girl lies on a couch, takes out her pink and metal brace from her mouth, lays it on the floor. A potted plant sits on a TV, a whisk is pictured next to an egg box on a work surface. The tranquillity of the scene is broken by the whisk apparently activating itself, the sound both aggressive and surprising. As if in response, a hairdryer on a dressing table turns on, the air blowing to a crescendo that pushes it off onto the floor, more compulsive actions. A breeze blows through the potted plants, and the girl picks up a plump, pink shrimp instead of her brace, and puts it in her mouth. The line between the everyday and the imagined is blurred, with the German meaning of uncanny – *unheimlich* – as being *both* familiar and strange pinpointing the surrealist play. This uncanny quality is overlaid with a sexualised atmosphere of unease, a process of fetishisation in which objects are both what they seem to be – a whisk, a plant, a girl – whilst at the same time evoking a narrative of desire, of submerged drives.

Alongside this surreal heritage, the style of the interiors and clothing in Castagner's work recall an '80s aesthetic, a Bret Easton Ellis desire for the hardbody, crossed with the domestic spaces of rented accommodation, as signified by the series titled *In Beige* (2003). In this early work, diptychs of photographs show the blond sleek hair of a model substituted for the domestic tableaux of whisks, hairdryers and mirrors. A similar evacuated space is explored in the photographs *Infinity* (2004) and *Mute Dislike* (2006). In *Mute Dislike* a girl sits on a bed in a completely white room, cotton balls blocking her ears and strewed on the bed beside her. The girl faces the camera, but her eyes are shut; she is cut off from the viewer by her refusal to see or hear, a resistance that underlies many of Castagner's scenes. Whilst the model may be an object for the viewer to observe, there is a childish refusal

of this encounter by the model that both highlights the futility of her gesture – we can still see her, even though she does not see us – whilst creating an awkward metaphorical space for the consumption of the female body that is so often taken apart in Castagner's work.

This construction of a resistant female model is found once more in *Corpse Variation* (2004). The artist herself appears as the model in an all-white room, lying on a yoga mat, face turned from the viewer, who is confronted by the layers of blinds and curtains that frame the prone body. A masturbatory gesture is held in tension with the seduction of the artist's body, laid out for the camera but caught in an imaginary space that is inaccessible and disturbing. As the title indicates, it is as if the laying out of the body for the camera is a kind of death, the life leeched out of the scene just as the colour has been bleached from all the fittings except for the blue of the mat. In Castagner's work, the spectral quality of her models is not to be confused with passivity, for in each piece, it is the presence of the model that appears to cause the psychic activity; a still centre around which to work through the fictions of femininity, revealing narratives of domestic disturbance and otherworldly seductions. With her new series in which her female protagonists act out their aggressive fantasies – albeit in small, suppressed gestures – the power that is felt across Castagner's films and photographs begins to rise to the surface. As with the face turned from the viewer in *Corpse Variation*, Castagner responds to the awkward imaginings of the viewer with a polished blankness that appears to mock narratives of mastery and masculinity, a distorting mirror that concretises the imaginary and reconceptualises the everyday.

Catherine Grant

Education
2001–03
MA in Photography, Royal College of Art, London
1995–98
BA (Hons) in Photography (1st Class), Edinburgh College of Art
1994–95
Diploma Foundation Studies in Art and Design, University of Ulster, Belfast

Exhibitions
2008
"In Our World: New Photography in Britain", curated by Filippo Maggia, Galleria Civica di Modena, Italy
2007
"Intraveloving", TANK TV, www.tanktv
"Romantic Anti-Humanism", Five Years Gallery, London
2006
"Albertine Goes South", Dorothee Schmid Art Consultancy, London
"The Responsibility of Forms", Atkinson Gallery, Somerset
"Kaleidoscope", one-night video and music event, Whitechapel Gallery, London
"Her Private Theatre", S1 Artspace, Sheffield
2005
"PILOT:2", International Art Forum, Farmiloes, London
"Not Yet Night", Studio Voltaire, London
2004
"Not Yet Night", The Ship, London
"The Principle of Hope", Three Colts Gallery, London
2003
"Animal, Vegetable, Mineral", Hoxton Distillery, London
"Headland", The Century Gallery, London
"Portobello Film Festival", Westbourne Studios, London
"Die Schachtel", Jakobsplatz, Munich
"Timeshare", Oxo Tower Wharf, London
"Urban and Suburban Stories", VTO Gallery, London

2002
"Sexperimental Weekenders", Five Years Gallery, London
"Perspective", International Group show, The Ormeau Baths Gallery, Belfast
"#2", Magnifitat & Sons, Edinburgh
"Sledge", Hartley's Jam Factory, London
1999
"To The Occupier", Solo show, The Scottish National Gallery of Modern Art, Edinburgh
1998
"Family Credit", The Collective Gallery, Edinburgh
"Still Moving", The Richard De Marco Gallery, Edinburgh

Publications, Events and Projects
2007
Frozen Tears 3, presented by John Russell, Article Press
2004
Liebeslied/My Suicides, documentary film for Rut Blees Luxemburg, filmed at ICA, London
"Not Yet", Babak Ghazi, London, September
2003
Die Schachtel, Christine Walter, Munich
2001
i-D: The Gallery Issue, London

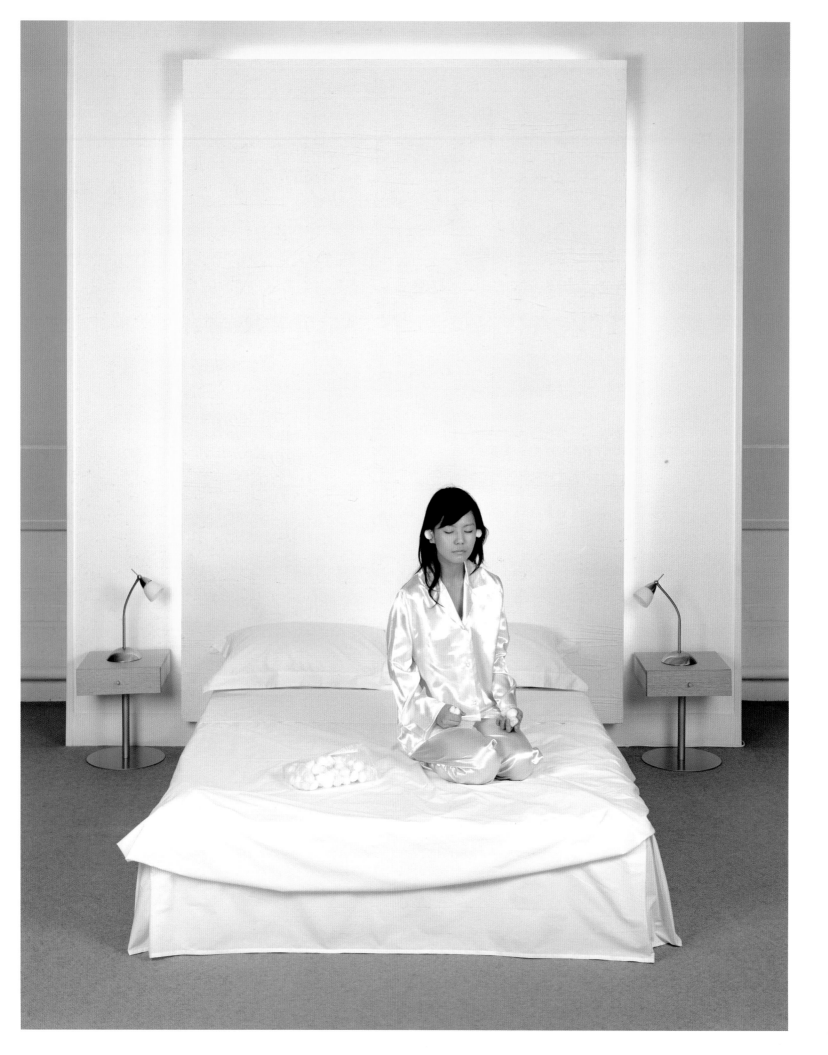

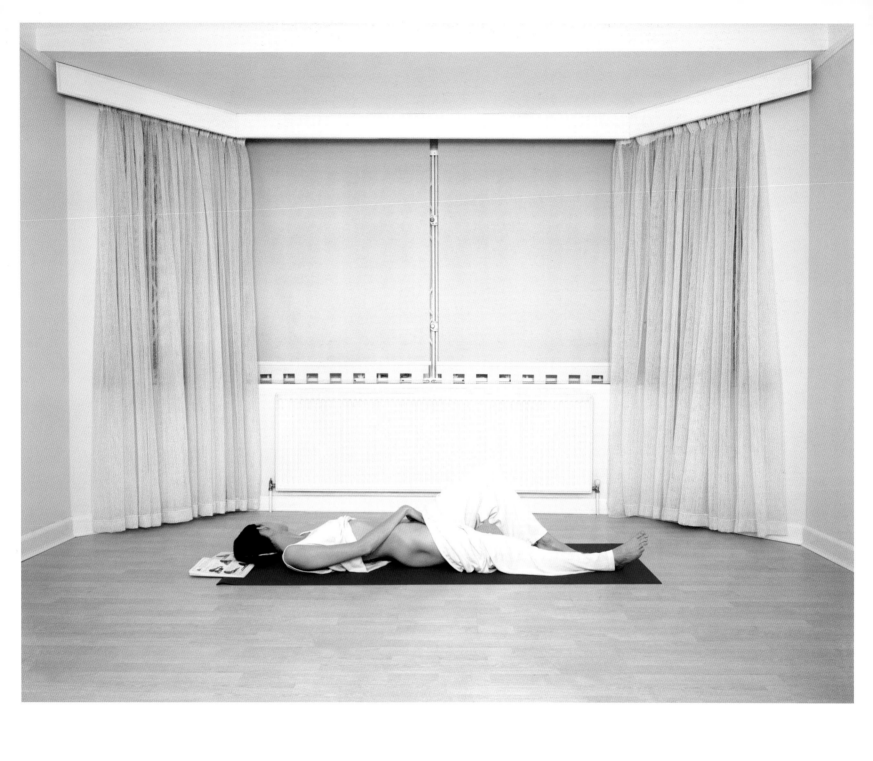

Facing page: *Mute Dislike*, 2006. Above: *Corpse Variation*, 2005
C-type prints, 152 x 123 cm, 123 x 152 cm

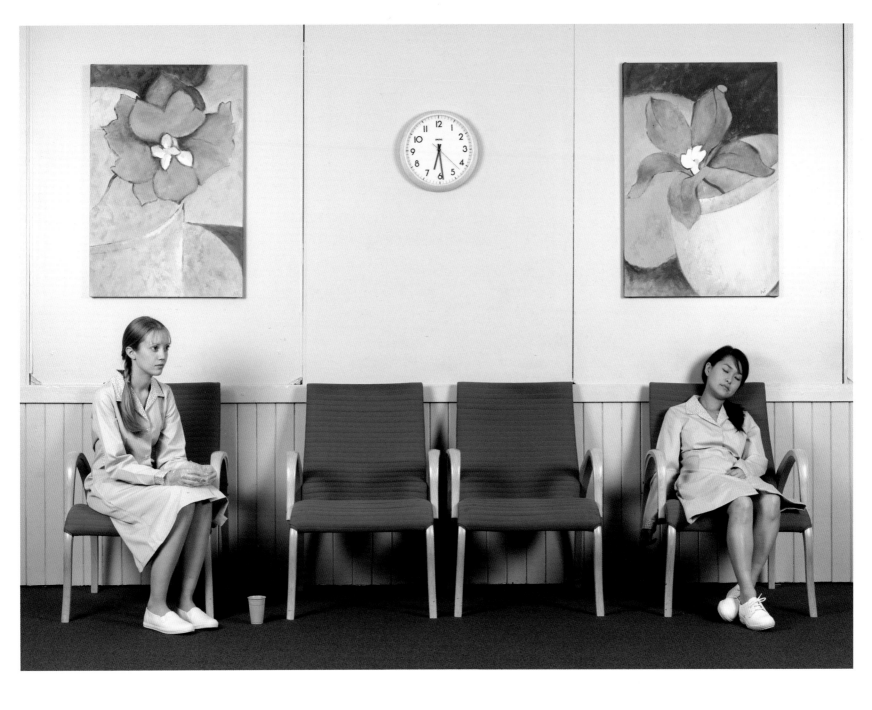

Break, 2007
C-type print, 115 x 153 cm

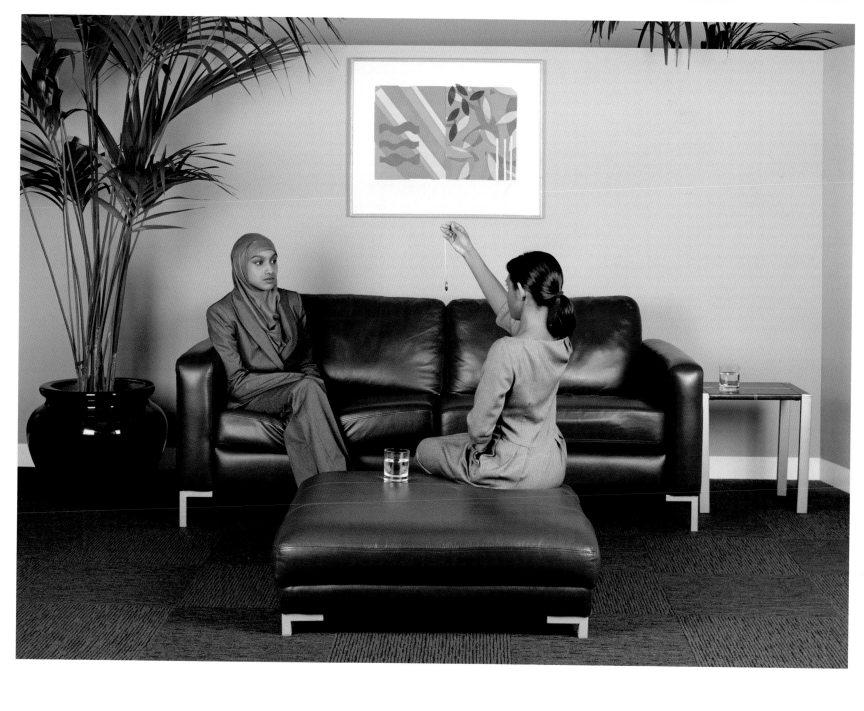

Cure, 2006
C-type print, 115 x 153 cm

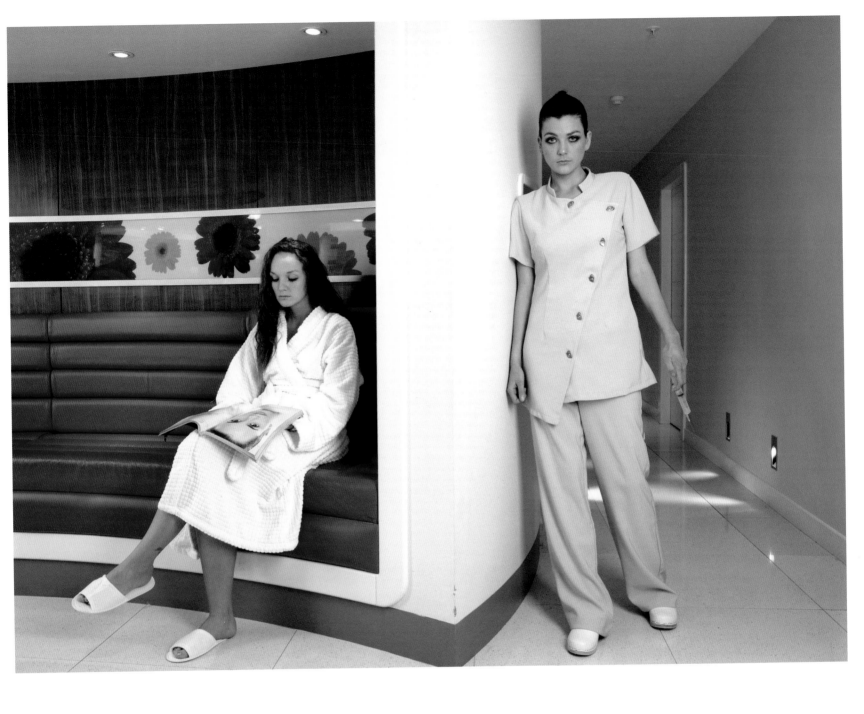

Treat, 2007
C-type print, 115 x 153 cm

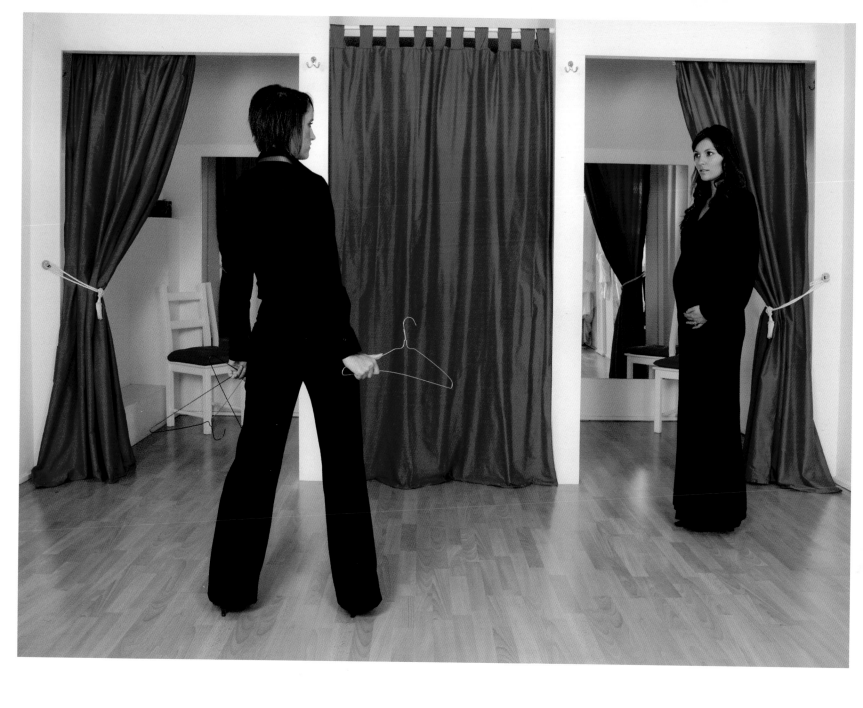

Change, 2007
C-type print, 115 x 153 cm

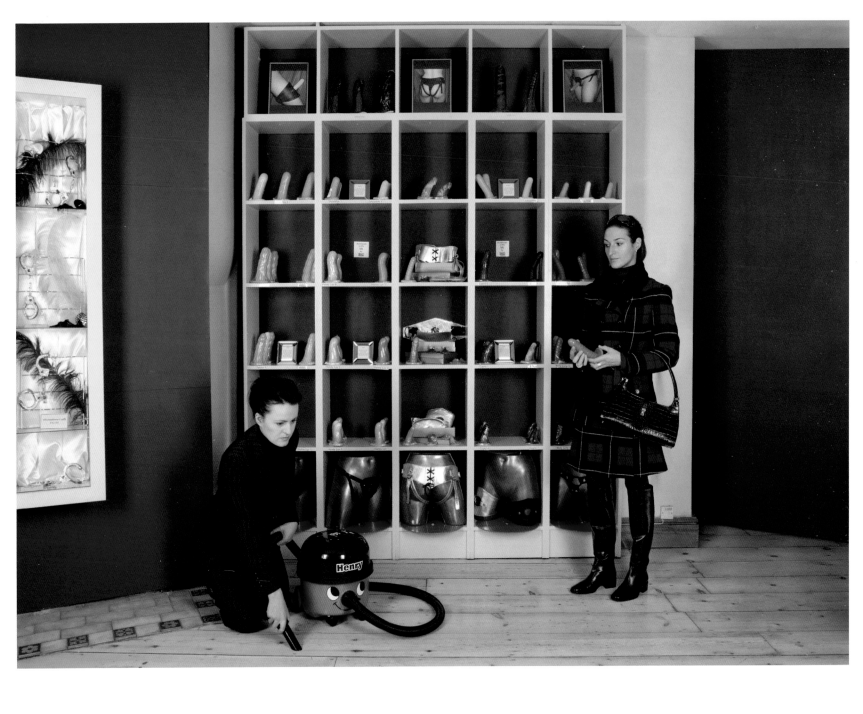

Clench, 2008
C-type print, 115 x 153 cm

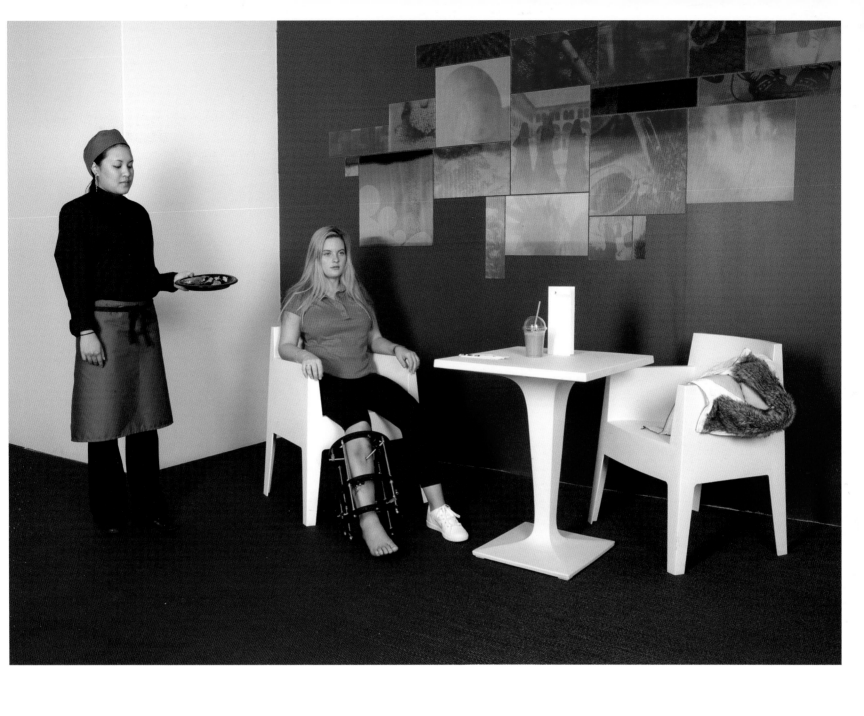

Wait, 2008
C-type print, 115 x 153 cm

Simon Cunningham

Lives and works in London.

Simon Cunningham:
The double-touch of a restless image

"The expression of a change of aspect is the expression of a new perception and at the same time of the perception's being unchanged."[1]
Ludwig Wittgenstein

"The separation of subject and object is both real and illusory. True, because in the cognitive realm it serves to express the real separation, the dichotomy of the human condition, a coercive development. False, because the resulting separation must not be hypostasized, not magically transformed into an invariant. This contradiction in the separation of subject and object is imparted to epistemology. Though they cannot be thought away, as separated, the *pseudos* of the separation is manifested in their being mutually mediated – the object by the subject, and even more, in different ways, the subject by the object. The separation is no sooner established directly, without mediation, than it becomes ideology, which is indeed its normal form. The mind will then usurp the place of something absolutely independent – which it is not; its claim of independence heralds the claim of dominance. Once radically parted from the object, the subject reduces it to its own measure; the subject swallows the object, forgetting how much it is an object itself."[2]
Theodor Adorno

The picture-object on the page opposite documents the most recent iteration of Simon Cunningham's extended work *Duckrabbit*. The photograph – something in Cunningham's practice to be received as an expression rather than a report – was made in his studio space and is emblematic of the kind of restlessly unstable images he produces.

Cunningham's art embraces flux. Perception is an entry point, though this soon gives way to the mesmeric double-touch of aspect-seeing and the inscription of difference within what is ostensibly the same. The work before you here is about looking, but equally as much about being looked at. Certainty is not Cunningham's preferred relation to images or objects. Immersive and possessing the contour of a daydream realised, his work challenges a viewer to let go and follow where an experience may lead – to recognition, or intimacy, or even only the engrossing mastery of a fractured and suspended moment. A great part of Simon Cunningham's gift and craft is to take something enmeshed in his own experience, at once unique and personal, and then open an experience up so that it might be shared in a picture. Boundaries therein, which frame not only the image but also subject and object, come unfixed and slip, or indeed wholly collapse, in conversations internal to, across and before his works.

John Slyce

[1] Ludwig Wittgenstein, *The Philosophical Investigations*, Oxford, Basil Blackwell, 1967, p. 196e.
[2] Theodor W. Adorno, *Subject and Object*, in *The Essential Frankfurt School Reader*, ed. by Andrew Arato and Eike Gebhardt, New York, Continuum, 1982, pp. 498–499.

Education
2005–07
MA in Photography, Royal College of Art, London
2001–04
BA (Hons) in Photography, Arts Institute, Bournemouth, UK

Exhibitions
2008
"In Our World: New Photography in Britain", curated by Filippo Maggia, Galleria Civica di Modena, Italy
"ARTfutures", Bloomberg SPACE, London
"Anticipation", London
"Fragile", Espai Ubu, Barcelona
2007
"Bodycity", Video APT 20, Docklands, Dublin
"Objects of Art", Matthew Bown, London
"The Region of Unlikeness", Bank, Los Angeles
"Group Show", 20 Hoxton Square, London
"The Future Can Wait", Atlantis Gallery, London
"The Great Exhibition 2007", Royal College of Art, London
2006
"Prix Leica", L'Ecole des Arts Decoratifs, Paris
"Videos Im Ballhaus", Ost Berlin
"Lovely Shanghai Music (Team 404)", Shanghai Museum of Modern Art, Shanghai
"Video Program", Kunstverein Langenhagen, Germany
2005
"Andmoreagain", Open Eye Gallery, Liverpool

Publications
2008
Next Generation, in "Wallpaper" magazine
Future Greats/Ones to Watch, in "Art Review", March, p. 106
2007
James Westcott, *One Thing at a Time*, in "20 Hoxton Square Newspaper"
Reference Book, Royal College of Art, London
2005
"Source" magazine, Issue 41

Awards
2007
Hiscox commission
Hoopers Prize
Studio residency, Cité Internationale des Arts, Paris
2006
Sir Richard Stapley Educational Trust

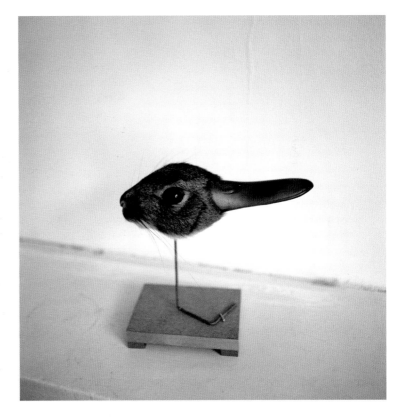

Duckrabbit, 13th March 2008

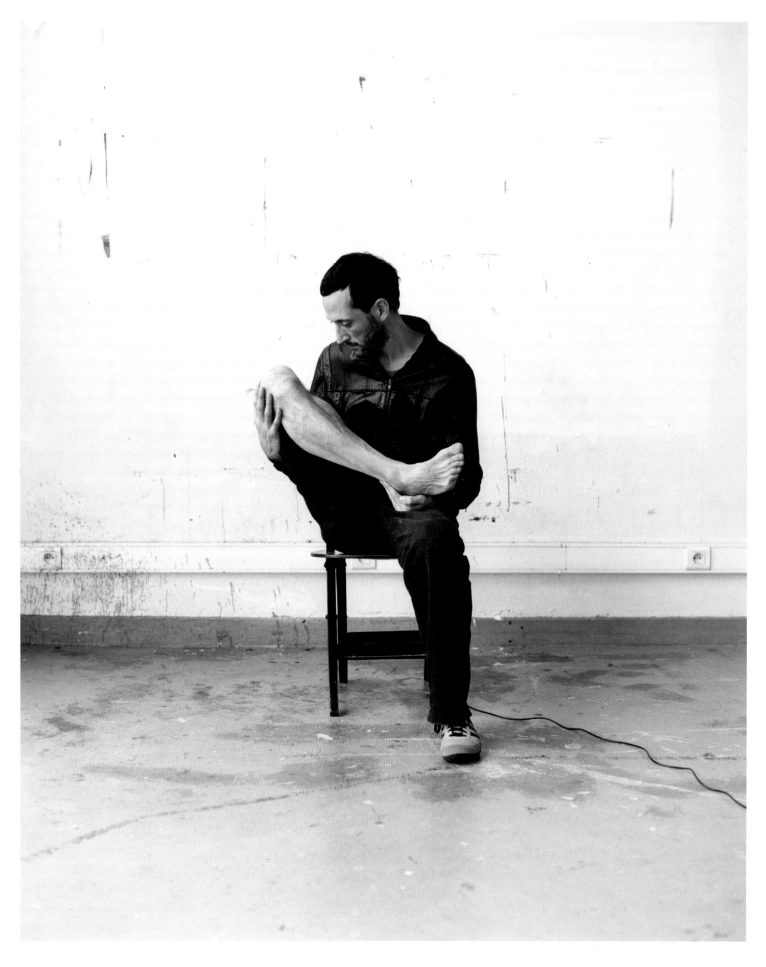

Mollymuddle, 2007. Single channel video, dimensions variable, 21'51" and 3 x (63 x 53 cm) separately framed C-type prints

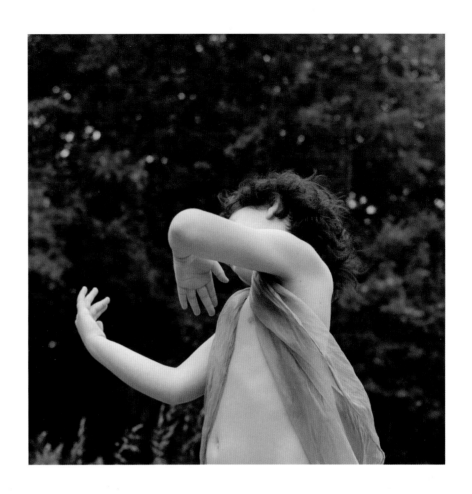

The Wrestlers, (2002–05) 2007
C-type prints, 61 x 61 cm each, separate oak frames

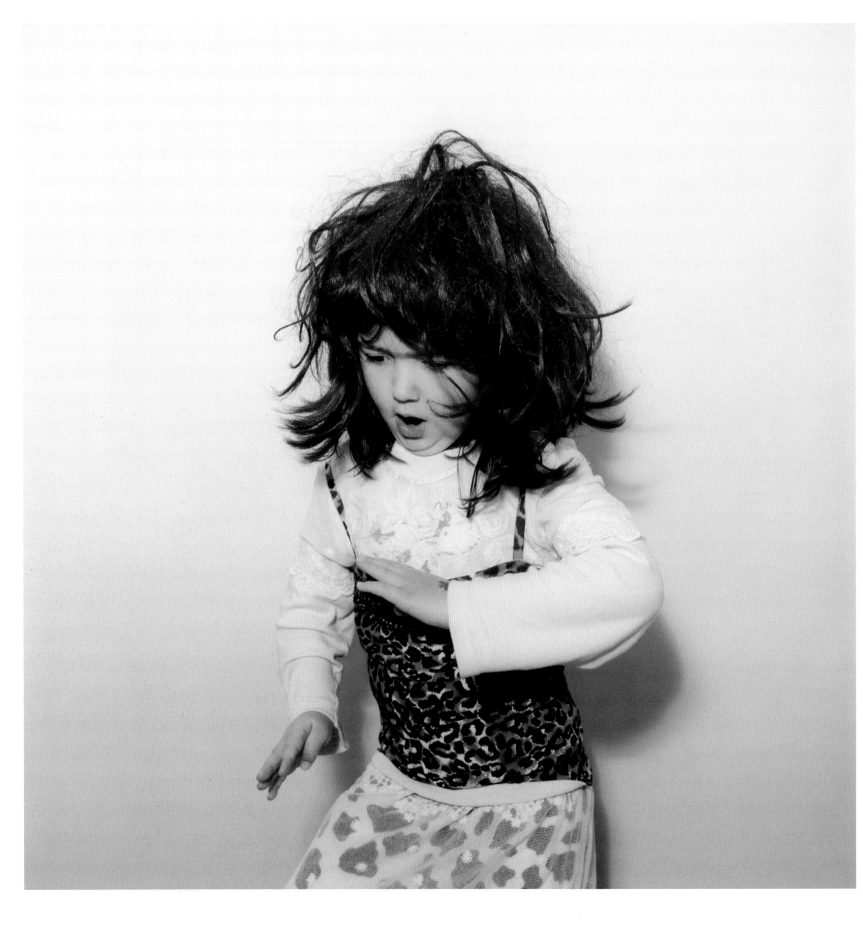

Ruby d n b, 2008
C-type prints, 122 x 122 cm each, separately framed

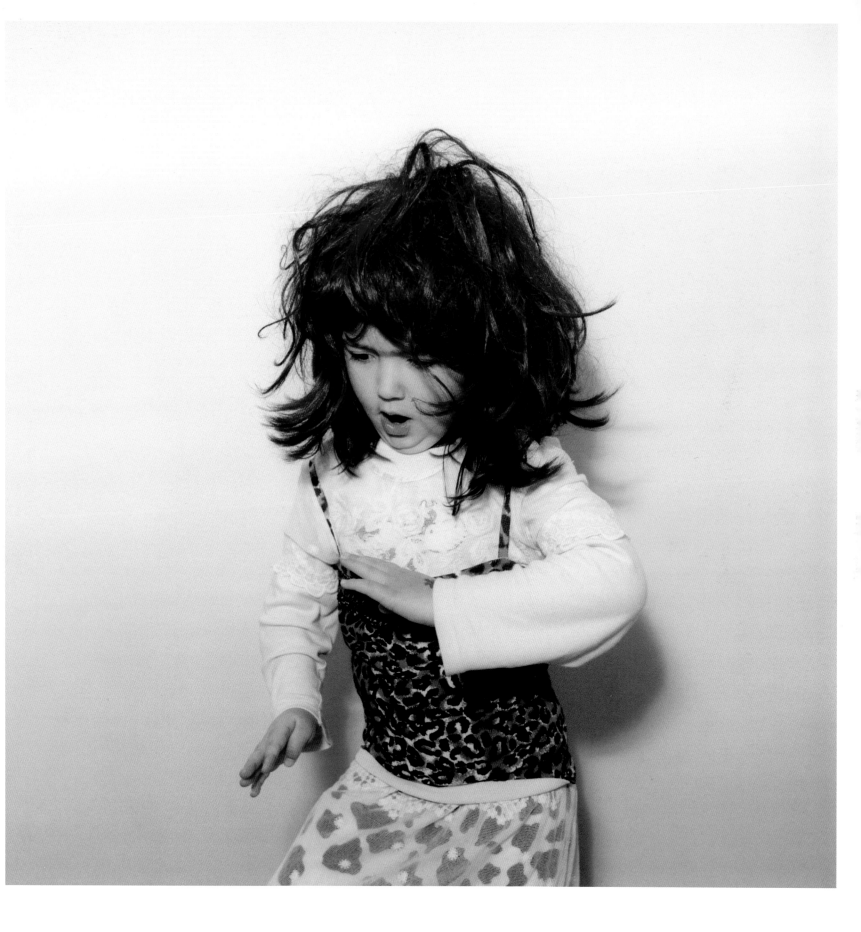

Tyger, Tyger. Found photographs

Skye is Falling, 2007. C-type print, 122 x 122 cm

Pander, circa 1970
Reproduction courtesy of the Zoological Society of London

Annabel Elgar

Born in Aldershot, UK, 1971.
Lives and works in London.

Annabel Elgar's photographic works map out a borderland of fragile enclaves and lost directions. Staged encounters, with heightened foregrounds and a voyeur's intimacy, are swiftly usurped by the notion that as fiction they are in fact false – their source remaining unclear. Details become covert signifiers, offering us narrative pointers to clue together what has happened. Peppered with cropped figures, fires and totemic symbols, we are made aware of ritual behaviour and the allusion towards cult and secrecy, and yet the locale is never clarified.

The work is concerned with sharp awakenings to the loss of innocence. Characters inhabit a fraught psychological space that acknowledges the contradictions of the ensuing spectacle. Narratives slowly reveal themselves as unforeseen antidotes to the assumed drama that is being witnessed: photographs where the prerogative is concerned with the exposure of vulnerability in its various forms.

Figures are often preoccupied by some distraction, or simply contained within their own space, with only their backs or cropped features to be seen. Fractured within the slow revelation of where they find themselves, they are oblivious to our position as onlookers and frequently to each other. They offer us a spectrum of divided and detached experiences rather than a unified whole, and the images communicate this layering of different worlds of introspection. Small and unobtrusive details gradually come into focus, alluding towards some past event, functioning as a bed of metaphor through which we are able to establish a half-knowledge of what we are seeing. A deflated football, a scrawled message on a wall and a bruised cheek become potent signs that – despite their sense of quiet and subtlety – become as important as the overriding image.

Annabel Elgar

Education
1999–2001
MA in Photography, Royal College of Art, London
1990–94
BA (Hons) in Film, Video and Photographic Arts (1st Class), Central London Polytechnic

Selected Solo and Two Person Exhibitions
2007
Nepente Art Gallery, Milan,
"Month of Photography", Bratislava
2006
"Secrets and Mysteries", Zephyr, Mannheim, Germany (with Anne Kathrin Greiner)
"Black Flag" (2), The Wapping Project, London (The Jerwood Commissions)
Galleri Image, Aarhus, Denmark
2004
"Black Flag" (1), The Wapping Project, London (solo show, The Jerwood Commissions)
Upstream Gallery, Amsterdam (with Cristian Andersen)
2000
Southampton City Art Gallery, Southampton
South Hill Park Arts Centre, Bracknell
1997
Zone Gallery, Newcastle upon Tyne
1996
Islington Arts Factory, London

Selected Group Exhibitions
2008
"In Our World: New Photography in Britain", curated by Filippo Maggia, Galleria Civica di Modena, Italy
2007
"ArtSway Open 07", Sway, UK
"The Joy", Nettie Horn Gallery, London
"Creekside Open", London (Selector: Victoria Miro)
"The Power of Language", Academy of Arts, Berlin
Lodz Art Centre, Lodz, Poland
"Off Programme", Krakow
2006
"Here Today", Jersey Galleries, Osterley Park, London
"Plug", County Hall Gallery, London
2005
"Narratives of the Presumed Invisible", Kunsthalle Lophem, Belgium (with Anthony Goicolea and Kristof Vrancken)
"The Madness of Paradise", Anne Gary Pannell Art Gallery, Sweet Briar College, Virginia, USA (with Gregory Crewdson and Justine Kurland)
"Locus Loppem", Kunsthalle Lophem, Belgium
"Fashion, Film and Fiction", The Wapping Project, London
2004
"Adolescenz", Fotogalerie, Vienna
2003
Upstream Gallery, Amsterdam
"Twenty White Chairs", The Wapping Project, London (Jerwood Commissions), touring to: Jerwood Space, London and Design Centre, Leeds
2002
"Urban Raw", Millais Gallery, Southampton
Inside Space, London
2001
"14 x 14", Mafuji Gallery, London
"Miniature Madness", Winkley Street Studios, London
2000
"Assembly", Jubilee Street, Whitechapel, London

1997
Cambridge Darkroom Gallery, Cambridge
1995
"The Fabergé Photography Awards" (in association with "The Guardian"), Victoria & Albert Museum, London
1994
"Agfa Bursary Winners' Exhibition", London

Selected Books and Catalogues
2007
Month of Photography, Bratislava, Exhibition Catalogue, Spoločnost', FOTOFO, pp. 58–59
Photomonth in Krakow 2007, Exhibition Catalogue, p. 164
2006
Twilight: Photography in the Magic Hour, Victoria & Albert Museum, Exhibition Catalogue, compiled by Martin Barnes and Kate Best, London and New York, Merrell, p. 21
We Were Until We Weren't, Galleri Image, Exhibition Catalogue
2005
The Madness of Paradise, Sweet Briar College Publications
2002
Assembly, Exhibition Catalogue
2001
Still moving still, Royal College of Art Photography MA Publication

Selected Reviews and Articles
2007
"Highlights", No 29, pp. 200–205, D.Art, Greece
2006
Kai Scharffenberger, *Secrets and Mysteries*, in "Die Rheinpfalz", *Theater der Dinge* (1 June)
Cristina Franzoni, *Vision Germany*, in "Zoom", 7 August, p. 16
Geheimnisvolle Spuren, in "Mannheimer Morgen", 30 May
Steffen Moestrupp, *British Photography*, in "Le Monde Diplomatique", No 3, March, p.13
2005
Marc Ruyters, "De Tijd", Belgium, 28 October

2004
Helen Sumpter, *Broken Boiler*, in "The Big Issue", 22–28 November, pp. 30–31
"Blueprint", September
"NextLevel", Edition 1, Vol. 3
"Bilder", No 192 (in association with Fotogalerie Vienna)
2003
"Camera Austria", Forum, No 82, June
2002
"Art Review", Vol. L1V, December–January 2003
2000
"Art Review", February
1999
"The Independent", The Review, 4–9 October
1996
"Words & Pictures", Issue 4, Glass Shelf Show, ICA, London
1995
"Women's Art Magazine", No 66, September–October
"British Journal of Photography", No 7040, 30 August
"The Guardian", 14 April

Selected Awards
2007
Shortlisted for "ArtSway Open 07"
Shortlisted for "Creekside Open 07" (Selector: Victoria Miro)
2006
Winner, "8th Portfolio Review", Month of Photography, Bratislava
2004
Arts Council Funding Award
Jerwood Commissions 2004
2002
London Arts Council Funding Award
2000
Winner, National Magazine Award

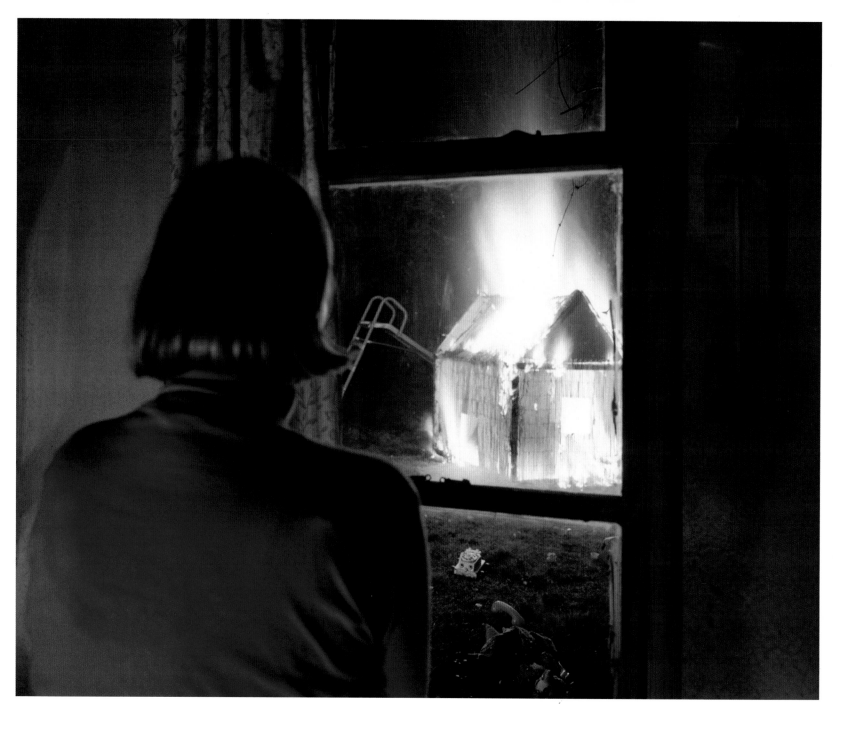

Torch, 2006
C-type print, 102 x 127 cm

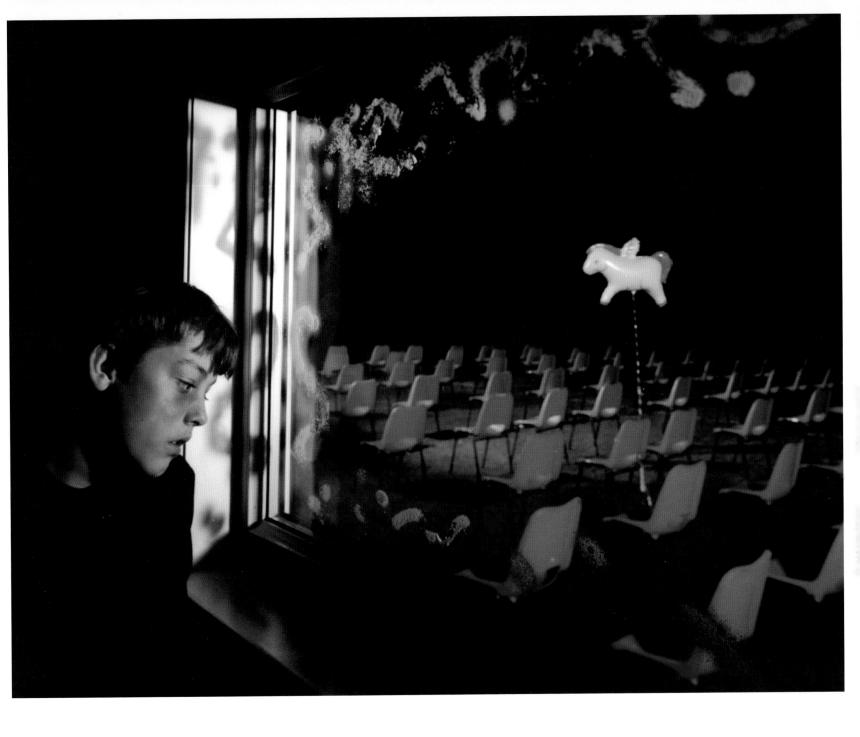

Pegasus, from the series *Black Flag*, 2004
C-type print, 102 x 127 cm
Commissioned by the Women's Playhouse Trust for the Wapping Project
as part of the Jerwood Charitable Foundation Commissions 2004

Twister, from the series *Black Flag*, 2004
C-type print, 102 x 127 cm
Commissioned by the Women's Playhouse Trust for the Wapping Project
as part of the Jerwood Charitable Foundation Commissions 2004

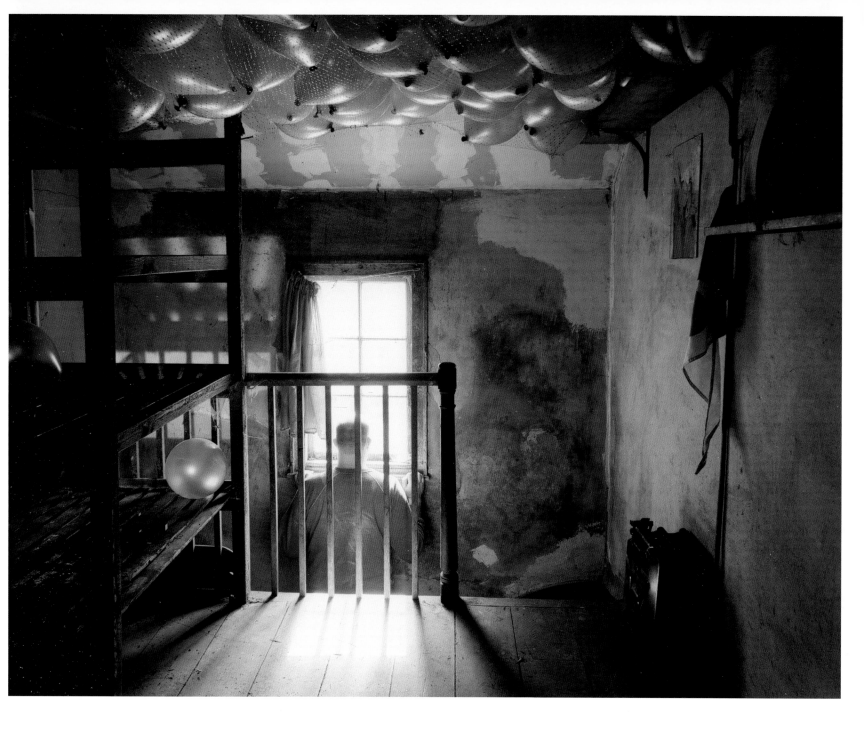

The Rehearsal, 2007
C-type print, 102 x 127 cm

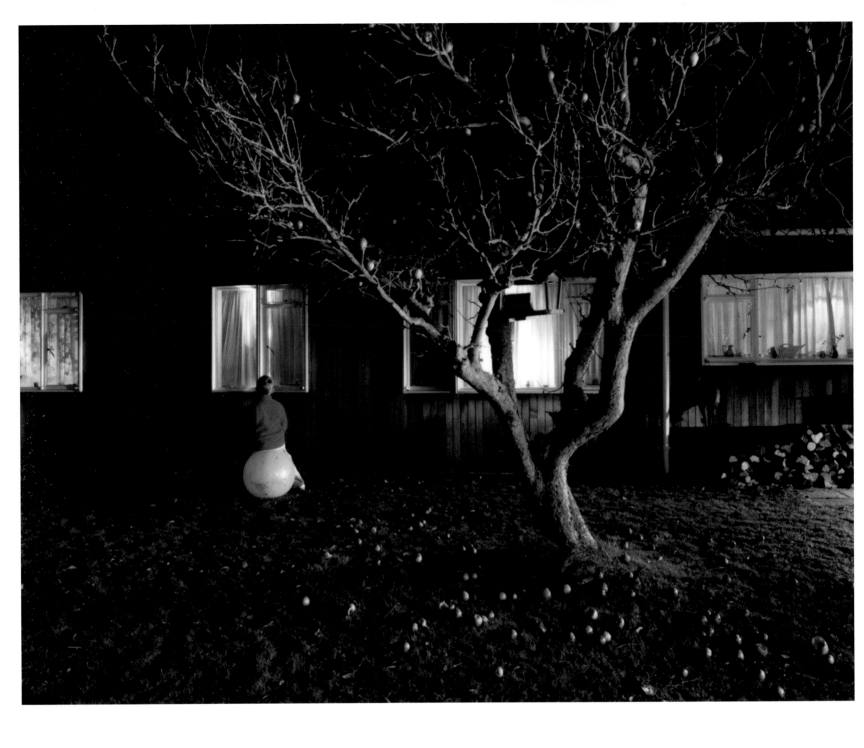

Spacehopper, 2001
C-type print, 102 x 127 cm

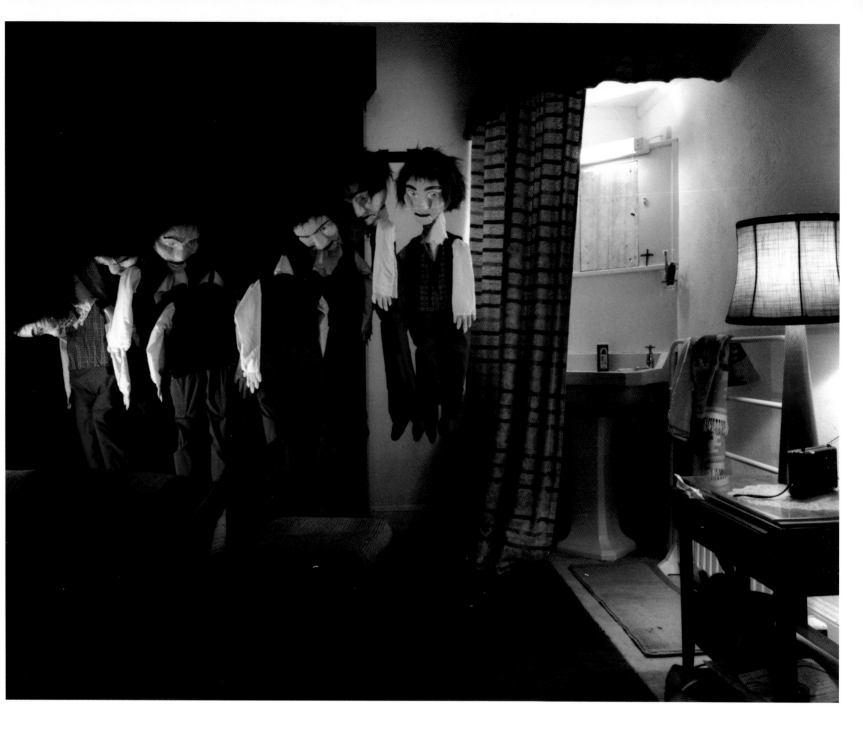

Legion, 2006
C-type print, 102 x 127 cm

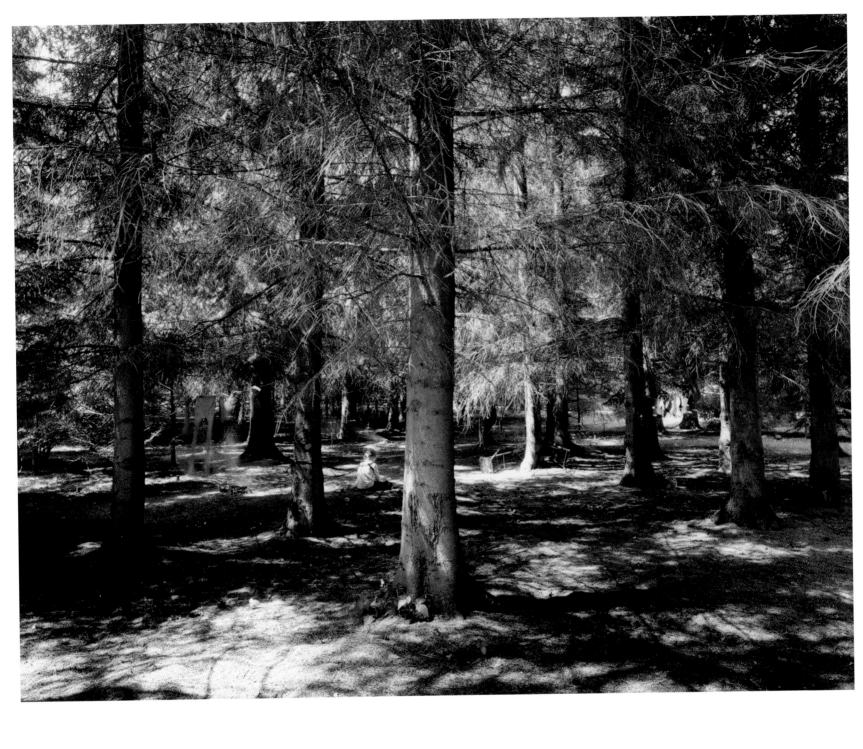

Retreat, from the series *Black Flag*, 2004
C-type print, 102 x 127 cm
Commissioned by the Women's Playhouse Trust for the Wapping Project
as part of the Jerwood Charitable Foundation Commissions 2004

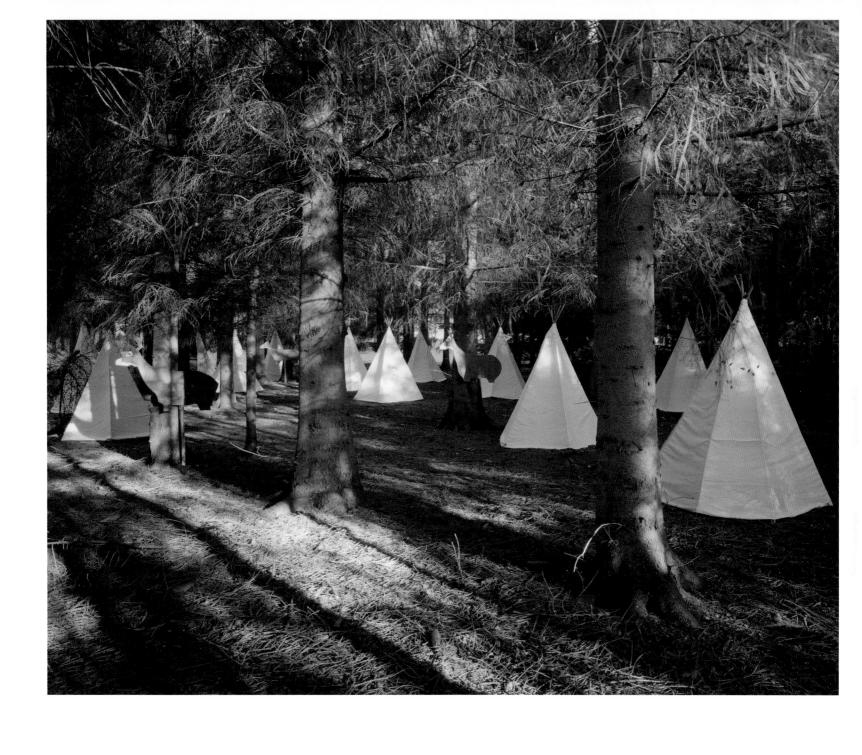

Decoy, 2007
C-type print, 102 x 127 cm

Anne Hardy

Born in London, 1970.
Lives and works in London.

Anne Hardy creates photographs that are rich with intrigue and detail; places that seem to carry the behaviour and personality of fictional and unseen inhabitants. For Hardy, like a number of high-profile photographers in recent years, the labour of her art is in the making of the scene that she depicts in each photograph. That is not to say that her photographs stand in for or merely document the environments that Hardy creates, but that her meditation on photography is spent creating the things – the stuff – that photography will then narrate.

One analogy for Hardy's working process is that of the novelist who develops a character to the point that it seems to take on an independent existence, guiding the writer like a scribe at the service of an imaginary but vivid character. Hardy's photographs may start with an object and an idea that instigates her building of the scene, but the final construction develops over time as Hardy imagines upon whom and how this fictional space is used.

Hardy's photographs stay within a tight range of types of spaces: a storage area, a communal hall, and a temporary office. All are run-down spaces, ones that display the vestiges of human storing, ordering, discarding, sites where nature begins to creep into dominance as regular human use declines. The anticipation of the relationship between the absent subjects of these photographs and the objects they have arranged and abandoned, is where the narrative content of Hardy's photographs is found.

The seemingly accidental visual details – the clustering and stacking of things, the trodden-in dust and dirt – resonate with human character and will. This effect is doubled up in Hardy's photographs: her working process is to imaginatively use as well as make these spaces and, simultaneously, invest them with the vestiges of her own use of the scene. In so doing, Hardy shifts the photographs from being simply well-crafted and uncanny simulations of a heightened reality to become genuine experiences of the fictional and real combined.

Charlotte Cotton

Education
2000
MA in Photography, Royal College of Art, London

Solo Exhibitions
2008
Bellwether Gallery, New York
2006
Maureen Paley, London
2005
"ArtSway", Sway, UK
2004
"Laing Solo", Laing Gallery, Newcastle (Cat.)

Group Exhibitions
2008
"In Our World: New Photography in Britain", curated by Filippo Maggia, Galleria Civica di Modena, Italy
"Martian Museum of Terrestrial Art", Barbican Art Gallery, London
2007
"07/08", Bellwether Gallery, New York
"52nd International Art Biennale di Venezia", New Forest Pavilion, Venice
"Present Future (solo project)", at "Artissima", Turin (Cat.)
"Royal Academy Summer Exhibition", Royal Academy, London
"The Lucifer Effect", Primo Alonso, London
"Still Life, Still: contemporary variations", T 1+2 Gallery, London
"The Juddykes", The Old Art Shop at John Jones, London
2006
"MERZ", curated by Peter Lewis, Magazin4, Bregenzer Kunstverein, Austria (Cat.)
2005
"to be continued.../jaatku...", curated by Brett Rodgers and Mika Elo, Finnish Photography Festival, Helsinki (Cat.)

Publications
2007
Cecilia Alemani, *Anne Hardy*, in *Present Future*, Exhibition Catalogue
Leo Benedictus, *Anne Hardy's Best Shot*, "Guardian G2", 11 January, p. 29
John Slyce, *Anne Hardy*, in *New Forest Pavilion 52nd International Art Biennale di Venezia*, Exhibition Catalogue
Anne Hardy, in "Slash/Seconds", Issue 7
2006
Alex Bagner, *Fashion crashes the art party*, in "Wallpaper", April 2006, p. 56
Iphigenia Baal, *Framed: Anne Hardy, Space in time*, in "Dazed", Vol. 2, Issue 34, February, pp. 30, 31
Camilla Brown, *Looking at the overlooked*, in *Stilled*, Ffotogallery/IRIS, pp. 72–75
Charlotte Cotton, *Anne Hardy, Recent Photographs*, in "Portfolio" Magazine, Issue 43, pp. 18–23
Charles Darwent, *Play Time*, in "Art Review", Vol. IX, January, pp. 20, 21
"Merz", Magazin4 Bregenzer Kunstverein, pp. 66–73
Sally O'Reilly, *Anne Hardy*, in *Vitamin Ph*, London, Phaidon, p. 31
Chris Townsend, *New Art From London*, London, Thames & Hudson, pp. 89–97
2005
Lauren Cochrane, *Artistic Endeavour*, in "British Vogue", December
Alice O'Keefe, *The New Art Elite: young gifted and female*, in "The Observer", 23 October
Sarah Thornton, *The Power 100* (extract), in "Art Review", Vol. LVIII, November, p. 101
Anne Hardy, in "Slash/Seconds", Issue 1
Claudia Stein, *Anne Hardy – Interior Landscapes*, in "Photography Now", Issue 4
Anne Hardy, in "The Guardian Guide", 7 March
Exhibitions, Pick of the week, in "The Guardian Guide", 18 March
Anne Hardy, in *To be continued.../jatkuu...*, British Council/Hippolyte Gallery, pp. 20–21
Exhibitions, Pick of the week, in "The Guardian Guide", 26 March

2004
Charlotte Cotton, *The Photograph as Contemporary Art*, London, Thames & Hudson, pp. 74–75
The House in The Middle, ed. by Gordon MacDonald, Photoworks, pp. 62–64
Really True! Photography and the promise of reality, Hatje Cantze Verlag
Laing Solo, Laing Art Gallery, pp. 6–13
Portfolio Interior Landscapes, in "Photoworks", Autumn–Winter, pp. 22–29
Charlotte Cotton, in "TANK", Vol. 3, Issue 12, pp. 88–89
Charlotte Cotton, *Photography in the UK today*, in "ARCO", pp. 15–18

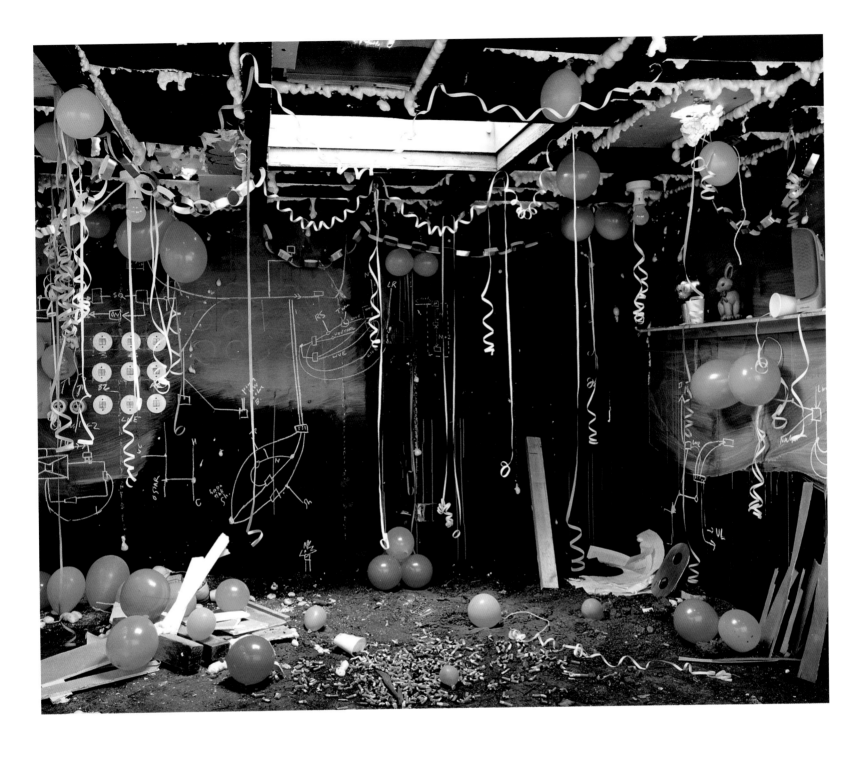

Untitled IV (Balloons), 2005
Diasec mounted c-type print, 120 x 150 cm
Courtesy Maureen Paley, London

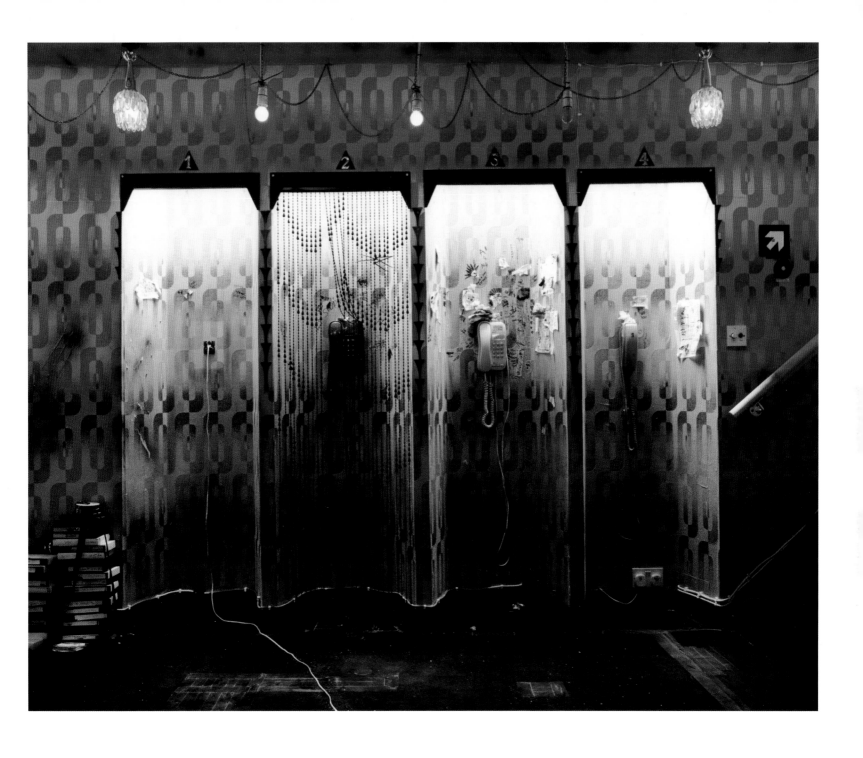

Booth, 2006
Diasec mounted c-type print, 120 x 150 cm
Courtesy Maureen Paley, London

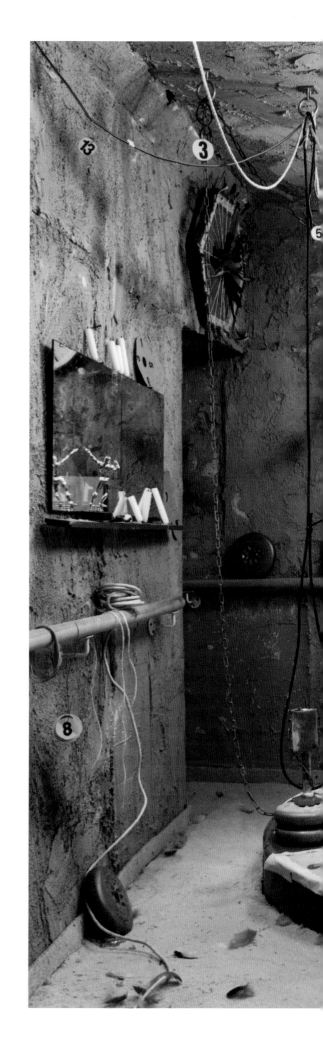

Cipher, 2007
Diasec mounted c-type print, 144 x 174 cm
Courtesy Maureen Paley, London

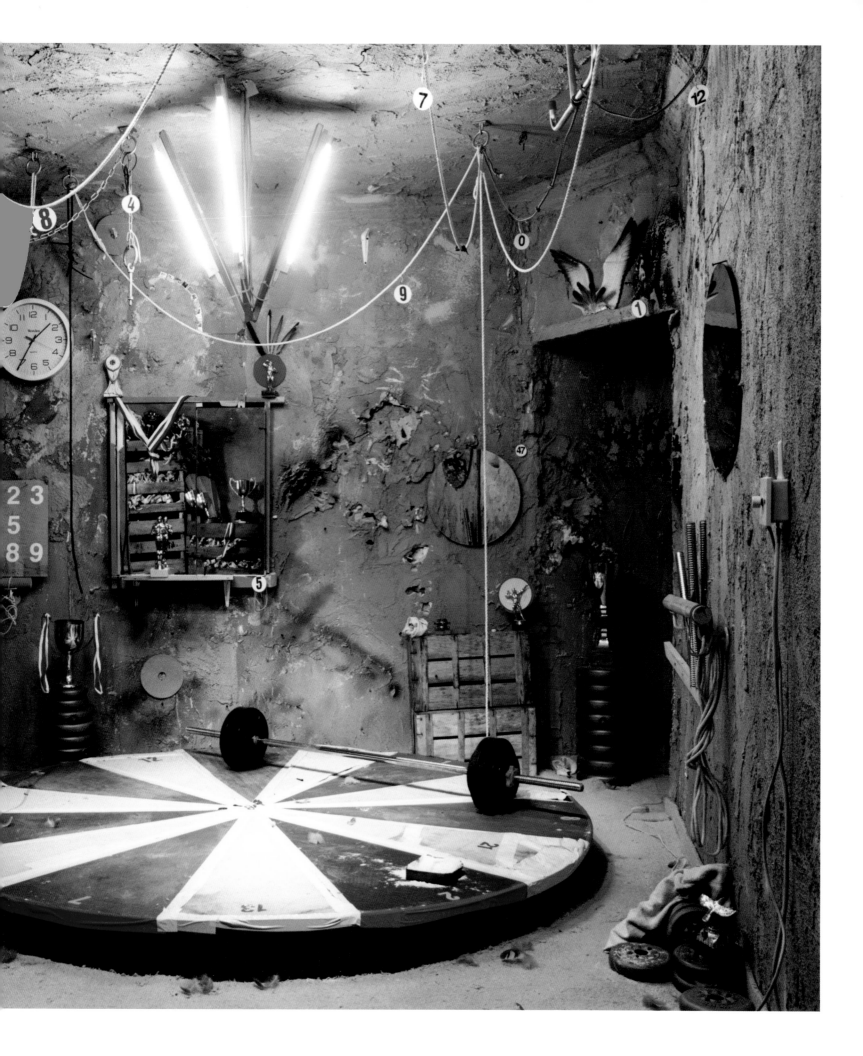

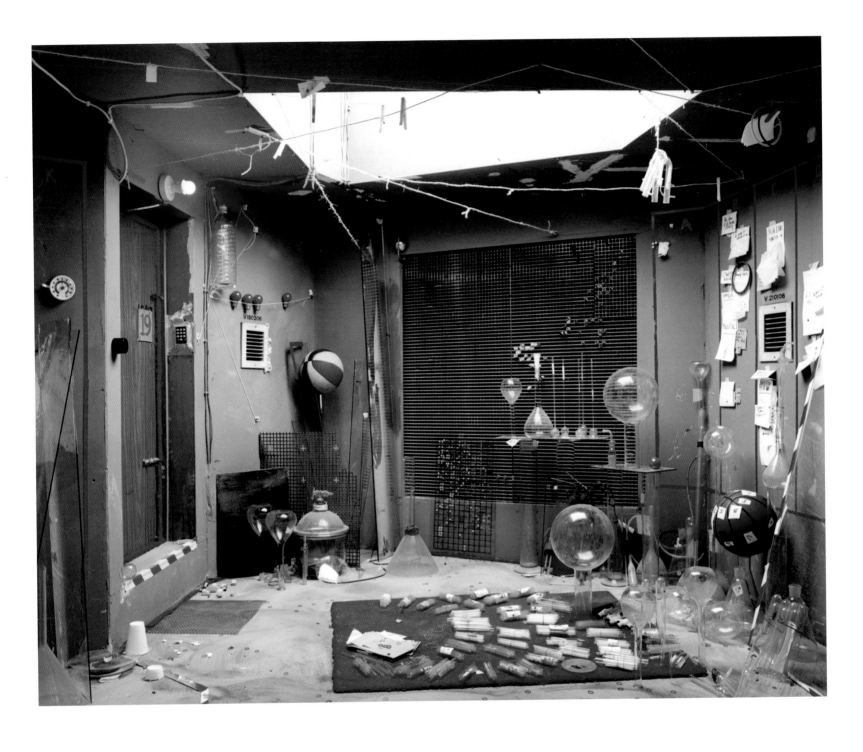

Untitled VI, 2005
Diasec mounted c-type print, 120 x 150 cm
Courtesy Maureen Paley, London

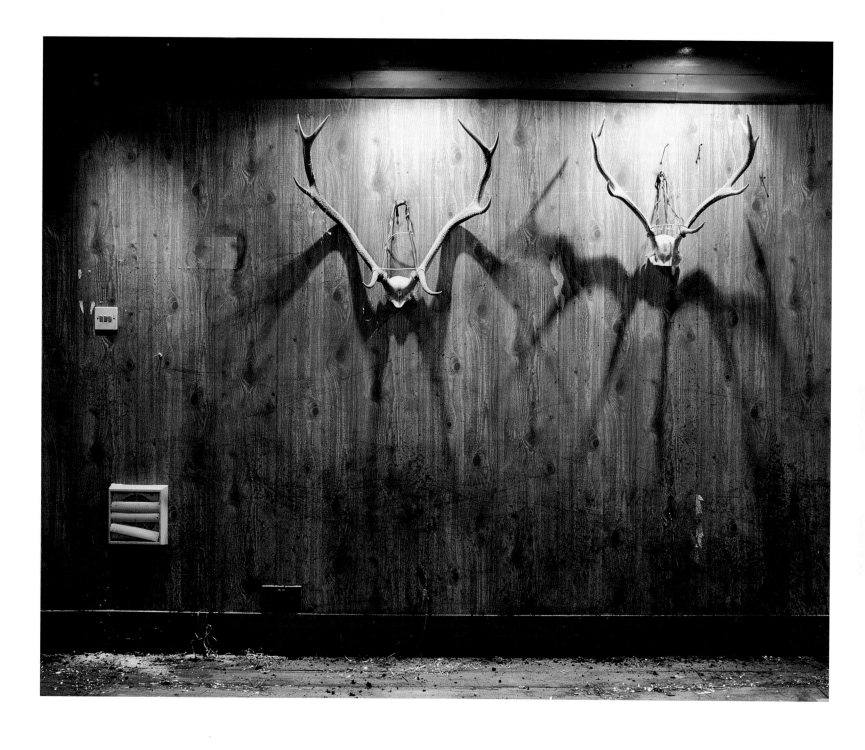

Swoop, 2003
Diasec mounted c-type print, 120 x 150 cm
Courtesy Maureen Paley, London

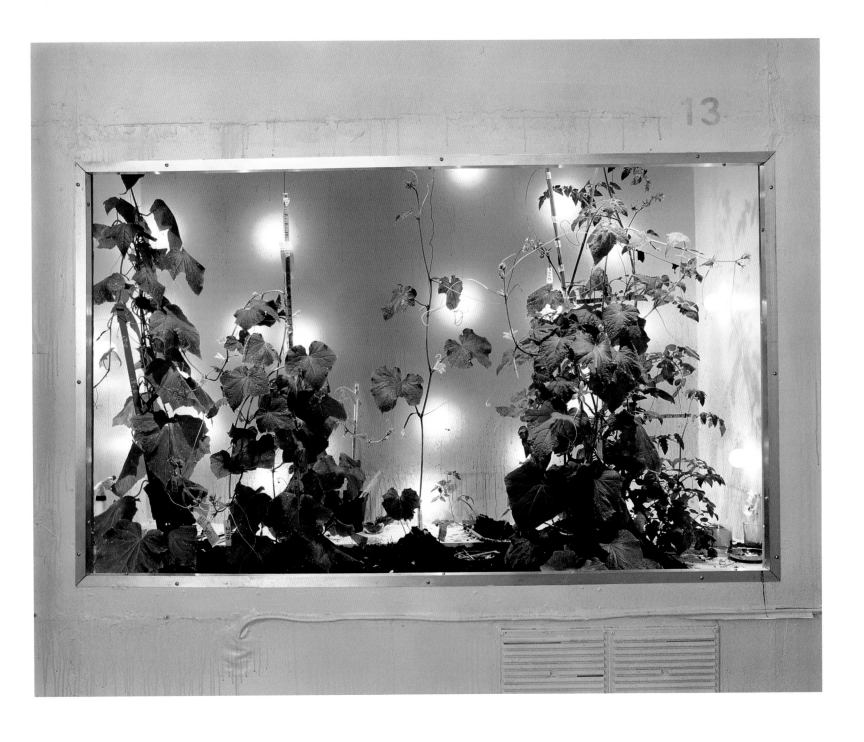

Untitled II (Plants), 2004
Diasec mounted c-type print, 120 x 150 cm
Courtesy Maureen Paley, London

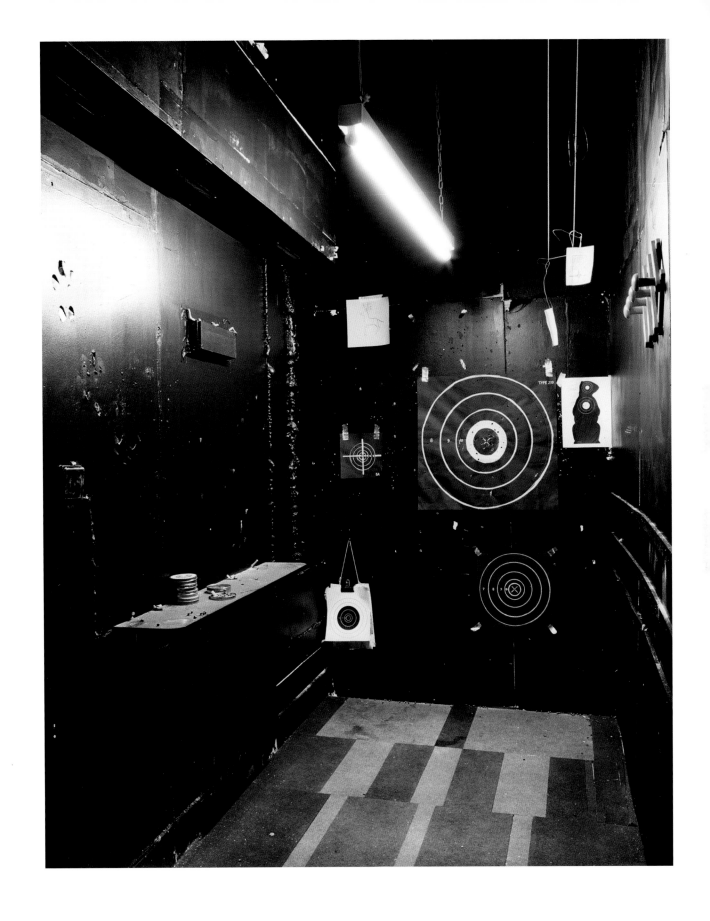

Close Range, 2006
Diasec mounted c-type print, 190 x 150 cm
Courtesy Maureen Paley, London

Lucy Levene

Born in London, 1978.
Lives and works in London.

Questions of intimacy are what characterise the photographs of Lucy Levene and the cultural collisions that arise in the encounter. The ambivalence that arises out of the impact of cultural pressure: to assimilate and yet to conform to the mores of the community (in this case the Jewish community) is explored and highlighted through the body of work entitled *Marrying In (Please God By You)*. In this work the artist poses with an array of young Jewish men of her acquaintance. Some of the images depict the artist with a young man in his living room, the others depict her with a young man in his bedroom. At first glance the work seems simple in its aims yet this is part of its currency – the subjects are laid bare in the full frontal arrangement, as if being offered up before the notional altar of marriage. However this seemingly open if contrived approach starts to pose questions in the viewing – the blank looks; the flat lighting and especially the contrivance speak of the power of the cultural narrative that young people inhabit and continue to perform. In the first grouping the men are dressed comparatively formally, while Levene is dressed as casually as she can presumably muster, a disavowal in itself of the class imperative in marriage.

Furthermore, the combination of the look of the artist – bored and impatient – contradicts her hold on the shutter release that lends her agency in this situation, giving weight to her own ambivalence. She doesn't want to partake in the parade (charade?) of Jewish male suitors that pass through her world and yet she feels compelled to perform this ritual, as here they are in front of the camera, dressed up and ready.

The second section of this work takes this theme further; the props and arrangement allude to the *Marriage of Giovanni Arnolfini* by Jan van Eyck, underlining the weight of history in the choice of marriage. There is a metaphorical pregnancy in the painting that transfers to the "couple" in the rooms of the young men. The beds are untouched yet prominent in the expectancy of use. Here again, ambivalence surfaces through the contrast between the formal and the informal: the auspiciousness of the moment and the casual dress, and the visible tension between the quest for intimacy and the discomfort enacted in the contrivance of the pose.

Rachel Garfield

Education

2002–04
MA in Photography, Royal College of Art, London

1997–2001
BA in Visual Communication (1st Class), Edinburgh College of Art

Selected Exhibitions

2008
"In Our World: New Photography in Britain", curated by Filippo Maggia, Galleria Civica di Modena, Italy

2007
"The Photographic Portrait Prize 2007–08", National Portrait Gallery, London
"©Emerging International Photographers", Aftermodern, June–August, San Francisco, USA
"The Delicate Triangle", Aftermodern, San Francisco, USA

2006
"Plug", County Hall Gallery, London
"The Seven Deadly Sins", Biennale Internationale de l'Image de Nancy, France

2005–25
"ReGeneration: 50 Photographers of Tomorrow"

2005–07
Thames & Hudson publication and group exhibition touring to the Musée de l'Elysée Lausanne, La Galleria Carla Sozzani, Milan, the Aperture Gallery, New York and the Pingyao festival, China, curated by Nathalie Herschdoerfer and William Ewing

2005
"Club Series", Lydia Goldblatt and Lucy Levene, Photofusion, London
"Focus On: New Photography", Norton Museum of Art, Miami, Florida

2004
"Night Shift", solo exhibition at 511 Gallery, New York
"Schweppes Photographic Portrait Award", National Portrait Gallery, London
"Exposure 2004", solo exhibition at the Hereford Photography Festival, UK

2003
"Ausländer", Dahl Gallery of Contemporary Art, Lucerne
"Essen Arts Festival", Screening, Folkwang Museum, Essen
"The Festival Times 2003", Stills Gallery, Edinburgh
"Lucy Levene: New Photographs", Miller/Geisler Gallery, New York

2001
"New Work", Solo exhibition at The Collective Gallery, Project Room, Edinburgh

Selected Publications

2005
William A. Ewing and Nathalie Herschdorfer, *ReGeneration: 50 Photographers of Tomorrow*, London, Thames & Hudson
Nightclub Documentary Project, "Portfolio, the Catalogue of Contemporary Photography in Britain", Issue 41

2003
John Calcutt, *Multiple Exposures*, The Archibald Campbell and Harley Award, Edinburgh
Ausländer, Exhibition Catalogue, Lucerne

2001
Marrying In, "Portfolio, the Catalogue of Contemporary Photography in Britain", Issue 34

Selected Reviews

2007
Tiffany Martini, in "The San Francisco Examiner", April

2005
Isabelle Shiavi, Lydia Goldblatt and Lucy Levene: Club Series, in "PLUK", November
Rahui Verma, *Alone in Clubland*, in "Metro", September
Diane Smyth, *Photography Club*, in "The British Journal of Photography", March

2004
Pick Hit, "The Village Voice", USA, December
Ken Edwards, *A Fresh New Crop, The Show, 2004 Royale College of Art*, in "Blueprint", July
Royal College of Art, the Show 2004, in "Hotshoe", June
Charlotte Cotton, *Contemporary Photography 2004*, in "The Guardian", May
Tim Ingham, *Swot Shots*, in "Metro", May
Duncan MacMillan, *Victim of a Split Personality*, in "The Scotsman", July

Mark Naftalin, from the series *Marrying In (Please God by You)*, 2001
C-type print, 101.6 x 101.6 cm

74

Billy Teasdale, from the series *Marrying In (Please God by You)*, 2001
C-type print, 101.6 x 101.6 cm

Timmy Green, from the series *Marrying In (Please God by You)*, 2001
C-type print, 101.6 x 101.6 cm

Ben Myers, from the series *Marrying In (Please God by You)*, 2001
C-type print, 101.6 x 101.6 cm

Marc Silvert, from the series *Marrying In (Please God by You)*, 2001
C-type print, 101.6 x 101.6 cm

Danny Gareh, from the series *Marrying In (Please God by You)*, 2001
C-type print, 101.6 x 101.6 cm

Mark Pilkington, from the series *Marrying In (Please God by You)*, 2007
C-type print, 101.6 x 101.6 cm

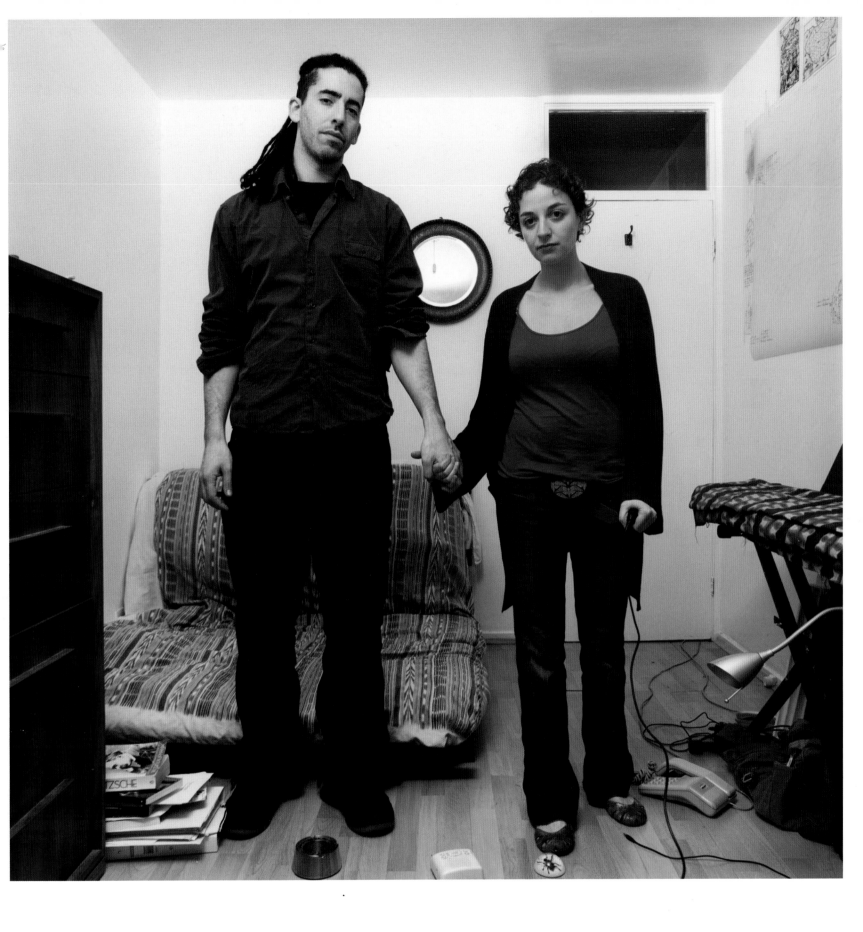

Matthew Lenciewicz, from the series *Marrying In (Please God by You)*, 2007
C-type print, 101.6 x 101.6 cm

Gareth McConnell

Born in Carrickfergus, Northern Ireland, 1972.
Lives and works in London.

Family. A 21st Century Love Poem

"You need not leave your room. Remain sitting at your table and listen. You need not even listen, simply wait. You need not even wait, just learn to become quiet, still, and solitary. The world will freely offer itself to you to be unmasked. It has no choice; it will roll in ecstasy at your feet."
Franz Kafka

Franz Kafka was a writer and a poet – he had the words… those beautiful, beautiful words. To paraphrase Lewis Hine, my words don't come – so I take pictures. I wanted to compose a poem though, a Love Poem, and I decided I would do this with photographs. I took Franz up on his advice and didn't leave the house, I waited quietly and patiently to gather my pictorial words to form the stanzas of my visual poem. My poem of love to a people, a time and a place – a kind of testimony to just how totally fucking beautiful things can be no matter how fucked up things might get or how fucked up things might have been. The moment is all. All we got. A poem of love to my friends and lovers, to my God, to my family, to *all* my brothers and sisters. A poem of love to the sad and the beautiful, to the laughter and the tears. A poem of the seasons, of the shifts and turns, of the reds and browns and greys and blues. Of food and flowers and music, of light and sun and birth and death, of how everything must change, a poem of how nothing can stay the same.

Gareth McConnell

Education
1997–99
MA in Photography, Royal College
of Art, London
1992–96
BA in Photography, West Surrey
College of Art & Design

Selected Solo Exhibitions
2007
"Orientation & Devotion", Gallerie
Charlotte Lund, Stockholm
"Milk and Honey", Counter Gallery,
London
2005
"Gareth McConnell", Hippolyte Gallery,
Helsinki
"Gareth McConnell", Counter Gallery,
London
2004
"Three Projects 1998–2003", Gallery
of Contemporary Photography, Belfast
"Back2Back", Byam Shaw School
of Art, London
2003
"Institutions", Unit 2 Gallery,
Whitechapel High Street, London
"Portraits and Interiors from the Albert
Bar", Artandphotographs, London
2002
"Wherever You Go", Lighthouse, Poole
1998
"Anti-Social Behaviour Parts One
& Two", Gallery of Photography, Dublin

Selected Group Ehibitions
2008
"In Our World: New Photography
in Britain", curated by Filippo Maggia,
Galleria Civica di Modena, Italy
2007
"Co-exist", FOIL Gallery, Tokyo
"Quietscapes", Museum Carrillo Gil,
Mexico City
2006
"Toutes Compositions Florales",
Counter Gallery, London
"The name of this show is not Gay Art
Now", Paul Kasmin, New York
"The Galleries Show", Extra City,
Antwerp
2005
"to be continued…/jaatku…", curated
by Brett Rodgers and Mika Elo,
Finnish Photography Festival, Helsinki
"Presence", Gimpel Fils, London
1999
John Kobal Foundation, National
Portrait Gallery, London
"The Show", Royale College of Art,
London
1996
"Mallpractice", The Mall, London
"Anti-Social Behaviour Part One",
The First Shoreditch Foto Biennial

Monographs
2004
Back2Back, All Change; 40 pages,
24 colour plates
Gareth McConnell, London,
Steidl/Photoworks; essays by Neal
Brown, Simon Pooley and David
Chandler; interview with the artist
by Charlotte Cotton; 128 pages,
90 colour plates
2002
Wherever You Go, Lighthouse;
foreword by Charlotte Cotton;
56 pages, 32 colour plates

Publications
2006
*Vitamin Ph: New Perspectives in
Photography*, London, Phaidon

Awards
2005
Recontres d'Arles Discovery Award
Nomination
1999
John Kobal Portrait Award, Runner up
Worshipful Company of Painter-
Stainers Prize for Photography
1998
Source, Olympus Portfolio

Residencies
2004–05
University of Wales, Newport, Visiting
Fellow
2003–04
London Metropolitan University

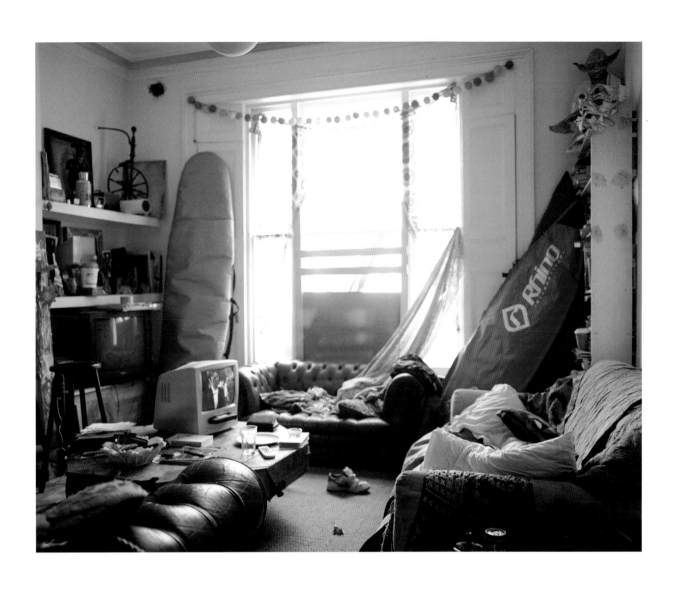

Living Room 1, 2006
35mm slide dissolve, dimensions variable

Untitled (Chair 2), 2006
35mm slide dissolve, dimensions variable

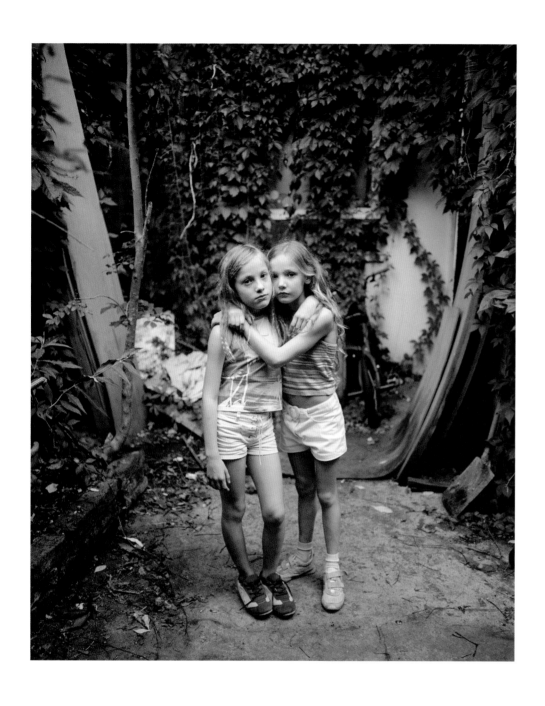

Karis & Astaria, 2006
35mm slide dissolve, dimensions variable

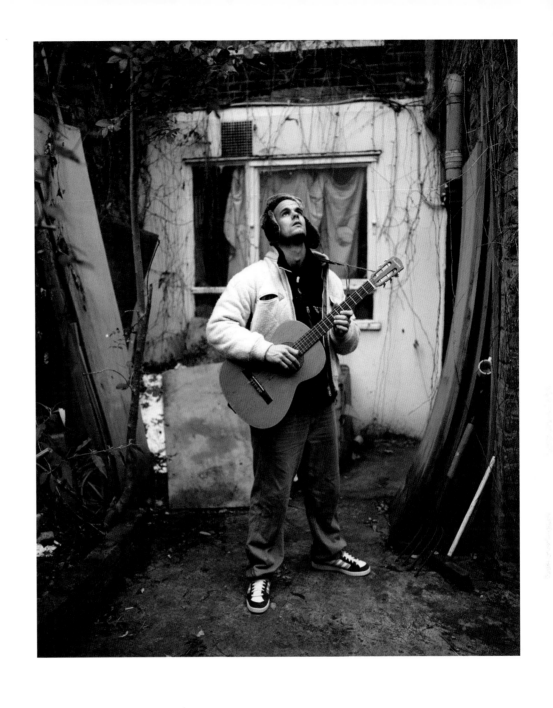

Mark 2, 2006
35mm slide dissolve, dimensions variable

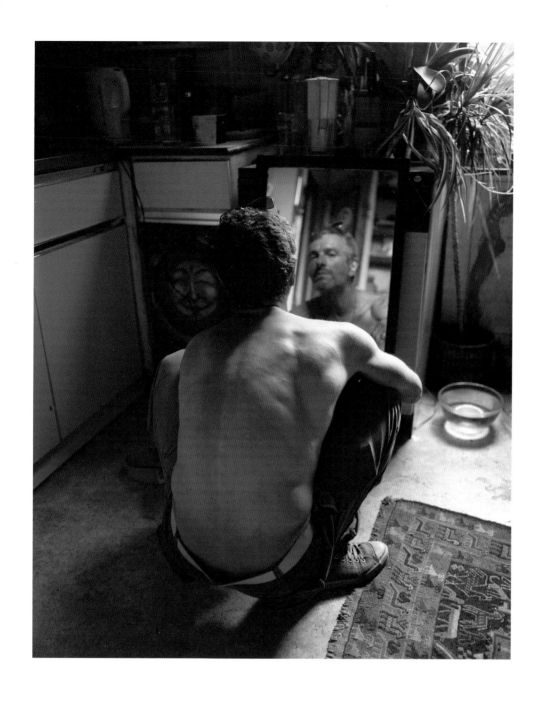

Mickey in Mirror, 2006
35mm slide dissolve, dimensions variable

Meditation 4, 2006
35mm slide dissolve, dimensions variable

Untitled (Bedroom Rainbow), 2006
35mm slide dissolve, dimensions variable

Untitled (Dead Flowers), 2006
35mm slide dissolve, dimensions variable

Brígida Mendes

Born in Tomar, Portugal, 1977.
Lives and works between Amsterdam,
London and Tomar.

Brígida Mendes's work investigates our perception of reality in relation to historical and present ideas of looking and depicting. Using the act of construction and implied deconstruction, she examines and overstates the line between fiction and reality where our notion of what's real becomes ungraspable. Developing an interpretation of everyday life, her work seeks to create a cultural commentary on different aspects of society, which invite the viewer to look behind the obvious, developing critical ideas and rejecting pre-established codes of perception.

Humorous and absurdist, her work shows a constructed and alternative reality, one which resists interpretation and yet proposes a new dimension of meaning. Dealing with looking and the role of the spectator, her work explores the factor of perception and our reaction in response to artwork – the gap between the viewer's observation and comprehension.

Experiments into the potential of the disguise in photography are assumed as a method of artistic investigation. Mendes's photographs are unmanipulated images, compositions based on optical devices and the strict planning of scenes. By exploring the staging strategy through her works, Mendes creates ambiguous photographs that range from provoking a sense of deception and illusion to discrediting mistakes and inaccuracies; thus dealing first with simulation, and then in dissimulation.

There is a desire to manipulate, yet this is optical rather than technical manipulation, subverting the concept of illusion to make the spectator interpret the deceptive as being truthful. There is no reason to doubt the reality of the actual photographic image, yet this is placed at odds with the manipulation that is present in the work, making the viewer apprehensive as regards human capacities to distinguish between fiction and reality.

Mendes's work also investigates the notion of identity, supported by the repeated representation of her mother, who becomes a stage prop, an expressive tool, which makes us think about the concept of appearance. The sitters that appear in Mendes's photographs are all members of her family: her sister, her mother and her mother's twin sister.

Brígida Mendes

Education
2004–06
MA in Photography, Royal College of Art, London
1998–2003
BA in Fine Art – Painting, Faculty of Fine Arts, University of Lisbon

Solo Exhibitions
2006
"Fotografia", Módulo – Centro Difusor de Arte, Lisbon
2004
"Fotografia", Módulo – Centro Difusor de Arte, Lisbon

Group Exhibitions
2008
"In Our World: New Photography in Britain", curated by Filippo Maggia, Galleria Civica di Modena, Italy
2007
"Arte Lisboa", F.I.L., Lisbon
"Body Sweet Body", Centro Artes de São João Madeira, Portugal
"50 Anos de Arte Portuguesa", Fundação Calouste Gulbenkian, Lisbon
"Creekside Open X2", APT Gallery, London
"Plat(t)form 07", Fotomuseum Winterthur, Switzerland
2006
"Albertine Goes South", Dorothee Schmid Art Consulting, London
"No Man is an Island", The Empire, London
"The Summer Show 2006", Hooper's Gallery, London
"Generation", Show 1 MA Photography, Royal College of Art, London
2004
"Mujeres de España y Portugal", Caja Rural del Sur, Huelva, Spain
2003
"Geração 2003", Módulo, Oporto, Portugal
"VV2 Vivere Venezia – Recycling the Future", Venice Biennial
"Foro Sur 2003", Cáceres, Spain
"48ème Salon de Montrouge", France

Publications
2007
Filipa Oliveira, *Brígida Mendes: O Falso Duplo*, in "Arte Contexto"
2006–07
Chris Mullen, in "Photoworks Magazine", November/April Issue
2006
Miguel V.H. Pérez, *Project Anamnese*, Fundação Ilídio Pinho
Fernando Montesinos, *Máscaras, Disfarces e Espelhos. Brígida Mendes e a Imagem Encenada*, in "Artnotes", No 12
John Slyce, *The Summer Show – RCA*, Photography Catalogue
2003
Maria de Fátima Lambert, *Extravagâncias e Argumentações*, in *Catálogo Salon Européen des Jeunes Créateurs*
Angela Vettese, *Recycling The Future*, in *Vivere Venezia 2, 50ª Biennale di Venezia*

Residencies
2008
Rijksakademie van beeldende Kunsten, Amsterdam
2003
"VV2 Vivere Venezia – Recycling the Future", IUAV – FAD, Venice

Awards
2007
Nominated for the 2007 Paul Hamlyn Foundation Awards for Artists
Prize Winner of "Creekside Open X2", APT Gallery (Selector: Victoria Miro)
2006
The Photographers' Gallery Graduate Award
The Worshipful Company of Painter-Stainers Award
Hooper's Annual Royal College of Art Award
Conran Foundation, Royal College of Art Graduate Awards, Shortlist
Bloomberg New Contemporaries, Shortlist
Calouste Gulbenkian Foundation Bursary
2005
Centro Português de Fotografia Bursary
First Prize, The National Magazine Company Award

Collections
Royal College of Art, London
UBS Collection, London
John A. Smith and Vicky Hughes Collection, London
Fundação PMLJ, Lisbon
António Cachola Collection, Campo Maior, Portugal

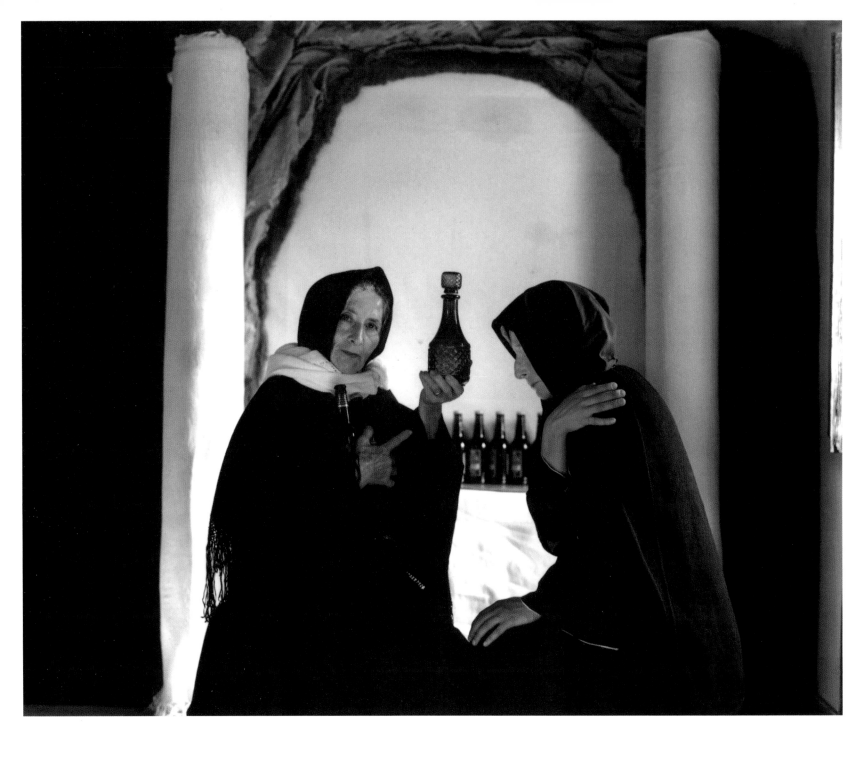

Untitled #4, from the series 05/1, 2005
Gelatin silver print, 120 x 140 cm

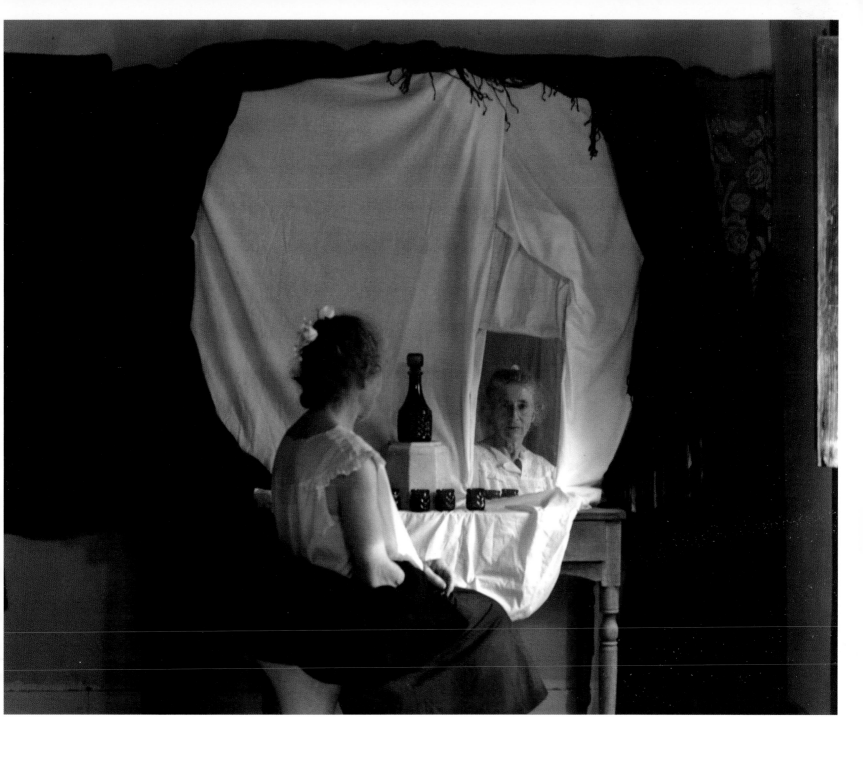

Untitled #5, from the series 05/1, 2005
Gelatin silver print, 120 x 140 cm

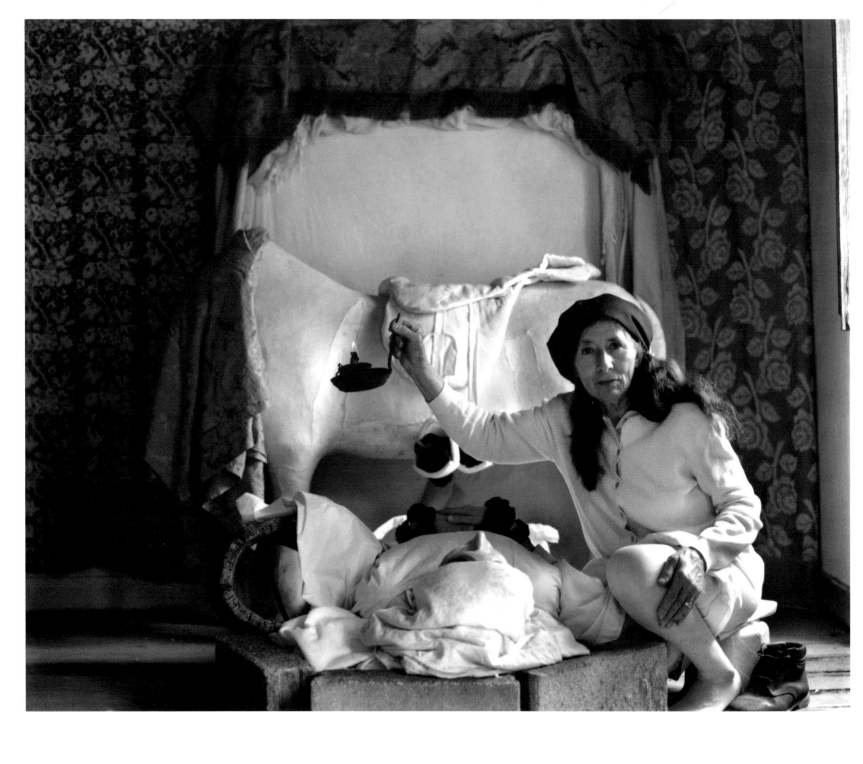

Untitled #6, from the series 05/1, 2005
Gelatin silver print, 120 x 140 cm

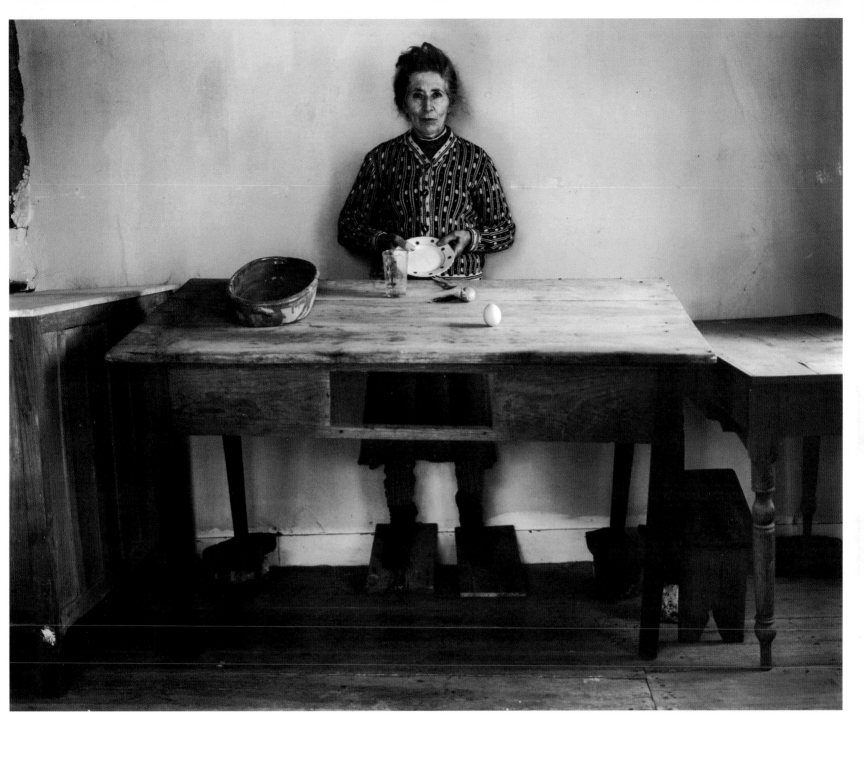

Untitled #2, from the series 05/3, 2005
Gelatin silver print, 120 x 140 cm

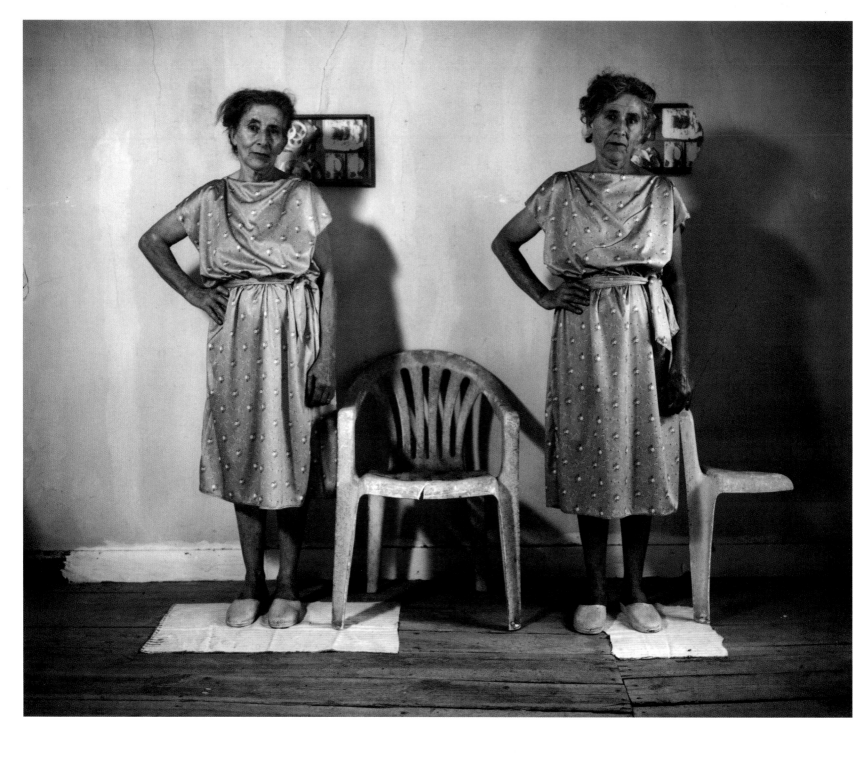

Untitled #2, from the series 05/2, 2005
Gelatin silver print, 120 x 140 cm

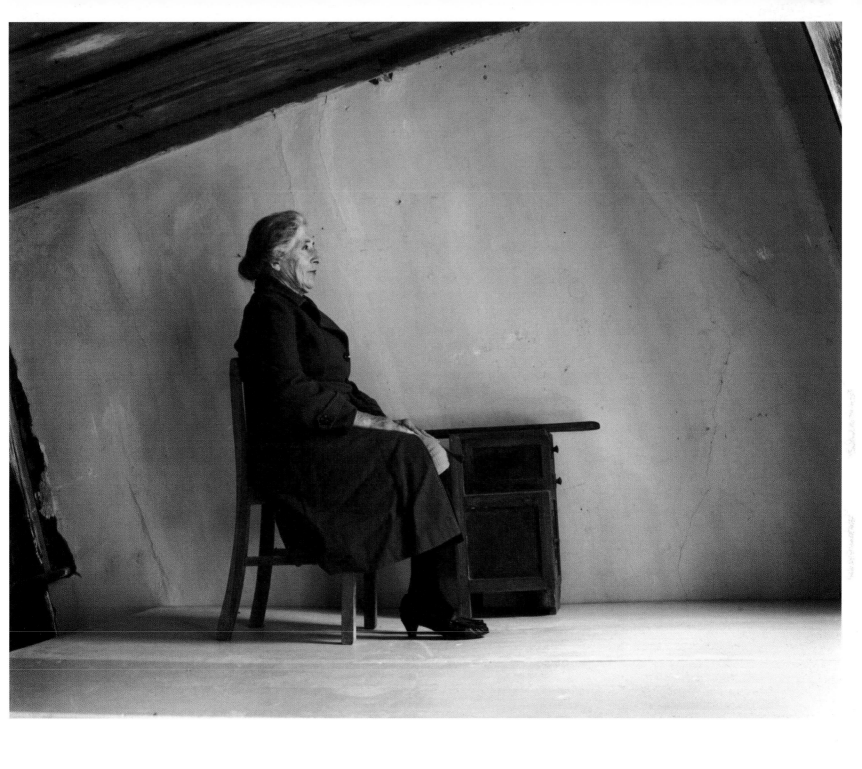

Untitled #1, from the series 07/1, 2007
Gelatin silver print, 120 x 140 cm

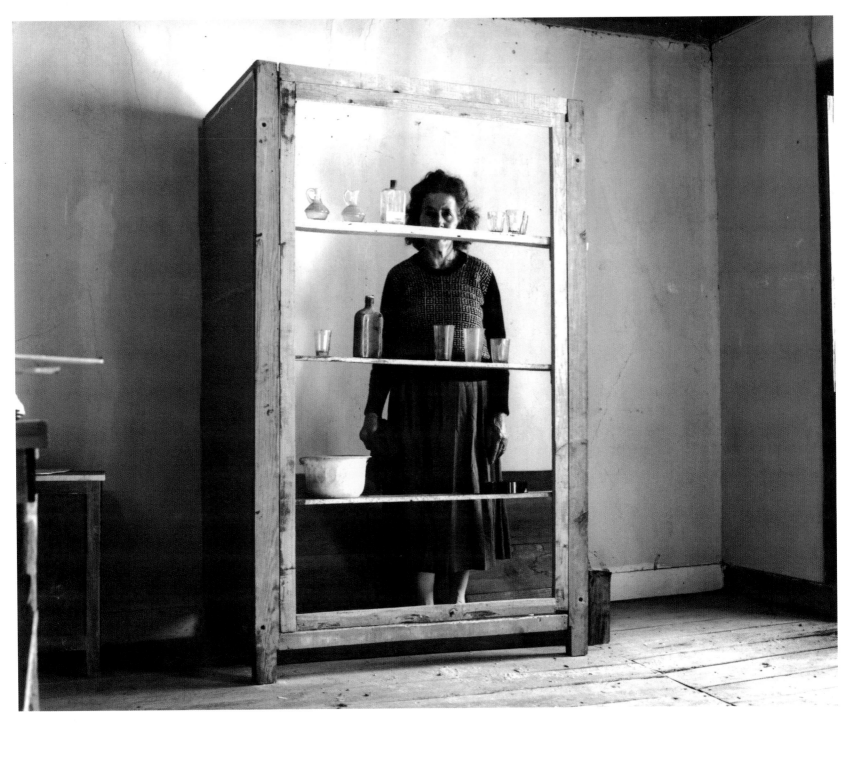

Untitled 07/3, 2007
Gelatin silver print, 120 x 140 cm

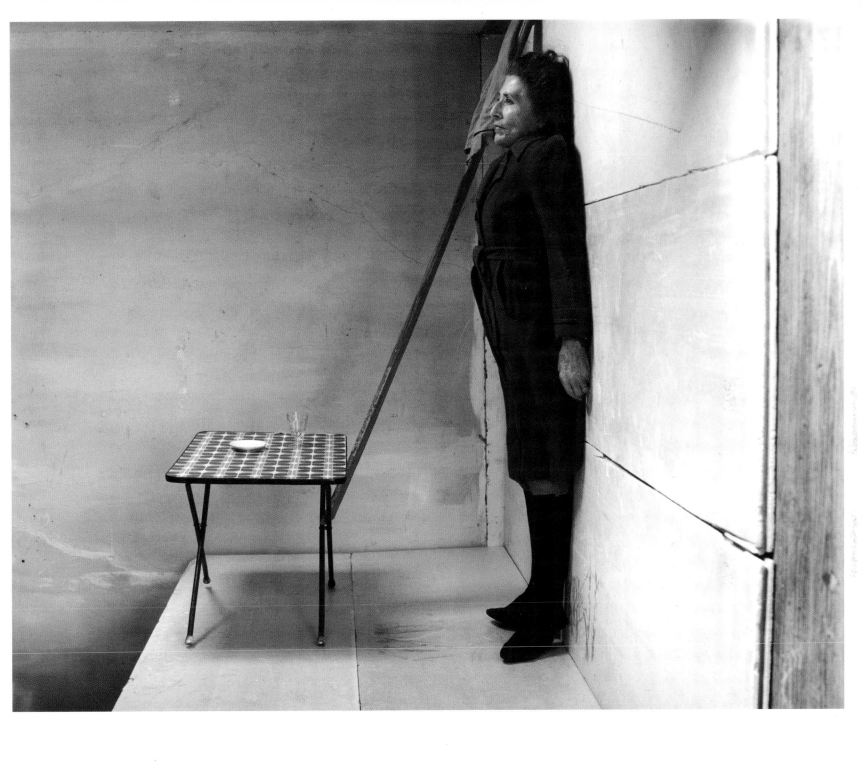

Untitled 07/2, 2007
Gelatin silver print, 120 x 140 cm

Suzanne Mooney

Born in Galway, Ireland, 1976.
Lives and works in London.

Suzanne Mooney's work reconsiders how we look at the world through representation, by exploring the medium and apparatus of photography itself. The relationship between production, function and mediation of the photographic image is central to the practice.

Behind the Scenes (2006) depicts carefully selected picturesque images of County Galway, Ireland, where the artist grew up. However, instead of enabling us to admire the landscape fully, these idyllic views are blocked by a camera as it records each shot. The camera, which appears to be suspended in mid-air, offers us access to the view while simultaneously denying us the full appreciation of the scenery.

This series registers a familiar phenomenon of the tourists' gaze, where the camera becomes the primary intermediary of experience. Behind the Scenes places the viewer in the position of the photographer, with the referent, the apparatus and the environment occupying a single frame. The artist also meticulously gathers and collates images and objects, and uses them as the source material for her process-oriented projects. For example, Make Love to the Camera (2004–ongoing) is an expanding collection of diagrammatic drawings collected by the artist over many years. Found in photographic manuals, these images were originally intended as informative layouts for photographing the female nude. Blown-up and displayed outside of their original context, the diagrams no longer exist as functional instructions but as life drawings in their own right.

Decommissioned Camera Series (2005–07) depicts hundreds of analogue cameras that have been traded in by their owners in part exchange for new digital cameras. The sheer scale of this ensemble is indicative of the camera's place in our day-to-day lives. These images thus register a key transitional moment in the history of photography and the dramatic shift from analogue to digital. Employing diverse photographic techniques, appropriated images and objects, video installation, slideshows and diagrammatic drawings, Mooney's work is a conceptual play with the processes involved in image-making, incorporating the space behind the camera, in front of the camera and the camera itself.

Suzanne Mooney

Education
2003–05
MA in Fine Art, Royal College of Art, London
2000–01
BA (Hons) in Theory & Practice of Visual Arts, Chelsea College of Art and Design, London
1996–99
BA in Photography, Dun Laoghaire Institute of Art, Design & Technology, Dublin

Solo Exhibitions
2008
"Souvenirs of Bedford", BCA Gallery, Bedford
2007
"Photographing Girls", Viewfinder Gallery, London
"Decommissioned Camera Series and other works", Gallery of Photography, Dublin
"Behind the Scenes", Ard Bia Gallery, Galway
2005
"Make Love to the Camera", Gallery for One, Dublin
"Through A Glass Darkly", The Office of Public Works, Dublin

Selected Group Exhibitions
2008
"In Our World: New Photography in Britain", curated by Filippo Maggia, Galleria Civica di Modena, Italy
2007
"Medium Project", Yorkshire Arts Space, Sheffield
2006
"First Sudden Gone the One, First Sudden Back", Peckham 133, London
"Transform – Format 06", Derby Photography Festival
"PLUG", White Space, County Hall Gallery, London
"Schema", Daniel Cooney Fine Art, New York
"Metropolis Rise: New Art from London" (temporarycontemporary), CQL Design Center, Shanghai and Dashanzi 798 Art District, Beijing
2005
"The Show", Royal College of Art, London
"Hermeneutics", The Pool, Curtain Street, London
"Blind Date", temporarycontemporary, Deptford, London
2004
Asia-Europe Foundations (ASEF) BizArt Art Centre, Shanghai, China
"Tonight", Studio Voltaire, Clapham, London
"Young International Photographers", European Parliament Offices, Brussels
"Interim Show", Royal College of Art, London
2003
"Hybrid", curated by artLab, Imperial College, London
"To Be Honest", Brighton Photo Biennial 2003, The Phoenix Gallery, Brighton
"The National Gallery", The Return, The Goethe Institut Inter Nationes, Dublin

Publications
2007
Becoming Redundant, review by Siun Hanrahan, in "Source", Issue 52

Commissions, Awards and Residencies
2007
Artist in Residence, Bedford Creative Arts Gallery, Bedford
Artist in Residence, The Edward James Foundation, West Dean, Surrey
2006
Travel and Mobility Award, Arts Council of Ireland
Gallery of Photography Artists' Award, Dublin
2005
Photography Commission to celebrate the 125th Anniversary of St. Stephens Green, Dublin, Office of Public Works, Dublin

Above: *Decommissioned Camera Series I*, 2005–07. Installation detail. The Gallery of Photography, Dublin
Below: *Decommissioned Camera Series II*, 2005. C-type print, 120 x 160 cm

Above: *Photographing Girls*, 2007. Installation detail. Viewfinder Gallery, London
Below: *Make Love to the Camera*, 2004–Ongoing. B/W photograph, dimensions variable

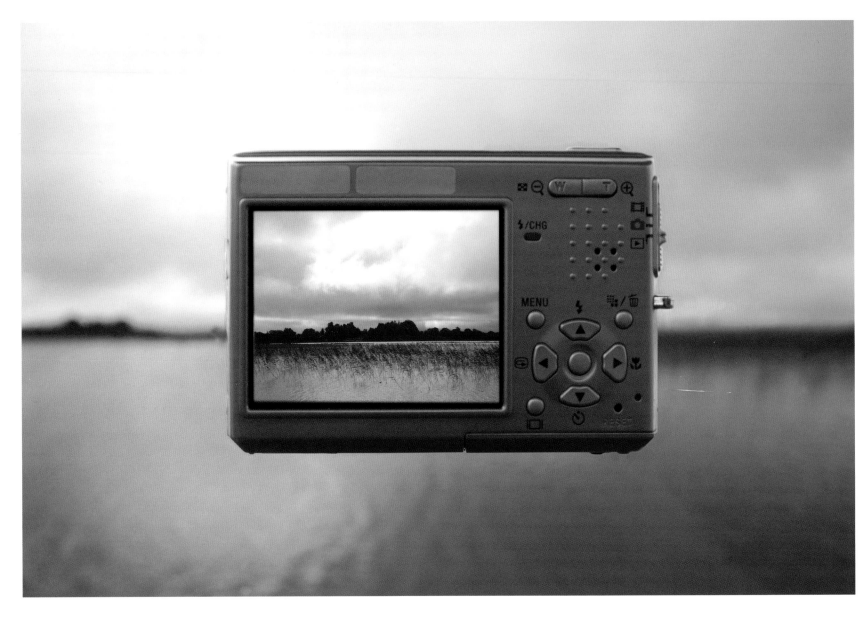

Behind the Scenes, Oughterard Bay, 2006
Light-jet print, 38 x 50 cm

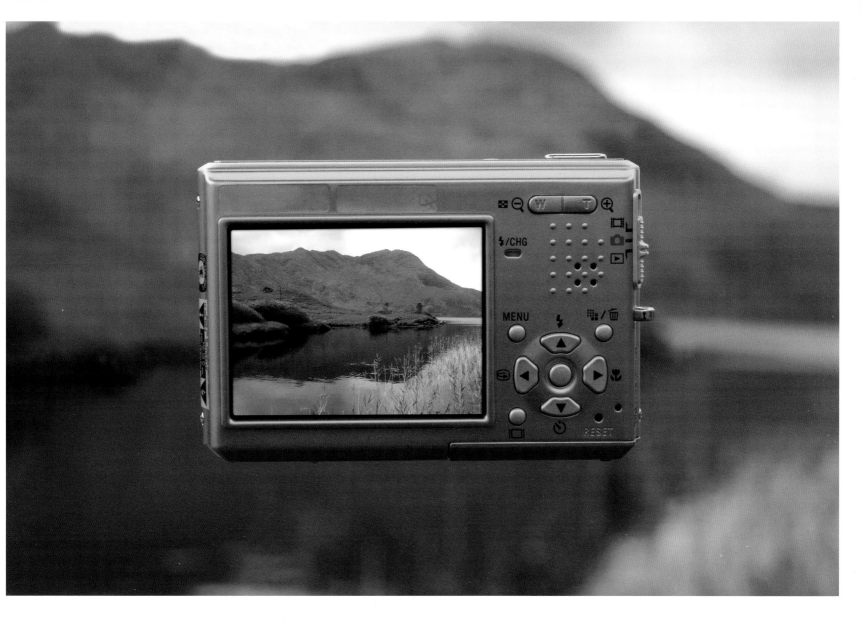

Behind the Scenes, Lough Fee, 2006
Light-jet print, 38 x 50 cm

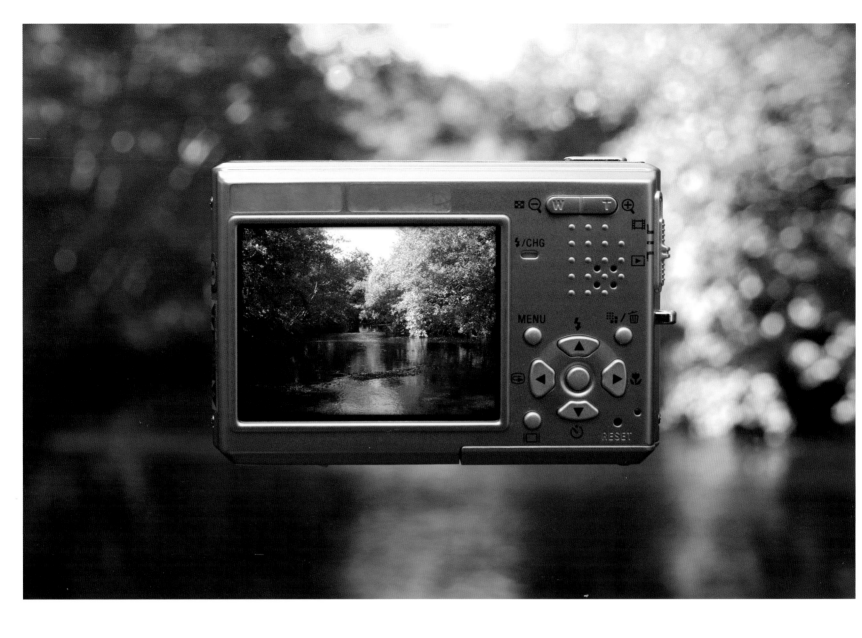

Behind the Scenes, Owenriff, 2006
Light-jet print, 38 x 50 cm

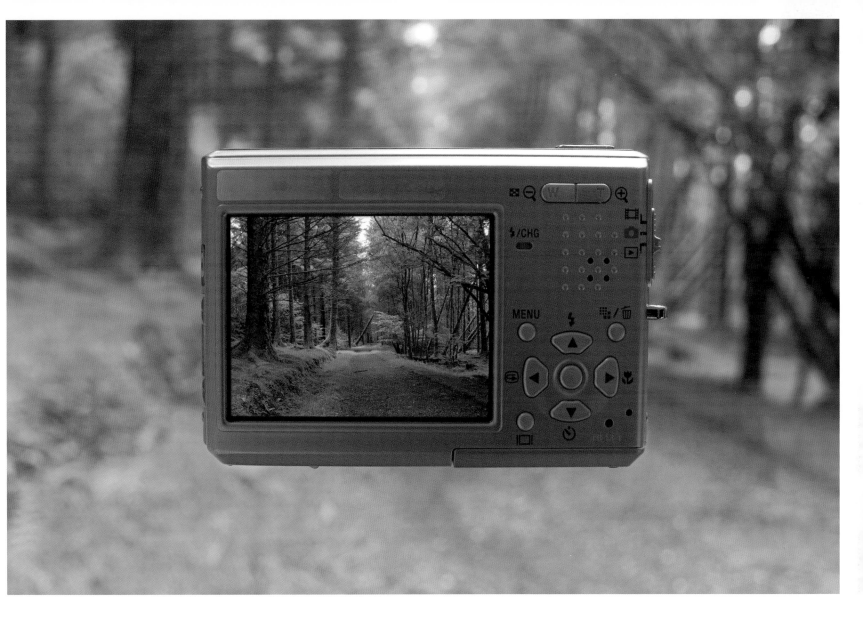

Behind the Scenes, The Western Way, 2006
Light-jet print, 38 x 50 cm

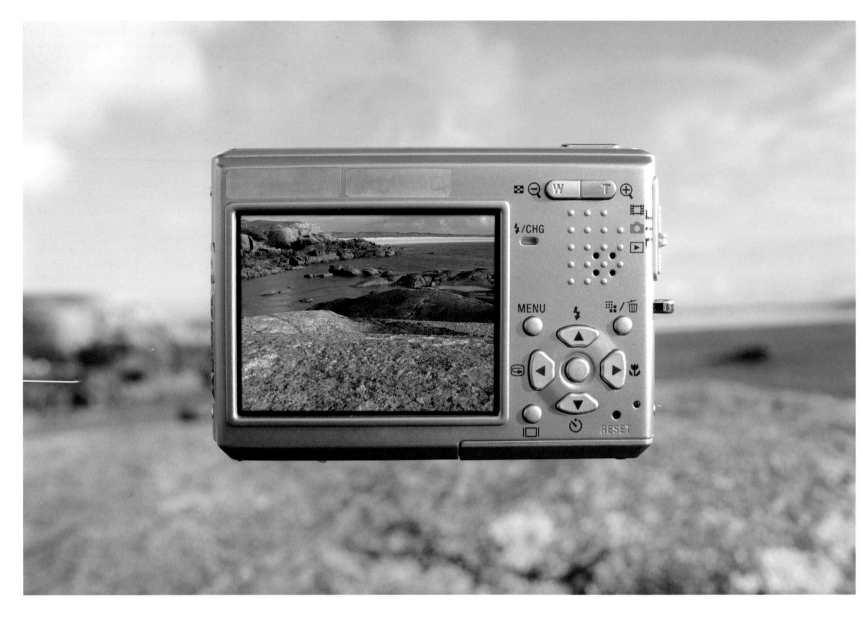

Behind the Scenes, Dogs Bay, 2006
Light-jet print, 38 x 50 cm

110

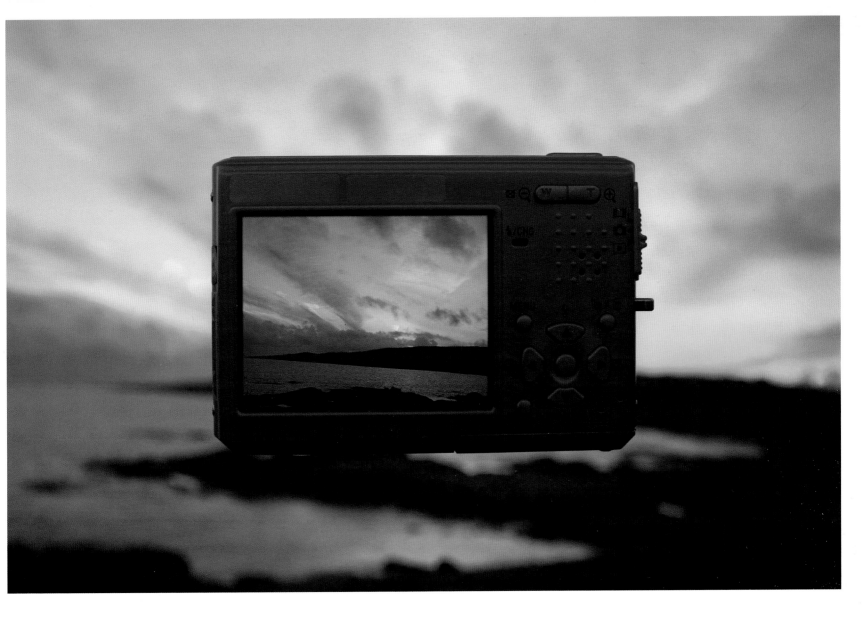

Behind the Scenes, Slyne Head, 2006
Light-jet print, 38 x 50 cm

Melissa Moore

Born in Nottingham, UK, 1978.
Lives and works in Gloucestershire
and London.

My work is centred on the exploration of various places through performance in relation to the camera. In these playful experiments with décor, costume and photographic communication, my tendency is to misbehave or challenge the prescriptive use of place. Parody, contrary use, or exaggerations of allegorical images are often called upon as a means to resist conformity. Traces of photographic apparatus are left visible, signalling the camera's presence as a collaborator. Although I rely on intuition to a large degree in areas of performance, I demand the camera to somewhat counter its historical role of specifying structure and regulation; here this staging does not harmonise the relations between body and architecture.

These photographs are from the series *Plasmic*, and were made in an extraordinary Jacobean mansion, Plas Teg. The building has a somewhat malign history and thus attracts regular groups of paranormal enthusiasts, who make their own investigations, searching for ectoplasm or signs. I choose not to haunt the house by showing a ghostly or "blurry trace", yet even so the figure is not presented as whole. Instead, the body exists more like an idea than an anatomical reality, a plastic hysterical wanderer with no fixed scale or position in the narrative; floating and attaching to different possible meanings.

Plas Teg is filled with an energetic accumulation of suggestive things, yet literary references are also called upon to be complicit in creating various inflections in the series. For example, a bathroom with a Victorian *memento mori* (a delicate pattern made of human hair, a pre-photographic act of nostalgia) and preserved butterflies brought to mind John Fowles's novel *The Collector*, where the withdrawn protagonist darkly "collects" a young artist, in addition to his butterflies, and keeps her in his cellar. In my diptych, equivalence is sought between the living hair and the framed, whilst the frame and scale of the collection is disrupted by the re-positioning of the camera – the camera at the same time accomplishes a sort of "taxidermy" of the scene.

The sumptuousness of the chamber room reminded me of Vladimir Nabokov's novel *Ada (or Ardour)* which is set around a decadent manor. Ada had a passion for insects, her "fluttery friends", and an intense love for her sibling. The figure on the Pianola is, in contrast, solitary. Perhaps seeking as an alternative an incestuous relation with the furnishings, attempting to establish a relation between body and objects and a move towards possession. Caught between the desire to solicit curiosity and seeking concealment, the figure appears self-contained, and perhaps in metamorphosis trying to elude the shackles of photographic exactitude through enigma.

Melissa Moore

Education
2004
MA in Photography, Royal College
of Art, London
2001
BA (Hons) in Photography, Manchester
Metropolitan University
2000
Master Class of Experimental Visual
Design, University of Art and Industrial
Design, Linz, Austria
1996
Art Foundation, Cheltenham and
Gloucester College of Further
Education

Solo Exhibitions
2008
Nepente Art Gallery, Milan

Group Exhibitions
2008
"In Our World: New Photography
in Britain", curated by Filippo Maggia,
Galleria Civica di Modena, Italy
"Phantasma", Ballhaus Düsseldorf,
Germany
2006
"Albertine Goes South", Dorothee
Schmid, Pimlico, London
2005
"Slick", Agallery, Wimbledon, London
2004
"Summer Show", Hoopers Gallery,
Clerkenwell, London
2003
"Photography Festival", Folkwang
Gallery, Essen
2002
"Flicker", Lighthouse Gallery,
Wolverhampton
"Loose Ends Biennale", International
Gallery, Manchester

Publications
2007
New Installation/New Staging,
"Fotograf", Prague, with essay
by Christopher Townsend
Video Interview featured on
www.flasher.com
2004
Featured as *Gallery Project* in
Ryuko-Tsushin, Japan
"Portfolio", Issue 30
"HotShoe", Issue 130
"Metro" (London)
Contemporary Photography,
"Guardian Supplement"

Awards
2004
Summer Show Prize, Hoopers Gallery

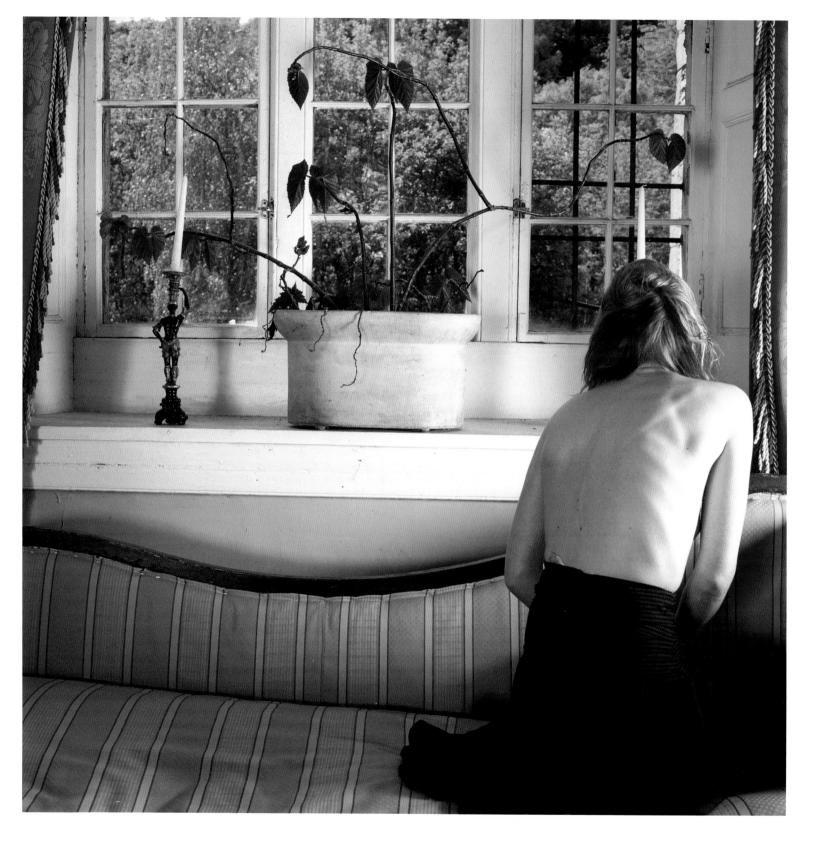

All photographs from the series *Plasmic*, 2007
C-type prints, 76 x 76 cm each

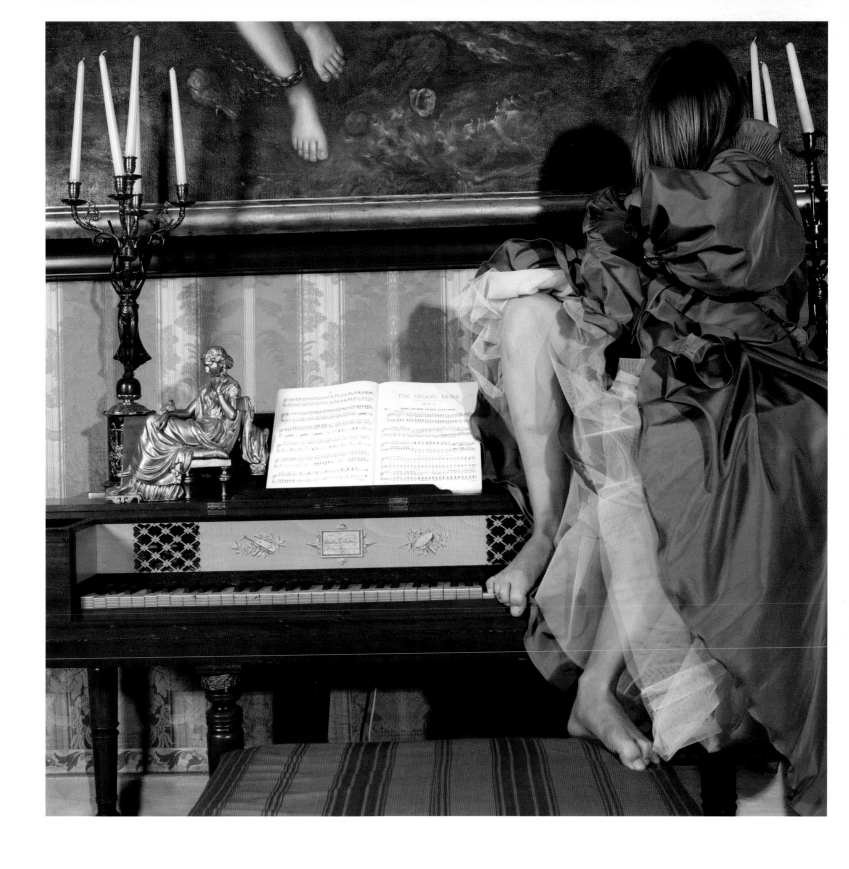

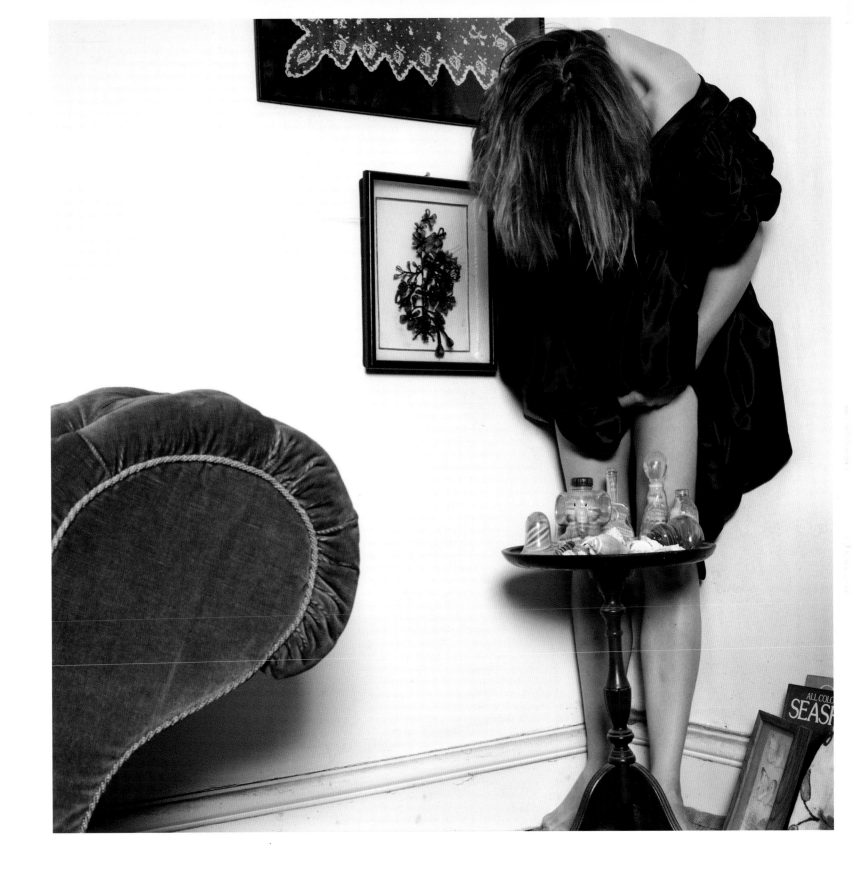

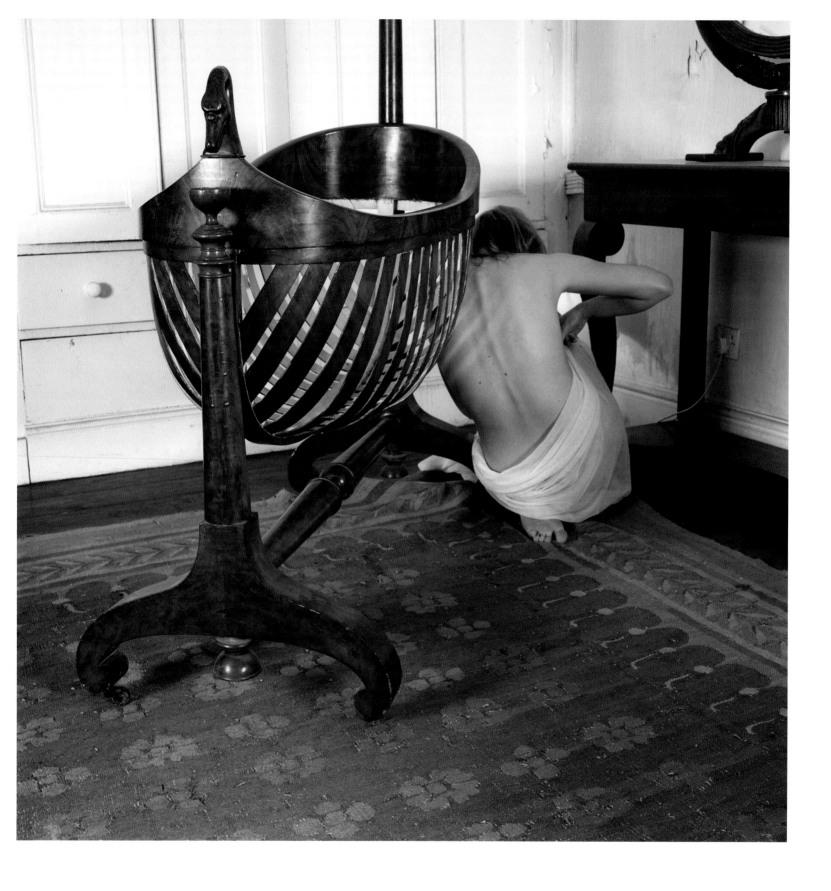

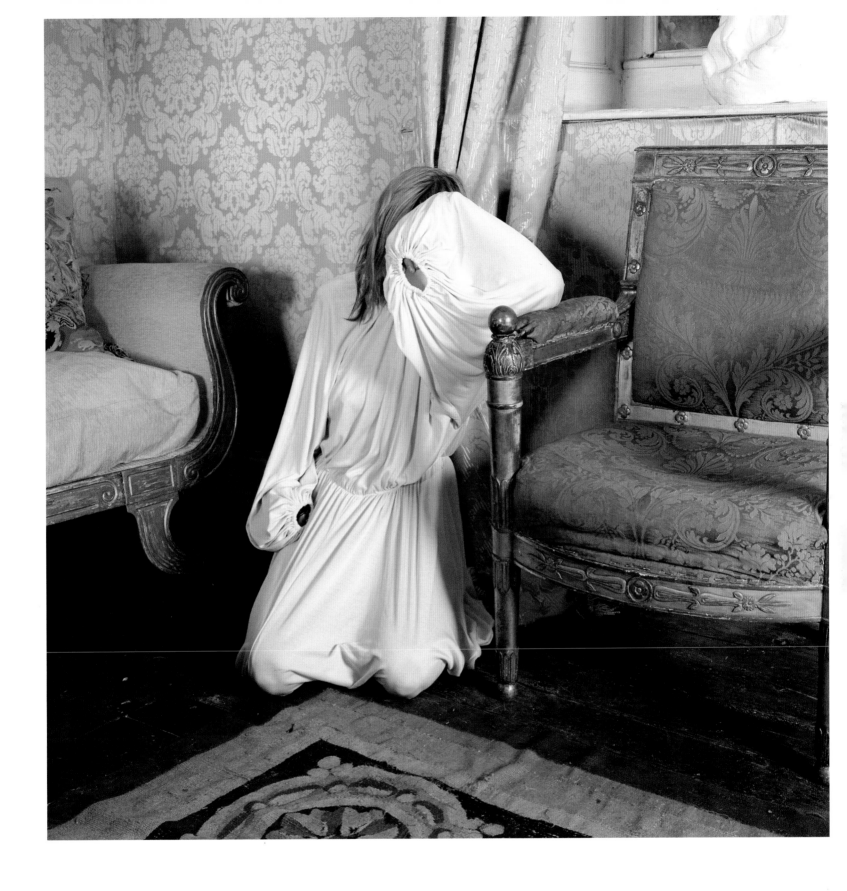

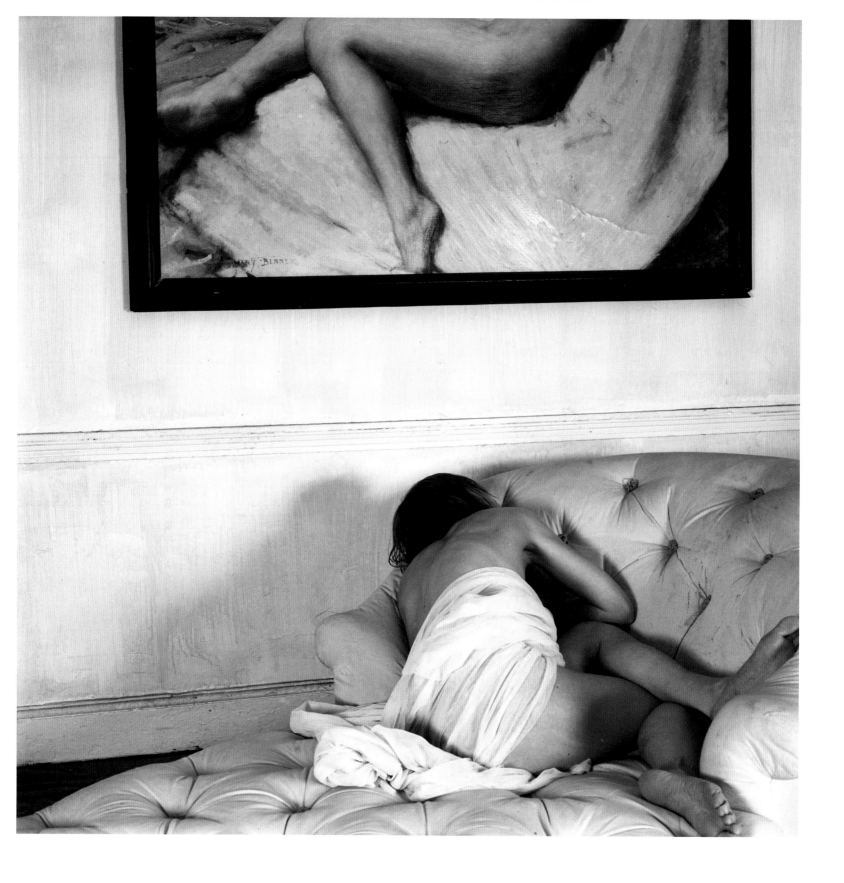

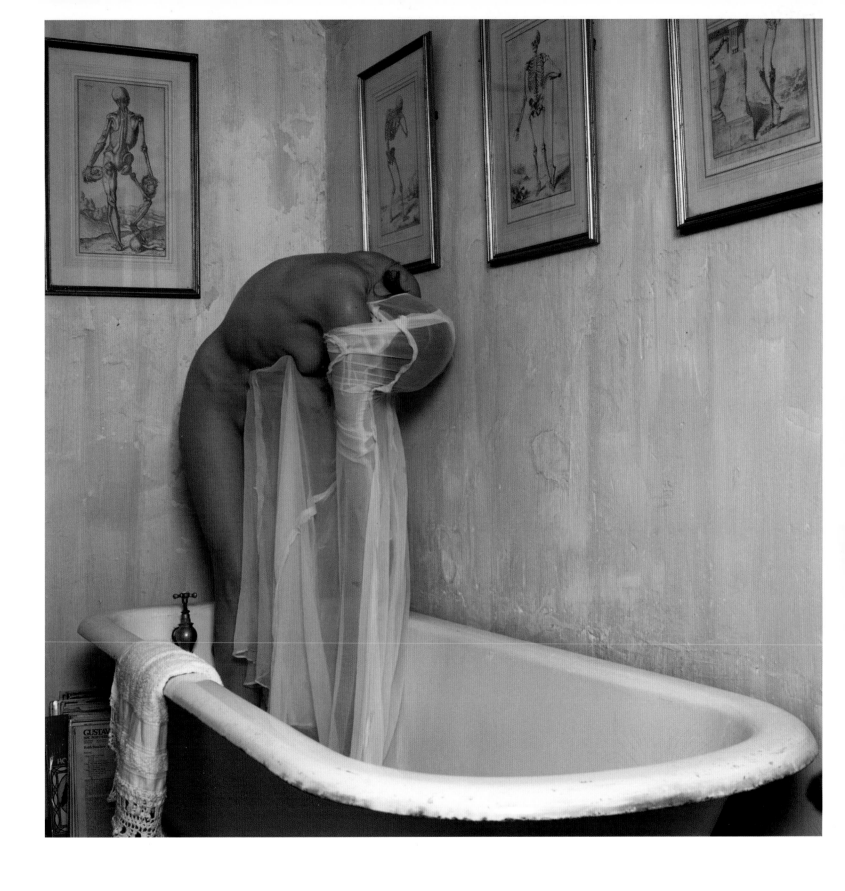

Harold Offeh

Born in Accra, Ghana, 1977.
Lives and works in London.

Moving image and video play several roles in artist Harold Offeh's work. Initially interested in performance-to-camera as an art student – in subverting the language and modes of popular culture and television using video as his tool – Offeh's recent work has developed beyond that medium to include collaborative projects and "curatorial" works where he devises larger projects with multiple artists and groups of participants. While the influence of the moving image is always present in Offeh's oeuvre, the effect of film and television culture in his practice is evident not only in the form his work takes, but also in the content found within it. Offeh's early work, made as he emerged as a graduate from the Fine Art Photography MA at London's Royal College of Art, was rooted in deconstructing ideas of identity and stereotypes through the media and languages of popular culture. In recent years, his work has developed out of such discourses to extend his interests towards collaboration and co-operation with other artists, children, and participants in his artwork. In turn, Offeh has developed his practice in terms of his sensitivity and response to stimuli in popular and contemporary culture.

The frequent use of personae plays a prominent role in Offeh's work, from little Harold, a samba-dancing, labourer's uniform-wearing cultural tourist (and cultural participant) in Brazil, to the artist as a deconstructed representation of the African American actress Hattie McDaniel. Offeh's influences are most often rooted in American video art from the 1970s – works by artists such as Vito Acconci, Bruce Nauman, and Martha Rosler. As a child Offeh watched a lot of TV, and at art school he became interested in the pervasiveness and dominance that TV possesses and operates within contemporary society. Both creative and analytical, Offeh's practice is influenced by the history of the moving image in popular culture, as well as being a product and a critique of it.

Communication across cultures – and deconstructing the boundaries that imply cultural difference in the first place – is what Offeh's work is all about. At its heart, Offeh's artwork is a practice both playful and deceptively light of touch. He's a dancer, a smiler, a Mammy, and the Afrofuturist Angela Davis in drag (aptly named Mangela Davis). And these strategies – whether personae or collaborations – allow Offeh to be constantly inside the work, maintaining a direct engagement with the camera and in turn with the audience.

Kim Dhillon

Education
1999–2001
MA in Photography, Royal College
of Art, London
1996–99
BA (Hons) Critical Fine Art Practice
(1st Class), University of Brighton

Solo Exhibitions
2008
"Being Mammy", Kulturhuset,
Stockholm
2005
"Peripheral Visions", Cork Film Centre,
Cork, Ireland
"Haroldinho", Gimpel Fils, London
2004
"Being Mammy", Aspex Gallery,
Portsmouth
"Animations", IBID Projects, Vilnius
2003
"Carioqinha/TV Dinners", Espaço
Bananeiras, Rio de Janeiro (with Lisa
Cheung)
2002
"Unfulfilled Desires", Tablet Gallery,
Tabernacle Arts Centre, London
"Harold Offeh", Gasworks Gallery,
London

Curatorial Projects
2008
"Down at the bamboo club",
various venues, Bristol
"Damn, I wish I'd done that!",
screening at 176 Project Space,
London
2007
"Emergency 3", Aspex Gallery,
Portsmouth (Selector)
2006
"The Mothership Collective",
South London Gallery

Selected Group Exhibitions
2008
www.agrifashionistas.tv, Club Row,
London
"In Our World: New Photography
in Britain", curated by Filippo Maggia,
Galleria Civica di Modena, Italy
2007
"London is the place for me",
Rivington Place, London
"Hybrid Narratives", Akbank Sanat,
Istanbul
"Black and White", IBID Projects,
London
2006
"Strangers with Angelic Faces",
Akbank Sanat, Istanbul
"Ghosting", Angel Row, Nottingham
and A. Bond, Bristol
"Metropolis Rise: New Art from
London" (temporarycontemporary),
CQL Design Center, Shanghai and
Dashanzi 798 Art District, Beijing
2004
"Veni Vidi Video", Studio Museum
in Harlem, New York
2002
"In Focus: From Tarzan to Rambo",
Tate Modern, London

Selected Publications
2007
Art Star 3 Video Art Biennial,
Exhibition Catalogue, SAW Gallery,
Canada
Hybrid Narratives, Exhibition
Catalogue, Akbank Sanat, Istanbul
The Black Moving Cube, The Green
Box
2006
*Ghosting: The Role of the Archive
within Contemporary Artists' Film
and Video*, Picture This.
Strangers with Angelic Faces,
Exhibition Catalogue, Space London
and Akbank Senat, Istanbul.
2003
*Veil: Veiling, Representation and
Contemporary Art*, inIVA, ed. by
D.A Bailey and G. Tawdros
2000
10th East International, Exhibition
Catalogue, Norwich Gallery

Awards
2006
Decibel Artists Award
2003
Arts Council England, Grants
for Individuals

Residencies
2007
Grizedale Arts Residency, Lawson
Park, Cumbria, UK
2005
Electric Greenhouse Digital Arts
Residency, Electric Studios, London
2004
Arts Council England International
Fellowship, Banff Arts Centre, Canada
2003
Triangle Arts Residency to Rio
de Janeiro
2000
Studio residency, Cité Internationale
des Arts, Paris

Collections
The New Art Gallery, Walsall, UK
Anita Zabludowicz

Alien Broadcasting Corporation (ABC), 2006
Video installation, 29'

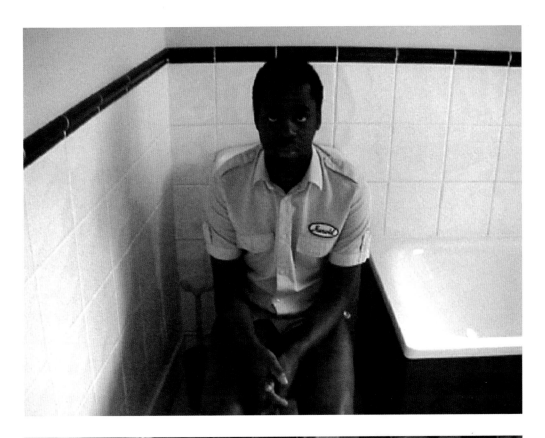

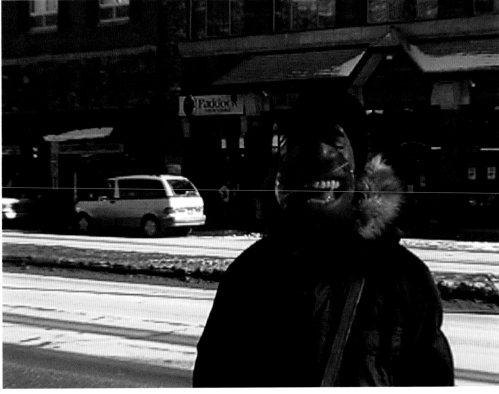

Four Ways to Feel Amazing, 2002
Video, 3'

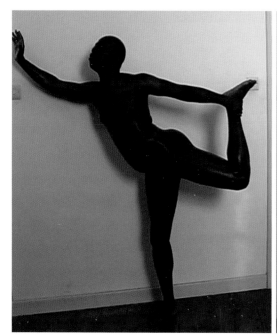 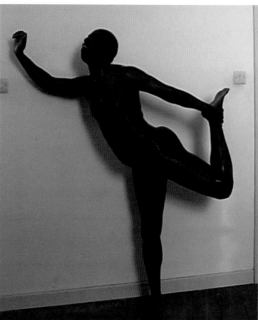 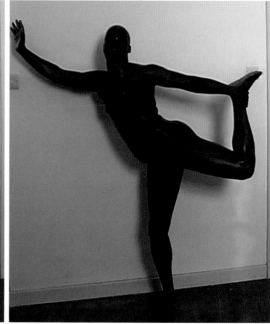

Arabesque (After *Grace Jones*, 1978), 2007
Video, 1'10"

Haroldinho, 2003
Video, 12'

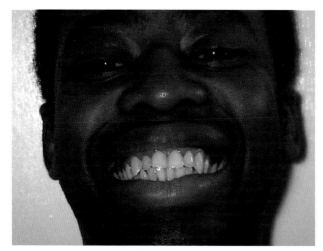

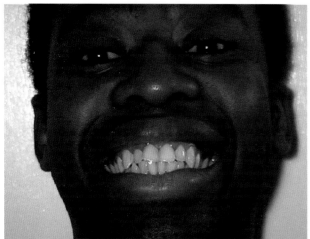

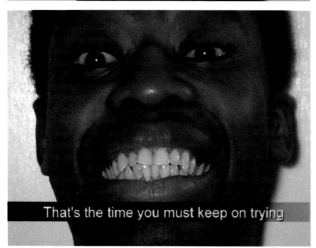

That's the time you must keep on trying

Smile, 2001. Video, 2'58"

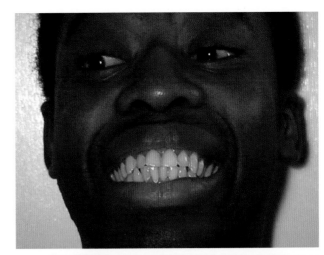

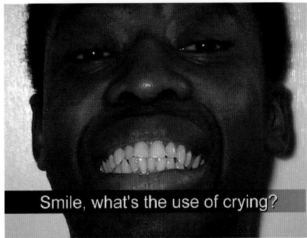

Smile, what's the use of crying?

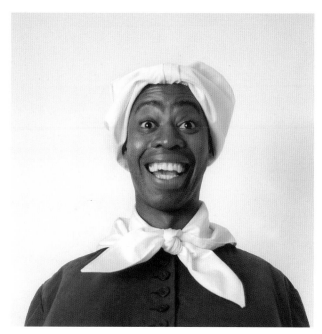

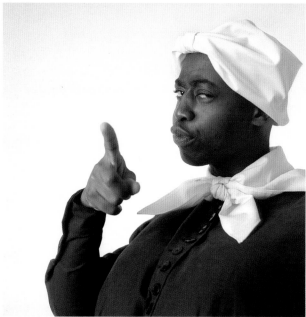

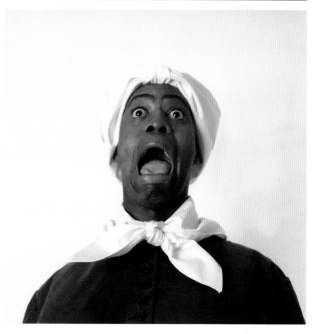

Being Mammy, 2004
6 C-type prints, 50 x 50 cm

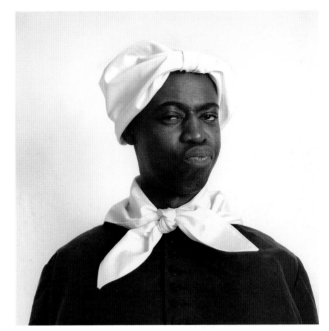

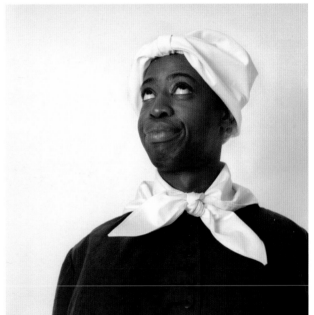

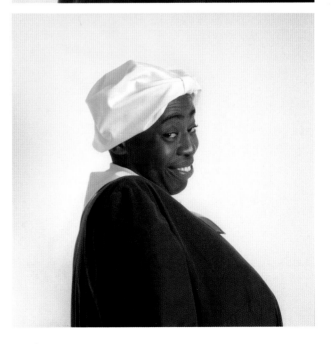

Kirk Palmer

Born in Northampton, UK, 1971.
Lives and works in London.

Kirk Palmer's practice investigates the specificities and interstices of the still and moving image. The contemplative nature of the artist's gaze teases out nuances in his subject matter, lending his work a poetic quality. Landscape and sense of place can be seen as broad themes, as can the existential nature of our relationship with the world. Palmer is intrigued by what lies on the threshold of our awareness – that which we intuit or experience momentarily. His photographs and films, such as *State* (2004), often explore the notion that traces of the past, whether actual, merely imagined, or remembered, somehow remain manifest in the present.

The artist's most recent works are thoughtful outpourings from time spent in Japan. The visually arresting, black and white video *Murmur* (2006) was shot in bamboo forests on the outskirts of Kyoto. The absorbing panoramic views of this terrain initially appear like lingering photographic stills in a slide projection sequence. However, the viewer's eye soon picks up on small movements, signs of life: the gentle rustling of branches which transforms the abstract swathe of textured greys and blacks into an animate, eerily anthropomorphic forest. These movements gradually build to a crescendo as great gusts of wind whip through the trees, sending them into a frenzy of arboreal gesticulation.

For Palmer, the history of landscape photography is a crucial influence. Questions of if, and how, the intangible properties of memory, atmosphere, or cultural identity are caught up in the physical substance of a place abound in *Dwellings* (2007) and *Hiroshima* (2007), poignant meditations upon the ghosts that can haunt a landscape. The Hiroshima of the latter film is a thriving, verdant place. We anticipate; we have certain expectations of how the weight of history will bear on the images we see once the camera moves from the hills of the opening sequence, down into the city. Yet, once it does, this palpable tension dissolves – the people of Hiroshima go leisurely about their daily lives. That we, as an audience, should demand any less says much about the historical burden of collective guilt we carry with us. Palmer's decision not to film locations such as the Peace Memorial Park is not an attempt to assuage this guilt. If anything, the conspicuous absence of the tragedy serves to make its presence felt all the more, highlighting the delicate dichotomy of remembering and forgetting in which the city is entangled.

Elena Kane

Education
2004–06
MA in Photography, Royal College
of Art, London

Solo Exhibitions
2007
"Hiroshima", Paradise Row, London

Selected Group Exhibitions
2008
"In Our World: New Photography
in Britain", curated by Filippo Maggia,
Galleria Civica di Modena, Italy
2007
"Zelda Rubinstein", Paradise Row on
Princelet St, London
"Videoclub: The Finale 2007",
Lighthouse, Brighton
"Zoo Art Fair", Royal Academy of Arts,
London
"Anticipation", One One One, London
"Video London 2 @ LOOP '07",
Convento de San Augustín, Barcelona
"Welcome to Paradise", Galerie Nuke,
Paris
2006
"Digital Space", Showroom Cinema,
Sheffield
"Videoclub: The Finale 2006", Fabrica,
Brighton
"Video London", Festival Edición
Madrid 6, Madrid
"Selected Works", Conran Ltd, London
"Zoo Art Fair", T1+2/Paradise Row,
London
"Cannibal Ferox", Paradise Row &
T1+2 Art Space, London
"Welcome to Paradise", Paradise Row,
London
"Still In Motion", Leonard Street Gallery,
London
"The End of Civilisation", Port Elliot
Literary Festival, Cornwall
"Case Study 2", Plymouth Art Centre,
Plymouth
"Seekquences", Chain Gallery, London
"16th ISE", Kyoto Art Center, Kyoto
2005
"Video London", Espai Ubu, Barcelona
"La Lenteur [Slowness]", Prix Leica,
Royal College of Art, London
"Gone in 60 Seconds", Gallery by the
Lake, Southwark Park, London

Selected Publications
2007
London: Paradise Row,
in "Contemporary Annual 2007"
Kirk Palmer – Hiroshima, in "Time Out",
July 11–17
Kirk Palmer: Interviewed by John Slyce,
RCA Photography 2006, Catalogue
Laura K Jones, *Anticipation: London's
Best Emerging Artists*, June 2,
www.saatchi-gallery.co.uk/blogon/
2007/06/anticipation_londons_best
_emer.php
Laura K Jones, *Kirk Palmer at Paradise
Row, London*, June 25, www.saatchi-
gallery.co.uk/blogon/2007/06/laura_k
_jones_on_kirk_palmer_a.php

Grants and Awards
2007
Shortlist, LUX Associate Artists
Programme
Shortlist, London Artists' Film and
Video Awards (LAFVA)
2006
Winner, The Conran Foundation
Awards
Winner, Axis Selected Graduate Artist,
(nominated by Brett Rogers)
Finalist, The Deutsche Bank Pyramid
Awards
2005
Finalist, Prix Leica

Residencies
2005
RCA Kyoto Scholarship and Residency

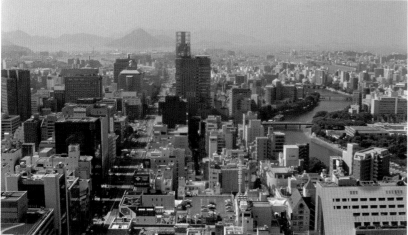

Hiroshima, 2007
16mm film/digital projection, colour, sound, 17'39"
All works courtesy Kirk Palmer and Paradise Row, London

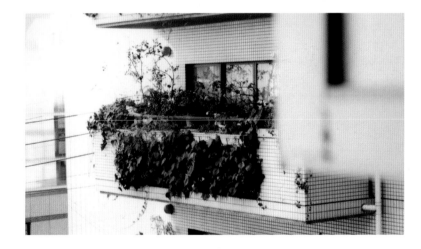

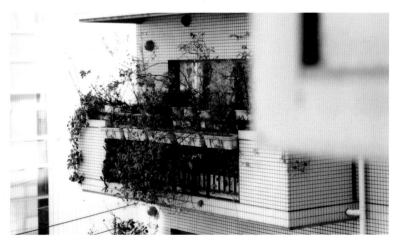

Dwellings, 2007
Refilmed photographs, four-screen installation,
colour, silent, endless loop

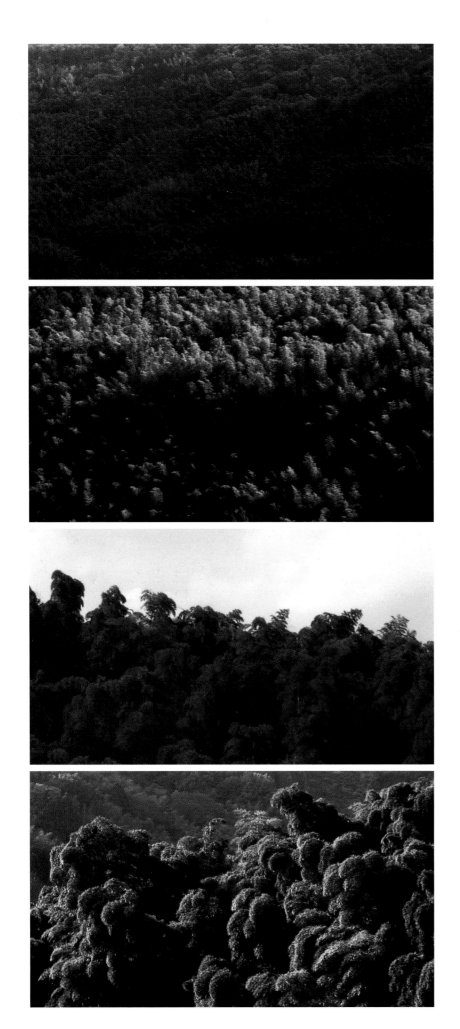

Murmur, 2006
HD video/digital projection, black and white,
sound, 6'45"

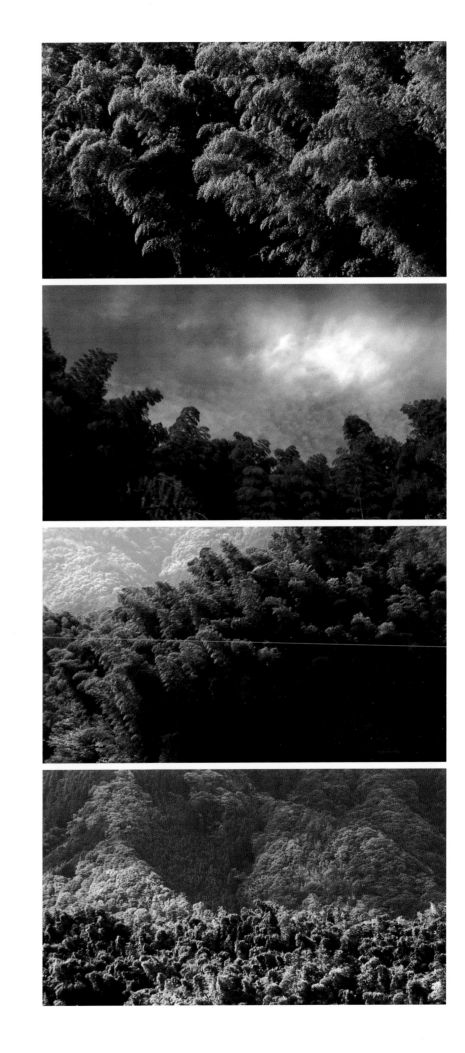

State, 2004
8mm film/digital projection, colour,
sound, 2'16"

Sarah Pickering

Born in Durham City, UK, 1972.
Lives and works in London.

Incident and *Fire Scene* are two separate series produced whilst Artist in Residence at the UK Fire Service College from 2006 to 2007. As with my previous work, *Public Order* and *Explosion*, these series concentrate on simulation and preparedness in an ongoing investigation into this abstraction and re-presentation.

The black and white *Incident* photographs depict purpose-built environments that have been set on fire as practice exercises for fire officers to extinguish. The blackened spaces reveal traces of human presence – marks where fingers have dragged across surfaces and bodies have rubbed past objects. Rather than the charred piles of debris expected to be seen in a burned-out building, these locations are strangely pristine. Objects are schematic and approximate as they are designed to be repeatedly burned, and have to retain a distinguishable form. The spaces catalogue potential sites of fires and resonate as an echo of an event. The photograph itself is also a subject of the series – dark areas often appear where lightness should be, creating a slippage between negative and positive; the matt surface of the print echoes the carbon-covered surface in the spaces; the photographic trace a record of multiple moments – anticipating the future and referencing the past.

Each room in the *Fire Scene* series is filled with narrative – clues as to the identity of the perpetrator or victim, scenes of disturbance, violence or carelessness. These are set-dressed interiors which are then strategically burnt to train forensic teams and crime scene investigators. Painstakingly assembled to provide a convincing level of realism, the spaces have pictures on the walls, underwear in drawers, ornaments, trinkets and books on shelves, and even food on the breakfast table. Scene of Crime specialists decide on a detailed scenario (sometimes based on a real-life case) for trainees to decipher from the charred remnants of the room. The forensic investigations look for "behaviour patterns" – marks left by the fire as it spreads – and here the behaviour patterns are also those of a low-income social group, often on the wrong side of the law, with guilty secrets and complicated personal lives (with more than a passing similarity to the sensational characterisations in British soap operas). Predictably, however, every time the culmination of the narrative is a fire. By photographing the rooms as they burn, each image is poised between completeness and ruin, set within a continuous cycle of construction and destruction.

In my work, the viewer can only imagine the scenarios that are set up as part of training exercises, and in actual fact they *are* imaginary experiences. There is a tension between what is perceived as real and what is actually real, and how we relate to extreme events such as war and disasters (eyewitnesses often describe their experience as "like a film"). I'm interested in the separation of the real from the imagined, and the complexities inherent in negotiating and representing this.

Sarah Pickering

Education
2003–05
MA in Photography, Royal College
of Art, London
1992–95
BA (Hons) in Photographic Studies,
University of Derby

Solo Exhibitions
2008
"Fire Scene", Daniel Cooney Fine Art,
New York
2007
"Explosion", The Photographers'
Gallery Print Sales, London
2006
"Sarah Pickering", PynerContreras,
Cultural Fair, Mexico City
"Explosion", Daniel Cooney Fine Art,
New York

Selected Group Exhibitions
2008
"Blown Away", Krannert Art Museum,
Illinois
"In Our World: New Photography in
Britain", curated by Filippo Maggia,
Galleria Civica di Modena, Italy
"New Typologies", New York 1st
Photography Festival, curated by
Martin Parr (May)
"Laurent Grasso and Sarah Pickering",
Prefix Institute, Toronto
(June–July)
2007
"Contemporary, Cool and Collected",
Mint Museum of Art, North Carolina
"How we Are: Photographing Britain",
Tate Britain, London
"MACO Art Fair", Mexico City (with
PynerContreras)
"The Big Picture", North Carolina
Museum of Art
"System Error", Palazzo delle Papesse,
Siena
2006–07
"War Fare", Chicago Museum of
Contemporary Photography
2006
"Photo Paris", Carrousel du Louvre
with the Photographers' Gallery
"The Universe in a Handkerchief",
Gallery Yujiro, London
"Shifting Terrain", Herter Gallery,
University of Massachusetts Amherst
2005–06
"Jerwood Photography Award Touring
Exhibition", UK
2005
"Sarah Pickering and Gonzalo Lebrija",
PynerContreras, London
"The Great Unsigned", Zoo Art Fair,
London
"EAST International", Norwich

Selected Publications
2008
Blown Away, Krannert Art Museum,
Illinois
2007
Prefix (Canada)
David Campany, *We are Here*,
in "Tate etc"
"The Independent", Visual Art Preview
in Extra, Interview with Warren Howard,
April 5, p. 21
"Dazed and Confused", Interview, April,
p. 196
50 British Career Artists, in "Avant
Garde" (Japan), April, p. 41
"Fotograf" (Prague), April
Richard B. Woodward, *War
Photography: Beyond Documentary*,
in "Art News", March, pp. 120–125
*System Error: War is a Force that Gives
us Meaning*, ed. by L. Fusi and N.
Mohaiemen, Silvana Editoriale, Italy
Brian Dillon, in "Art Review", February,
pp. 109–111
2006
"Photograph" magazine (USA),
November–December, pp. 74–75
*Vitamin Ph: A survey of Contemporary
Photography*, London, Phaidon
"Cabinet" magazine, July
John Slyce, in "Portfolio", Issue 43:
Explosion Series, May
"Seesaw Magazine", Spring (online:
www.seesawmagazine.com)
"Codigo 06140" magazine (Mexico),
Issue 31: *Public Order*, April–May
"Art Forum", Critics Picks (online)
by Nicole Rudick, January–February
Blake Gopnik, *Up in Smoke:
An Explosive Approach to Art*,
in "Washington Post", January 15, p. 4
Amy Benfer, *Napalm with a side of fuel
air explosion*, in "Metro New York",
January 10, p. 11
2005
Val Williams, *Jerwood Photography
Awards 2005*, in "Portfolio", Issue 42,
December, pp. 64–66, pp. 80–83
*The Best Emerging Photographers of
2005*, in "Art Review", October, p. 90

Awards
2005
Jerwood Photography Awards
The Photographers' Gallery Graduate
Award
Worshipful Guild of Painter-Stainers
Award

Bedroom, from the series *Incident*, 2007
Silver gelatine print, 86 x 108 cm prints on 107 x 128 cm paper
Courtesy Daniel Cooney Fine Art, New York

White Goods, from the series *Incident*, 2007
Silver gelatine print, 86 x 108 cm prints on 107 x 128 cm paper
Courtesy Daniel Cooney Fine Art, New York

Fireplace, from the series *Incident*, 2007
Silver gelatine print, 86 x 108 cm prints on 107 x 128 cm paper
Courtesy Daniel Cooney Fine Art, New York

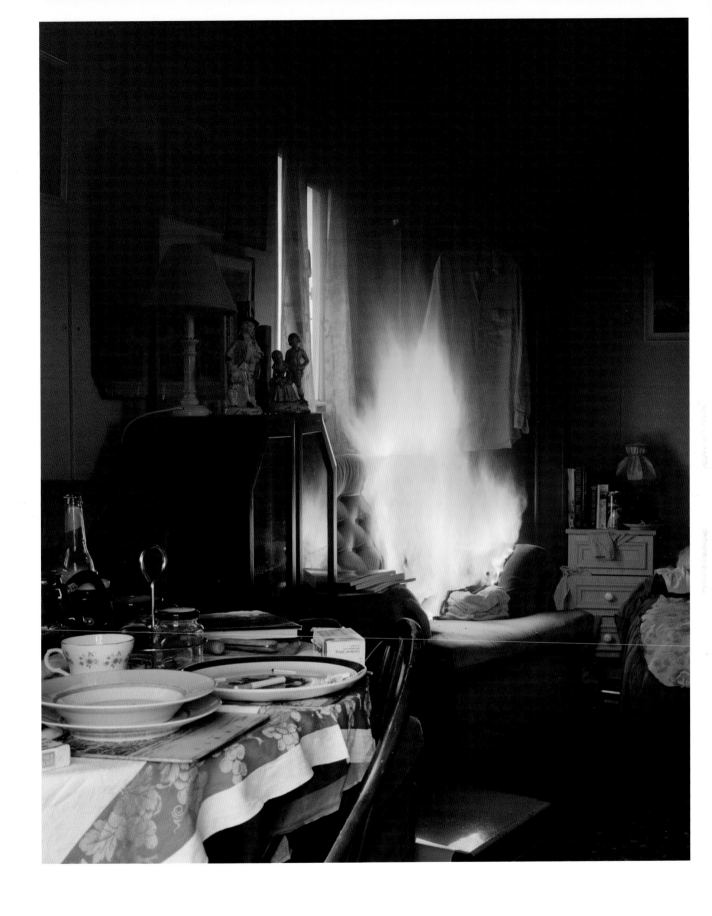

Cigarette, from the series *Fire Scene*, 2007
C-type print, 120 x 96 cm
Courtesy Daniel Cooney Fine Art, New York

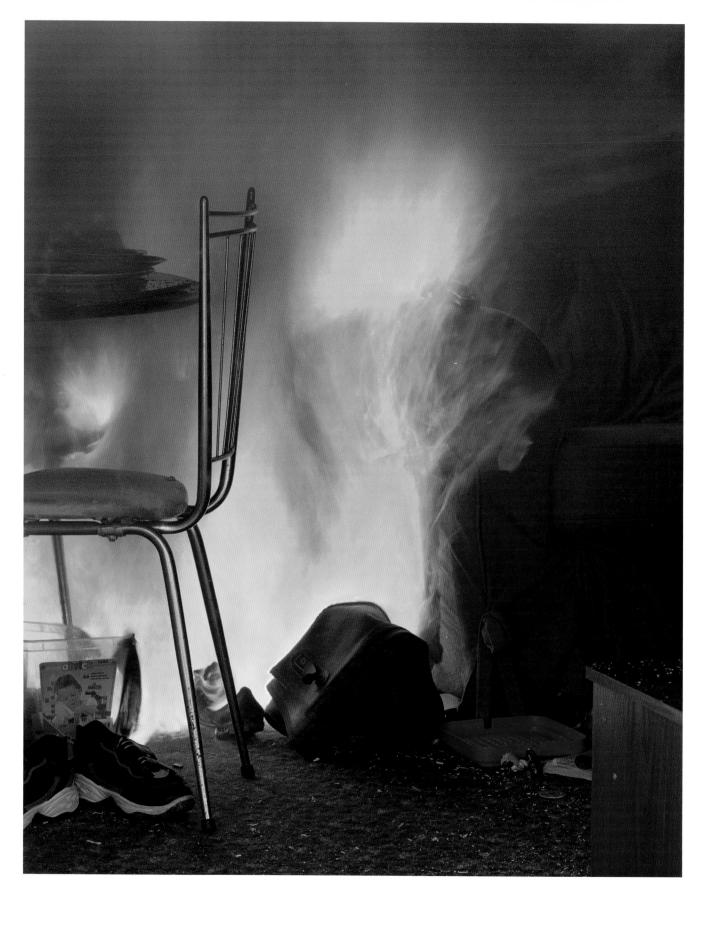

Abduction, from the series *Fire Scene*, 2007
C-type print, 120 x 96 cm
Courtesy Daniel Cooney Fine Art, New York

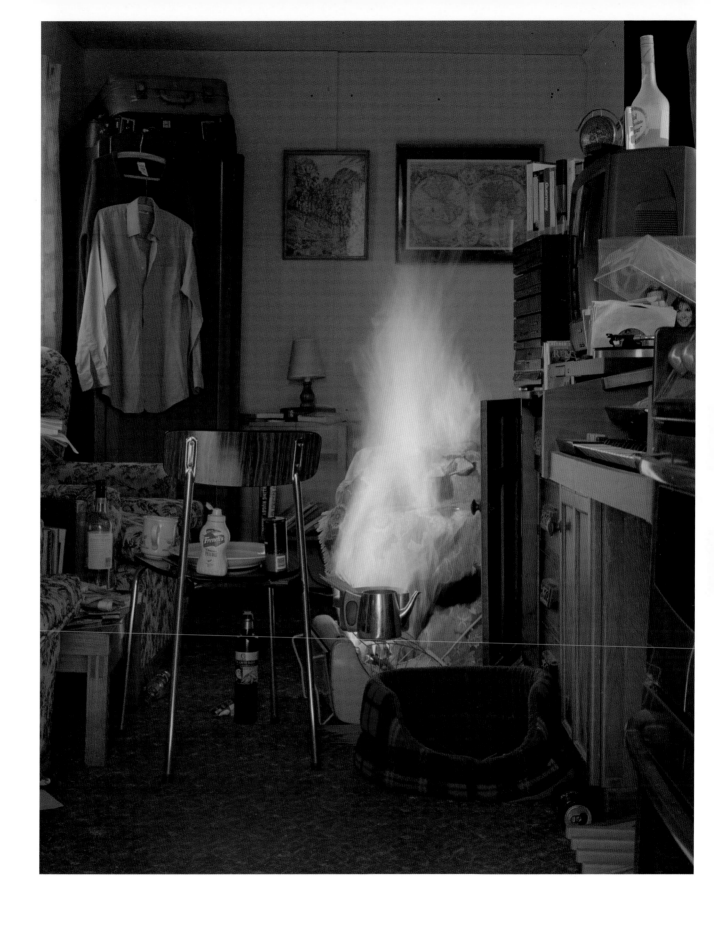

Makeshift Cooking, from the series *Fire Scene*, 2007
C-type print, 120 x 96 cm
Courtesy Daniel Cooney Fine Art, New York

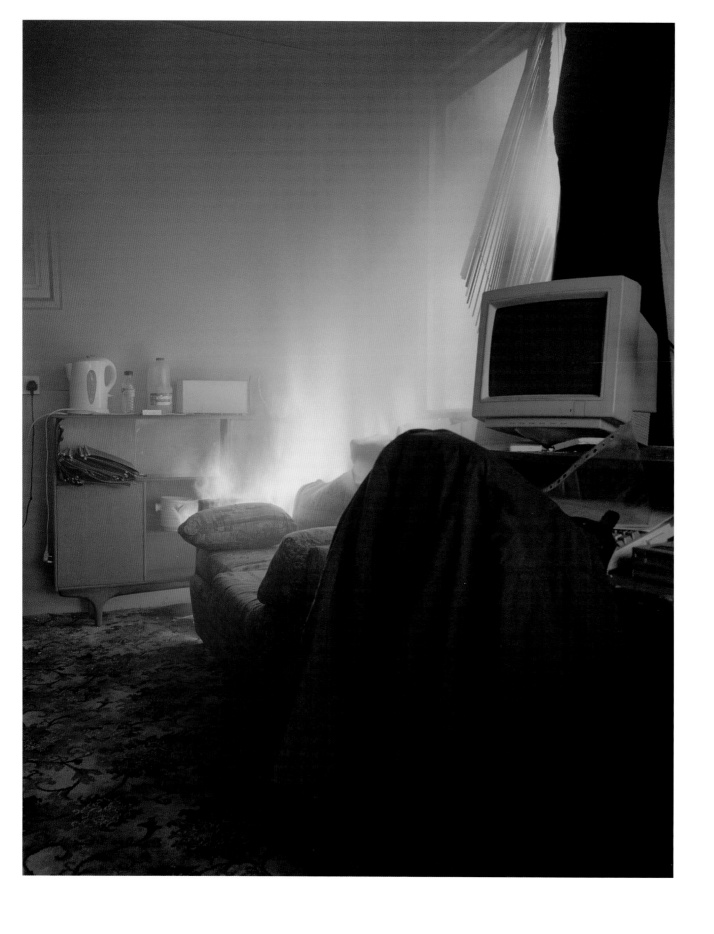

Insurance Job, from the series *Fire Scene*, 2007
C-type print, 120 x 96 cm
Courtesy Daniel Cooney Fine Art, New York

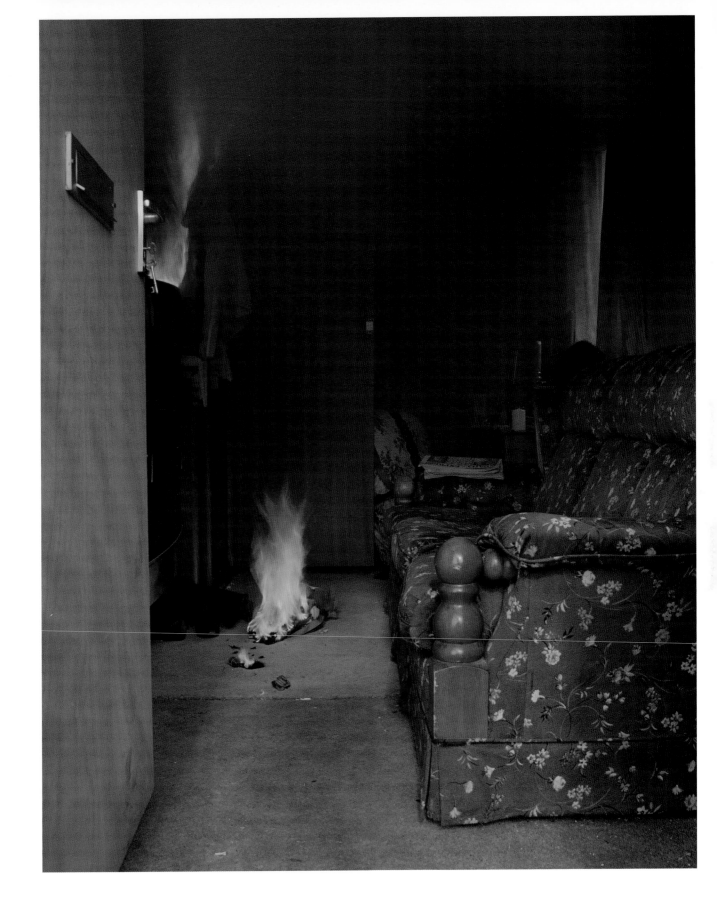

Candles, from the series *Fire Scene*, 2007
C-type print, 120 x 96 cm
Courtesy Daniel Cooney Fine Art, New York

Sophy Rickett

Born in London, 1970.
Lives and works in London.

Auditorium

Theatre is a place of multiple concealments: backstage from stage; orchestra from stage; audience from stage. In each of these pairings, the stage may be seen as a space of revelation that at the same time implies a concealed other.

In western epistemology that which is revealed, brought to light, is assumed to be inherently truer than that which is concealed; the metaphor of knowledge as enlightenment, of seeing as understanding, is commonplace. And in western aesthetics, from Aristotle to Heidegger, art is also about revelation: the bringing of that which is not immediately evident to us into the light of presence.

Sophy Rickett's film *Auditorium* leads us through the stage, backstage and auditorium of the Glyndebourne opera house in a series of such revealings: veils lifted, light cast, dark spaces made visible. In the opening sequence, on the left-hand screen, bars of light ascend from the stage floor to the top of the proscenium to illuminate (we assume), on the right-hand screen, the dome of the auditorium. At the end of the film a series of flimsy curtains is raised to expose not, as we expect, the stage, but, for the first time, the complete auditorium as seen from the stage, miraculously filled with glowing light.

And yet: surely the stage is a place of illusion and make-believe, not a place of truth? Indeed, in western metaphysics, theatre has often served as a metaphor for illusion and deceit; Plato's cave, in which the audience is entranced by the shadows cast on the wall, failing to recognise that they are *only* shadows, is a founding image in the long history of anti-theatrical prejudice. In western metaphysics (as opposed to western epistemology), that which is concealed from us is implicitly more certain than that which is visible; what lies within is truer than what we can see on the surface. Never trust appearances, we learn. Behind the tinsel illusion of the stage lies the hard and unglamorous reality of the backstage machinery and the labouring stage hands who operate it. In the auditorium the viewers may temporarily suspend disbelief, but, Plato notwithstanding, they are never truly deceived, and they bring the judgement of the real world to bear on what they witness. *Auditorium* turns the stage, backstage and auditorium of Glyndebourne into a play of deferred revelations that implicitly acknowledge the tensions and contradictions between those two core theatrical metaphors of truth and knowledge. At times her film is impassively formal, offering an austere image of truth as geometry. At other times it turns the functional modernist spaces of the Glyndebourne opera house into a baroque fantasy; a joyful play of illusory spaces. Human presence is banished from the theatre, save for a solitary fly-man, whom we glimpse twice, hauling on the ropes that raise and lower her bars of light, her curtains, and indeed her camera. It is a *Wizard of Oz* moment. We have been led to believe that this modern theatre is a feat of technological omnipotence. But behind even that imposing structure is, no, not God (who is, indeed, the hidden stage-manager in the theatre of Goethe's *Faust*), but a fly-man. This is the *mise-en-abîme* of theatrical metaphysics, and perhaps of all metaphysics: at the heart of the machine, after the play of deferred revelations, there is nothing more than the modest fly-man. In the end, all the film can reveal is a procession of absences: the absent drama on stage; the absent orchestra, and finally, the absent audience in the empty auditorium.

Nicholas Till

152

Education
1997–99
MA in Photography, Royal College
of Art, London
1990–93
BA (Hons) in Photography, London
College of Printing, London

Selected Solo Exhibitions
2008
Ffotogallery Cardiff, UK
Alberto Peola Arte Contemporanea,
Turin
Nichido Contemporary Art, Tokyo
2007
"Auditorium", De La Warr Pavilion,
Bexhill-on-Sea, UK
2005
Emily Tsingou Gallery, London
2004
Alberto Peola, Turin
2003
Nichido Contemporary Art, Tokyo
"Viva Roma" – A special commission
of the British Council, Rome
Centre pour l'image contemporaine
Saint-Gervais, Geneva
Emily Tsingou Gallery, London
Alberto Peola, Turin
RENN Art Gallery, Paris
2001
Emily Tsingou Gallery, London
Dundee Contemporary Arts, UK

Selected Group Exhibitions
2008
"In Our World: New Photography
in Britain", curated by Filippo Maggia,
Galleria Civica di Modena, Italy
2007
"Les Peintres de la Vie Moderne",
Pompidou Centre, Paris (Cat.)
2006
"La Donna Oggetto", Castello
Sforzesco, Vigevano, Italy (Cat.)
"Contempor'art", Piccolo Miglio
in Castello, Biennale Internazionale
di Fotografia di Brescia, Italy (Cat.)
"Responding to Rome", Estorick
Collection, London (Cat.)
2005
"Autowerke", Museum of Fine Arts,
Leipzig
2004
"Everything's Gone Green:
Photography and the Garden", National
Museum of Photography, Film and
Television, Bradford, UK
2003
"Order & Chaos", curated by Urs
Stahel, Fotomuseum Winterthur,
Switzerland (Cat.)
"Where Are We?", Victoria & Albert
Museum, London
"A Night on Earth", curated by
R. Christofori, Kunsthalle Münster
"The Fantastic Recurrence of Certain
Situations", Canal de Isabel II, Madrid
(Cat.)

Publications
2005
Sophy Rickett (monograph), London,
Steidl/Photoworks
2001
Sophy Rickett: Photographs
(monograph), London, Emily Tsingou
Gallery

Selected Reviews and Articles
2006
Andrew Wilson, *Sophy Rickett*,
in "FotoMuseum Antwerp"
2005
Darien Leader, *Sophy Rickett*,
in "Portfolio", June
M. Herbert, *Sophy Rickett*, in "Time
Out", June
2003
Rob Tufnell, *Rickett*, in "Boiler", No 2
Barry Schwabsky, Review in
"Artforum", May
Katie Kitamura, Review in
"Contemporary", No 4
Clare Manchester, Review in "Art
Monthly", March
Sophy Rickett, in "The Times",
February 8
Stefano Ricci, Review in "Tema
Celeste", March–June
Olga Gambari, Review in "Arte
e Critica", April–September
Più che la luce spicca il buio,
in "La Stampa", March 22
Izi Glover, *Sophy Rickett*, *DCA*, Review
in "Frieze", July
Oral History of British Photography,
Interview with Martin Barnes in
"The British Library", November
Roy Exley, Review in "Flash Art",
July–September
Rob Tufnell, *Sophy Rickett, Yellow Tree*,
in "Portfolio", June
Sophy Rickett, Review in
"The Independent on Sunday", April 1
Giles Sutherland, *Around the Galleries*,
Dundee, in "The Times", February 22
Neil Cameron, *Telling Tales in the Dark*,
in "The Scotsman", February 13

Awards and Commissions
2007
Research Grant from AHRC
2006–07
Commission from Glyndebourne
Opera/Photoworks, hosted by
Glyndebourne Opera
2004
Individual Artists Award, Arts Council
of England
2002
Individual Artists Award, Arts Council
of England
Arts Council of England, Helen
Chadwick Fellowship, hosted by The
British School at Rome/Ruskin School
of Drawing, Oxford University

Auditorium, a film by Sophy Rickett,
with music by Ed Hughes
Screening at Glyndebourne Opera House,
Sussex, November 2007
Image Courtesy Richard Rowland

Auditorium was commissioned by
Photoworks, Glyndebourne and the De La
Warr Pavilion with support from Arts Council
of England, the Henry Moore Foundation,
the Foyle Foundation, the Arts and
Humanities Research Council and the Open
Studio at the University of Derby

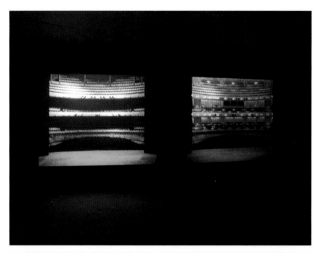

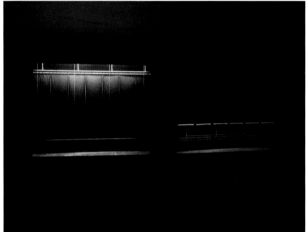

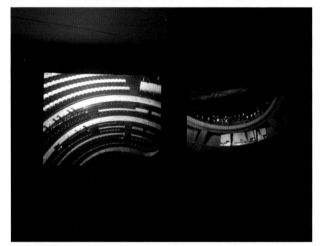

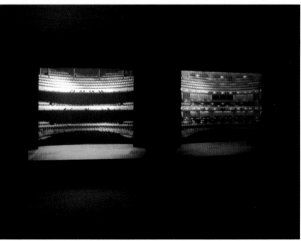

Auditorium, a film by Sophy Rickett with music by Ed Hughes
Installation, De La Warr Pavilion, Bexhill, UK, September 2007
Image Courtesy Sophy Rickett and De La Warr Pavilion

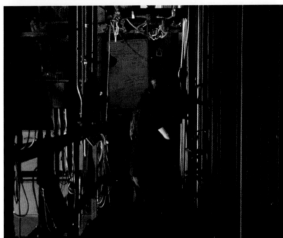

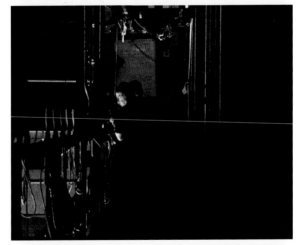

Stills from *Auditorium*
a film by Sophy Rickett with music by Ed Hughes
Image Courtesy Sophy Rickett

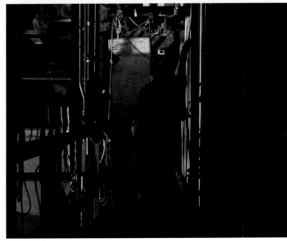

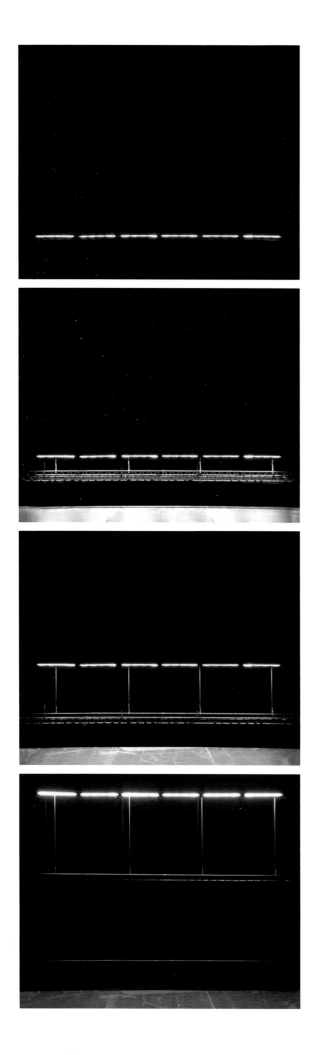

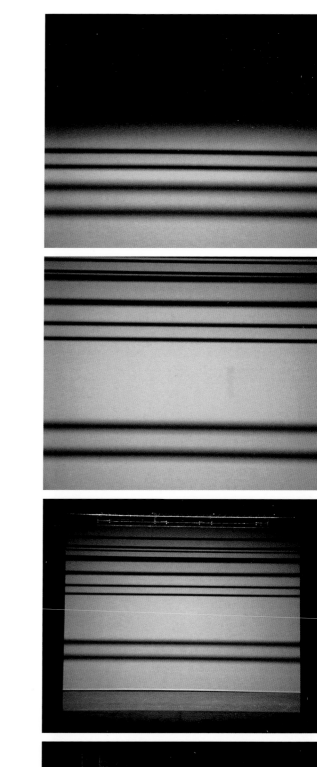
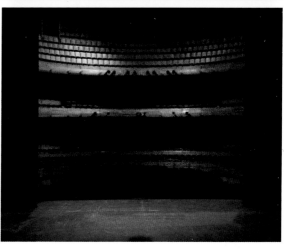

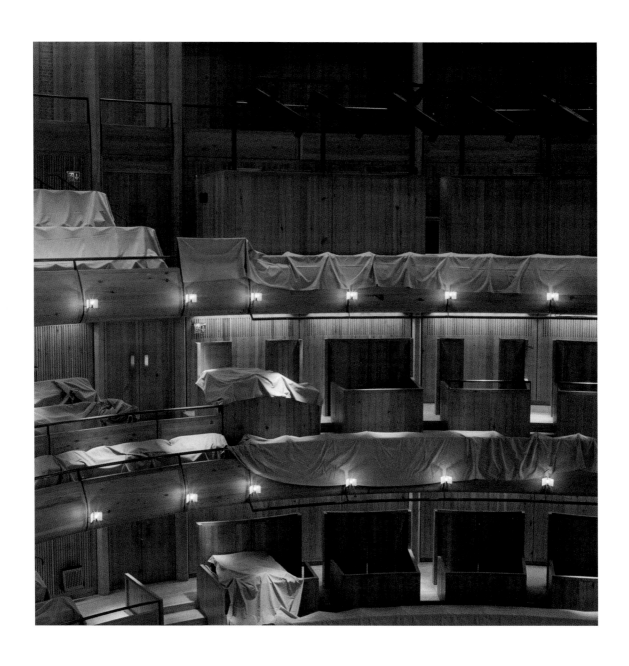

Auditorium 1, 2007. Silver gelatin print
Courtesy Sophy Rickett and Alberto Peola Arte Contemporanea

Auditorium 3, 2007. Silver gelatin print
Courtesy Sophy Rickett and Alberto Peola Arte Contemporanea

Esther Teichmann

Born in Karlsruhe, Germany, 1980.
Lives and works in London.

Esther Teichmann's watery, slippery world of another order is… taboo. In *Silently Mirrored*, the viewer slips and slides between photographs of the exuberance of her husband's black skin (so dark that it hails deep sea blue) and photographs of the exuberance of her mother's white skin (so clear that it hails sky blue). In Teichmann's black (body) and blue (washcloth) landscape of touching feelings, made of breath, water and skin, one is bruised (black and blue) by naked love.

To speak so nakedly of such love is taboo. Teichmann's utopian island-world lies somewhere between black and blue seas, between here and now and the fantasy of where one might go, or perhaps, even, where one has been. At the heart of the work is the experience of the primal loss of the mother, who necessarily turns away, as Teichmann's mother does in some of the photographs.

This turned-away mother, this fragmented mother, like all mothers, does not answer our cry. She goes to work. She leaves us behind. She eventually leaves us for good.

This splitting between the mother and child is, then, tragically repeated later, with the same-shared intensity, between the adult and his or her lover. Like the mother, the lover also turns away. The lover does not answer our cry. The lover goes to work. The lover leaves us behind. The lover may leave us for good. And, just as the mother may have another child, the lover may find another one to love. (Every older child knows all about this, as does every betrayed lover.) To wait for a lover to return home is, as the French essayist and philosopher Roland Barthes suggests, not unlike a child waiting for the mother. For Barthes, a pair of lovers is no more or less erotic and nourishing than the mother and child pair – nor is it any less of a catastrophe.

Carol Mavor

Education
2006 onwards
MPhil/PhD Research by Practice/Fine Art/Photography, Royal College of Art, London
2005
MA in Photography, Royal College of Art, London
2002
BA in Visual Communication/ Photography, Kent Institute of Art and Design, Maidstone, UK

Solo Exhibitions
2008
"Fragments", Gallery Karlheinz Meyer, Karlsruhe, Germany (Cat. with essay by Jonathan Miles)
2007
"Silently Mirrored", Man&Eve Gallery, London (Cat. with essay by Carol Mavor)

Selected Group Exhibitions
2008
"In Our World: New Photography in Britain", curated by Filippo Maggia, Galleria Civica di Modena, Italy
2007
"Nature and Society", curated by Robin Mason, the Dubrovnik Museum and the Glyptotheque, Zagreb, (Cat. with essay by Richard Dyer)
"Tagesstunde", Sassa Trülzsch Gallery, Berlin
"The Region of Unlikeness", curated by Kim Schoen, Bank Gallery, Los Angeles
"The Esthacus Teichwynd Photos", Galerie Giti Nourbakhsch, Berlin (with Spartacus Chetwynd)
"Storytelling", Man&Eve Gallery, London
2006
"Hyères Festival", Hyères, France (Cat.)
"Habitat Phoenix Arts", Brighton
2005
"minus7/plus 18" (duo show), curated by Shirley Read, Lounge Gallery, London (Cat.)
"Made in Britain", Wetterling Gallery, Stockholm (Cat.)
2004
"Perspective 2004", Ormeau Baths Gallery, Belfast (Cat.)

Selected Publications
2008
"Qvest", Special Issue (Germany)
"Rodeo", February (Italy)
2007–08
"032C", No 14, Winter (Germany)
2007
"Piktogram", No 8 (Poland)
"Time Out", September 26
2006
"Camera Austria", No 93
"Capricious", No 4, May (USA)
"Wallpaper", May, October
2005
"Art Review"
"Creative Review", March
"V&A Magazine"

Selected Awards
2007
Man Group Award, The Royal College of Art
2005
Creative Futures Photography Award, Creative Review
2004
Guardian Student Media Awards – Photography
Leica Prix, The Royal College of Art
Fujifilm Student Awards

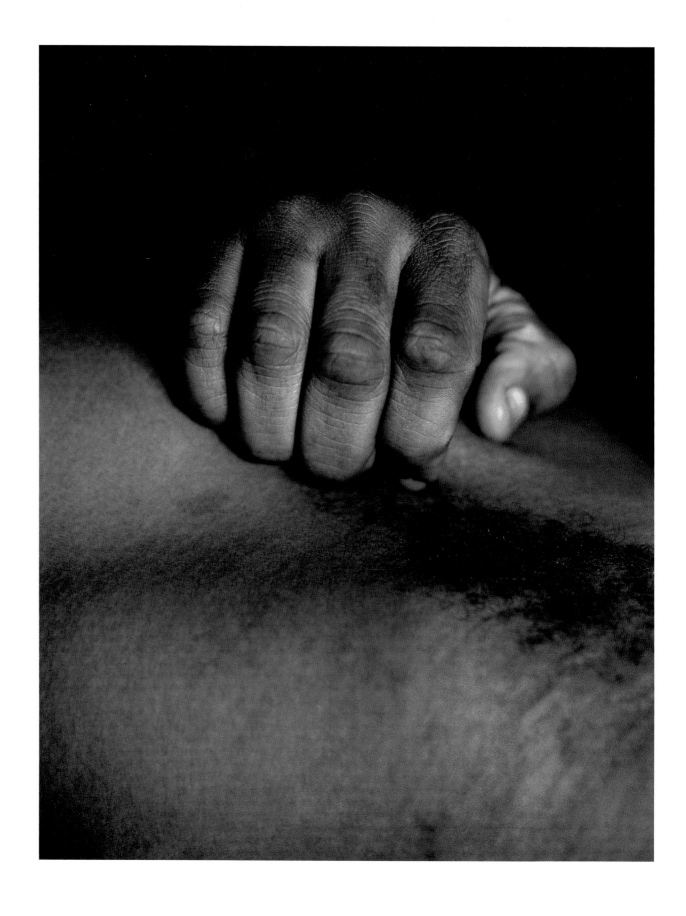

Diptych I from *Stillend Gespiegelt*, 2007. C-type prints, 102 x 76 cm, 76 x 102 cm

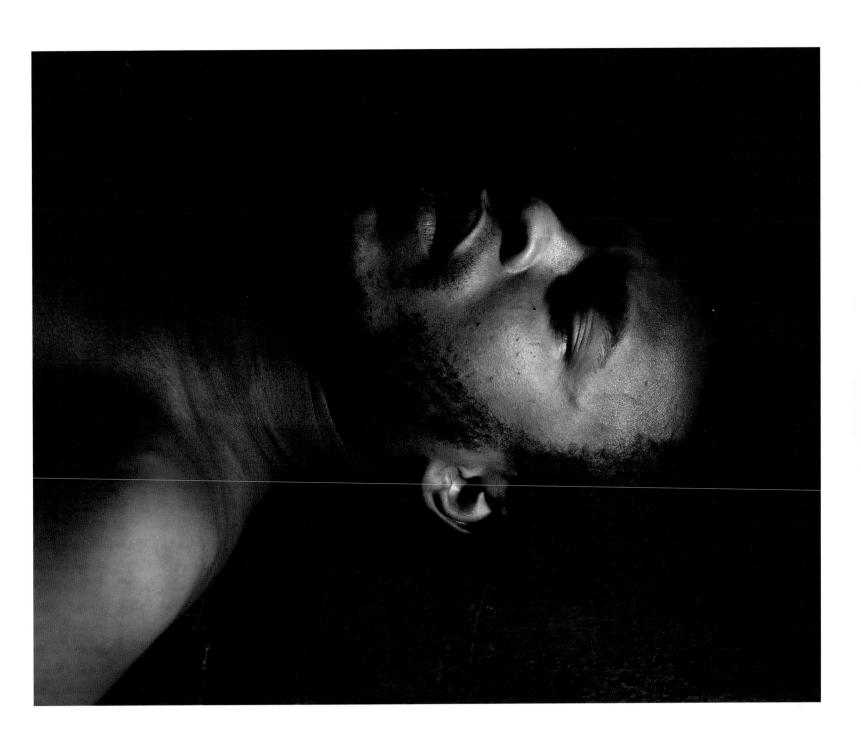

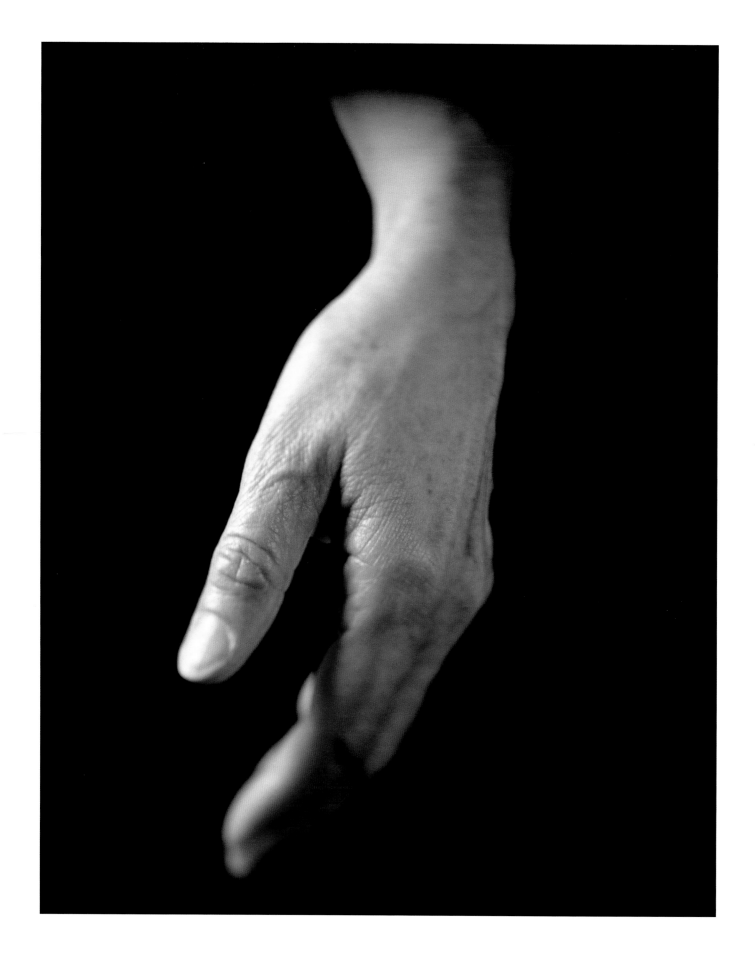

Untitled from *Stillend Gespiegelt*, 2005. C-type print, 61 x 51 cm

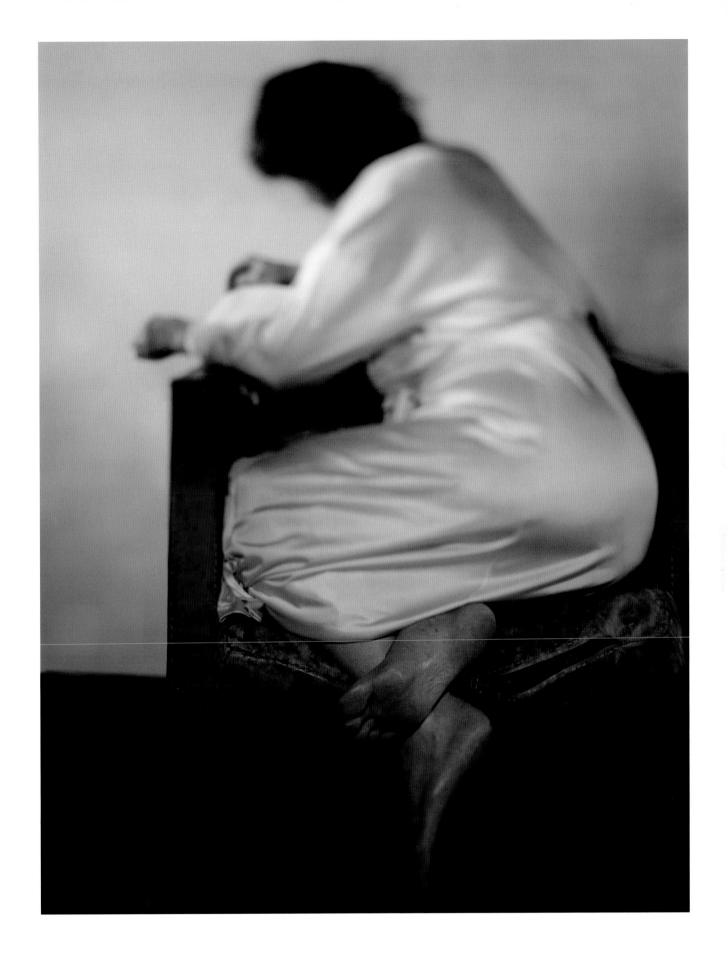

Untitled from *Stillend Gespiegelt*, 2004. C-type print, 102 x 76 cm

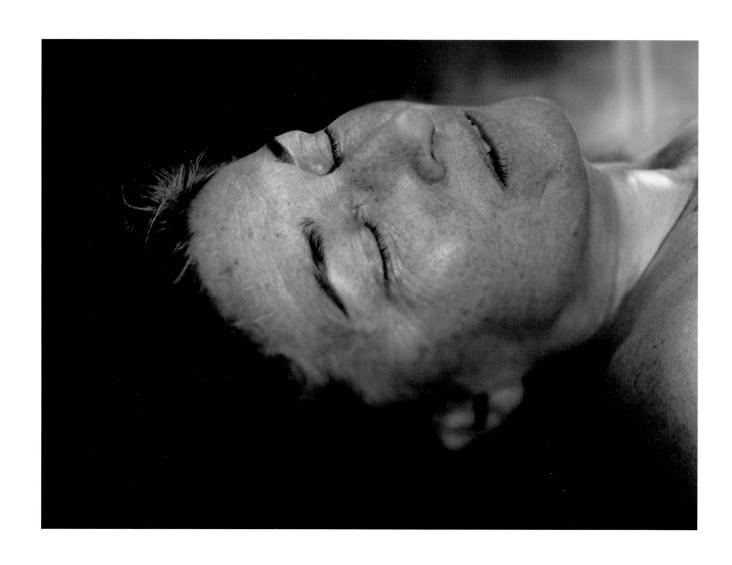

Diptych II from *Stillend Gespiegelt*, 2007. C-type prints, 76 x 102 cm, 102 x 76 cm

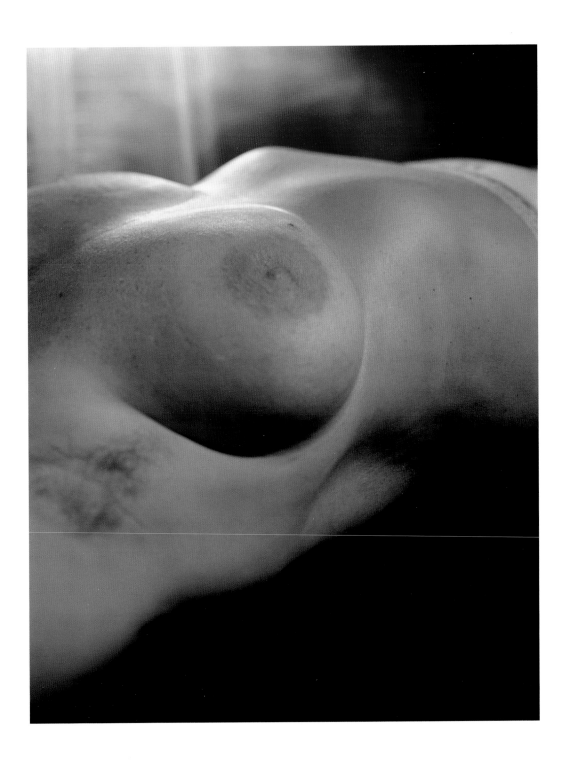

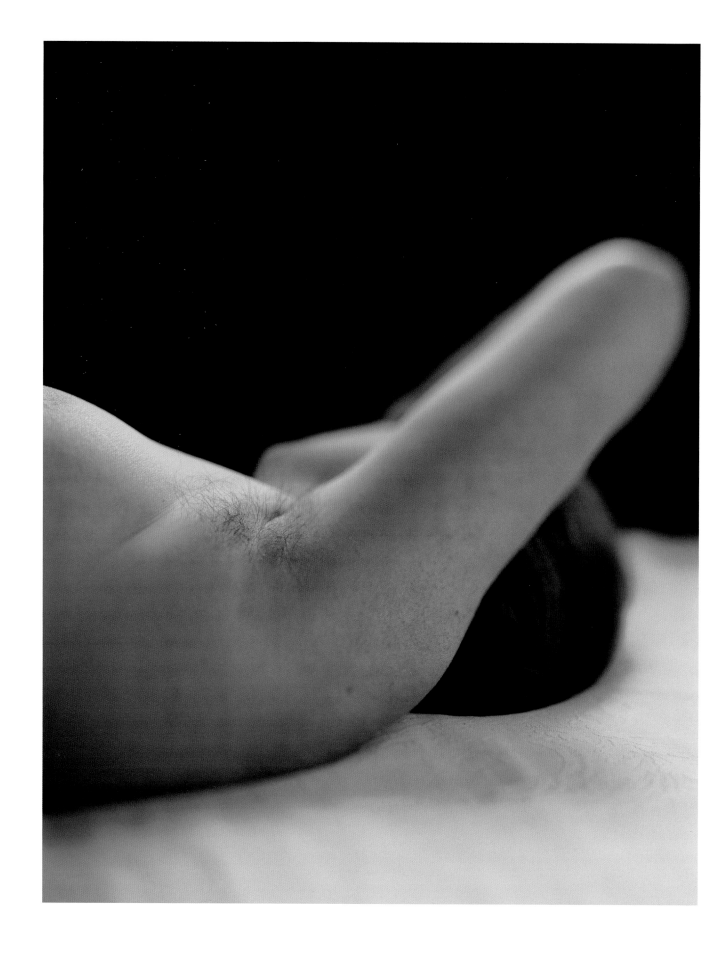

Untitled from *Stillend Gespiegelt*, 2005. C-type print, 102 x 76 cm

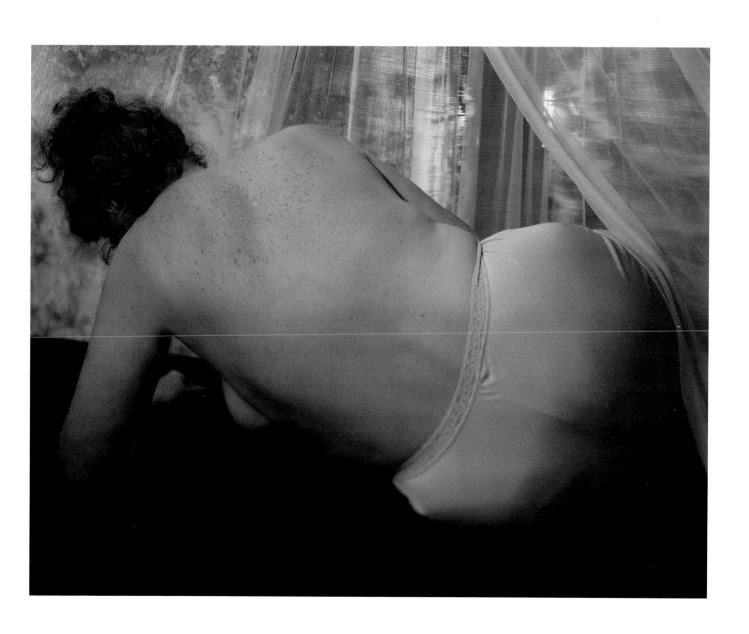

Untitled from *Exuberant Skin*, 2007. C-type print, 76 x 102 cm

Heiko Tiemann

Born in Bad Oeynhausen, Germany, 1968.
Lives and works in Düsseldorf and London.

My work is a kind of approach (as is, in my mind, any work of art), a thought towards my own motivations on how to look at the world. Within that, I aim to create an atmosphere which dissolves with my surroundings, which will then transform itself into a field of fascination. This is a feeling of being a stranger to oneself. A somnambulist. A person who walks through reality without knowing it. It is a dreamlike state of suspension. Totally unfocused and open, yet very intense. A desire to become heavy in a state of almost unbearable lightness. A search for sense within objects and situations of obvious senselessness. It is an "in-between" state, where we do not know how things will develop. The image has to be recognizable as a trigger for individual imagination and therefore should transcend a kind of collective state, but only to depart from there as a concept against redundancy. Before I photograph, I am not exactly certain what the image will look like. It's unpredictable and that is, of course, the fascination of it. The concept is clear, but within that I play and adapt myself to unforeseen intuitions. The process of taking a portrait for example is very intimate and much more complicated. It depends on the psychological interaction between the person, the space and myself. Sometimes I have to wait for a very long time to be able to capture that moment in which a person looses the sense of her/himself in order to show their own vulnerability. Surprisingly, it is virtually the same for me when photographing landscapes and still-lifes. Sometimes it takes quite a long time before the imagination clicks in and I am able to transform that into an image. I think these are also "portraits" in the widest sense. There is this kind of gloom which crawls into your mind and then starts to make you re-think reality and the way you look at things. It totally changes the perception of what is real and what's not, or rather: it destroys the border between reality (whatever that is...)

and imagination. In that sense, it is a deeply photographic view, yet it is also about the inherently melancholic aspects of this medium. To achieve an openness with regard to possible interpretations, with – at the same time – an intense, almost unpleasant presence. This interplay between openness and the picture's own independent strength is the point of contact, where, in my opinion, an image reaches its greatest animation as it builds up an intense relationship with the observer's imagination. On close examination of such images, it hits us like a shock: how can something so mundane give off such a threatening appearance? What's more, my subjects cannot be classified and are not specific. Individual characters of course go in specific directions, but then they lead themselves into the void. Nothing is then clear anymore and the observer loses his sense of security. These places only attain their uniqueness through the shifting juxtapositions within the area of the image. If, at first glance, you think it's not important where the pictures were taken, it's in fact quite the opposite: it is only by filtering out the atmosphere of a certain environment that I can position the characters precisely and let this flow in subliminally. My work *Animism* was one such experience, as at the time I was in Japan and those images were unthinkable and impossible to take under any other circumstances. It's important for me to be focused and concentrated, but also, at the same time, to be open towards the situation. There is always a kind of pre-conception, but it shouldn't dominate my process of observation. A process which always reaches a degree of intensity, a depth of imagination that plays an integral part. The more an image manages to entangle the viewer in a network of questions, suppositions and fears, the more it fulfils the process of self-reflection.

Heiko Tiemann

Education
2002–04
MA in Photography, Royal College
of Art, London
1997–98
London College of Printing, London
1993–2001
Photography at University
Essen/Folkwang
1991–93
Psychology WWU, Münster

Solo Exhibitions
2004
"Heiko Tiemann: Photographic Works",
Goethe-Institut, London
2003
"Monaden des Eigensinns",
Medienzentrum, Bremen
2002
"Void", Galerie der
Arbeitnehmerkammer, Bremen
2001
"Kammer", Kunsthaus, Essen

Selected Group Exhibitions
2008
"In Our World: New Photography
in Britain", curated by Filippo Maggia,
Galleria Civica di Modena, Italy
"Northpark", Ballhaus Düsseldorf
"Cold Song" (solo), Studio Tina Miyake
2007
"MAN Group Photography Prize", Royal
College of Art, London
2006
"Photo London", Hoopers Gallery,
London
"Alienated Spaces", Bristol
2005
"Top Secret", Gulbenkian Gallery,
London
2004
Royal College of Art, MA Degree Show
Hoopers Gallery, London
"Wirklich Wahr", Ruhrlandmuseum,
Essen
"New Contemporaries 2004",
Liverpool Art Biennale
"New Contemporaries 2004", Barbican
Art Gallery, London
"Open Spaces", Canary Wharf, London
2003
"Warm Up", Galerie 20.21, Essen
"Warm Up", Kunstverein Bremerhaven
"Festival der Künste", Museum
Folkwang, Essen
"Artist in Residence", Kyoto Art Center,
Japan
2002
"Mal sehen 2", Galerie Wolfram Bach,
Düsseldorf
"John Kobal Award", National Portrait
Gallery, London
"Top Secret", Gulbenkian Gallery,
London
2001
"Der bessere Mensch?", Westfälischer
Kunstverein Münster, Förderpreis
Hamburger Kunsthalle

2000
Galerie der Kunsthochschule für
Medien, Cologne
Kunstraum d. St. Petri - Kirche
Dortmund, Westenhellweg
1999
Royal Photographic Society, Bath
Midlands Art Centre, Birmingham
"Gesundheit", Ausstellungsprojekt,
Kunsthaus Essen
1998
"Inventories", Internationale Shoreditch
Biennale in London
National Portrait Gallery, London (John
Kobal Photographic Portrait Award)
1997
Kunstschacht Zeche Zollverein, Essen
(Türken im Ruhrgebiet)
Museum für Kunst und Gewerbe,
Hamburg (Reinhart Wolf Preis 97)
Zeigung Essen, Zeche Zollverein
1996
"Das grosse stille Bild", Euroshop,
Düsseldorf
Museum für Kunst und Gewerbe,
Hamburg (Reinhart Wolf Preis 96)

Publications
2006
"Nuke Magazine", December
2005
The me, das ich, in "Public Folder"
2004
New Contemporaries 2004, Exhibition
Catalogue
*Wirklich Wahr? Die Faszination des
Realen*, Ruhrlandmuseum, Exhibition
Catalogue
John Harten, in "Public Folder",
2003
"Camera Austria International", Issue
82
2002
Ten years, a Celebration, 1993–2002,
Catalogue, "John Kobal Photographic
Portrait Award"
2001
Im Zentrum: Ernst Ludwig Kirchner,
Eine Hamburger Privatsammlung,
Exhibition Catalogue
2001, 1999, 1998
*John Kobal Photographic Portrait
Award*, Exhibition Catalogue

1999
Gesundheit, Exhibition Catalogue
"British Journal of Photography",
September 29
"Independent Magazine", October 2
"RPS Journal", December
"Self service magazine"
"Zoo-magazine", March, The Friary
Press
Das grosse stille Bild, Hrsg. Norbert
Bolz und Ulrich Rüffer, Wilhelm Fink
Verlag, München

Awards
2007
Shortlisted for MAN Group
Photography Prize
2004
Selected for Bloomberg New
Contemporaries
Felloswhip of the Kunststiftung NRW
2003–04
Artist in Residence Scholarship of the
City University of Arts, Kyoto
2003
Visual arts grant MSWKS-NRW 2003,
Düsseldorf
2001
Award of the Westfälischen
Kunstvereins in Münster
2000
Grant from the Arts Council
1999
John Kobal Photographic Portrait
Award, Winner
1998
John Kobal Photographic Portrait
Award, Runner up
1997–98
DAAD – Grant for visual arts
1996–97
Reinhardt Wolf Prize, Runner up

Collections
John Kobal Foundation
Ruhrlandmuseum Essen
National Portrait Gallery, London
Hamburger Kunsthalle
Various private collections

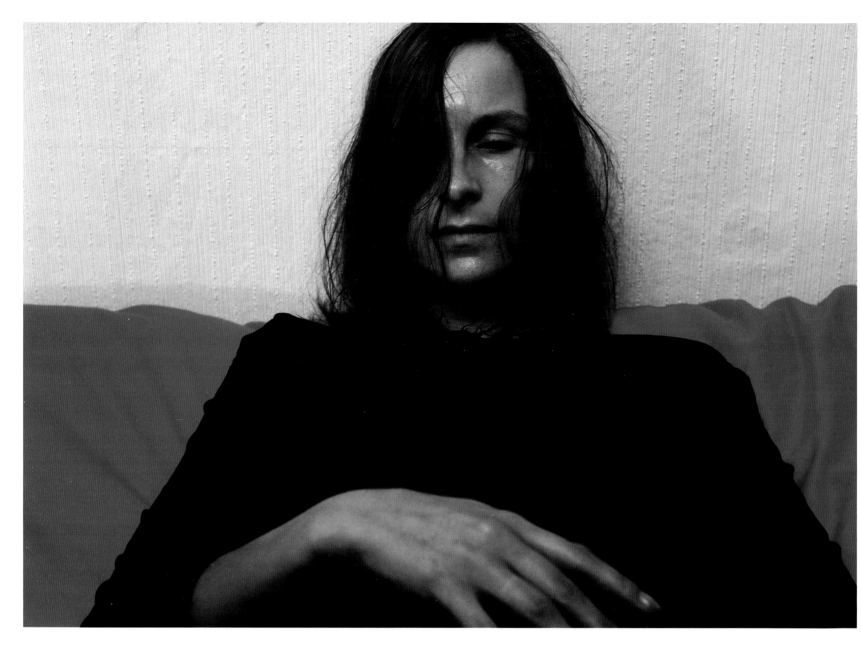

Stef, from the series *Delusion*, 2001. C-type light-jet, dimensions variable

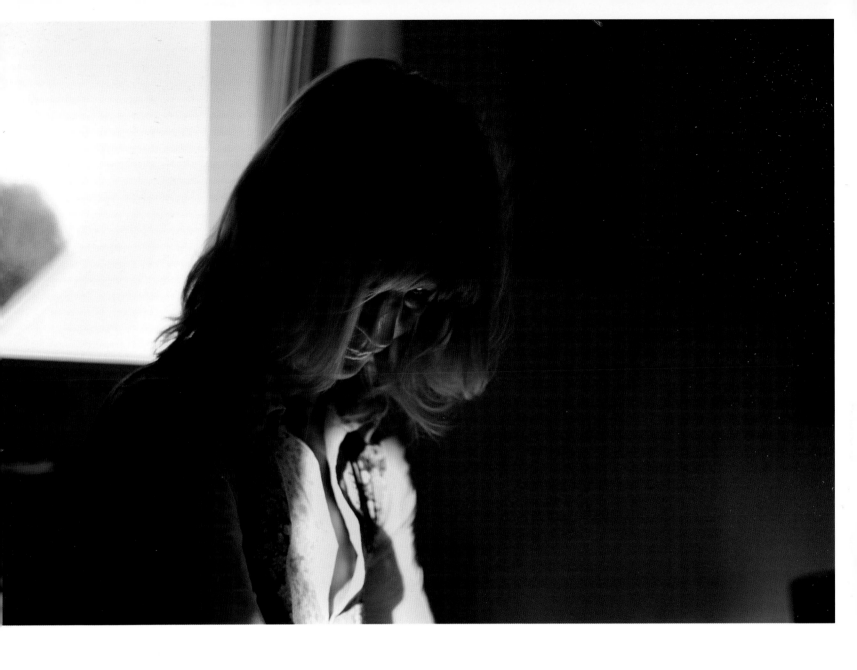

Ulrike, from the series *Delusion*, 2007. C-type light-jet, dimensions variable

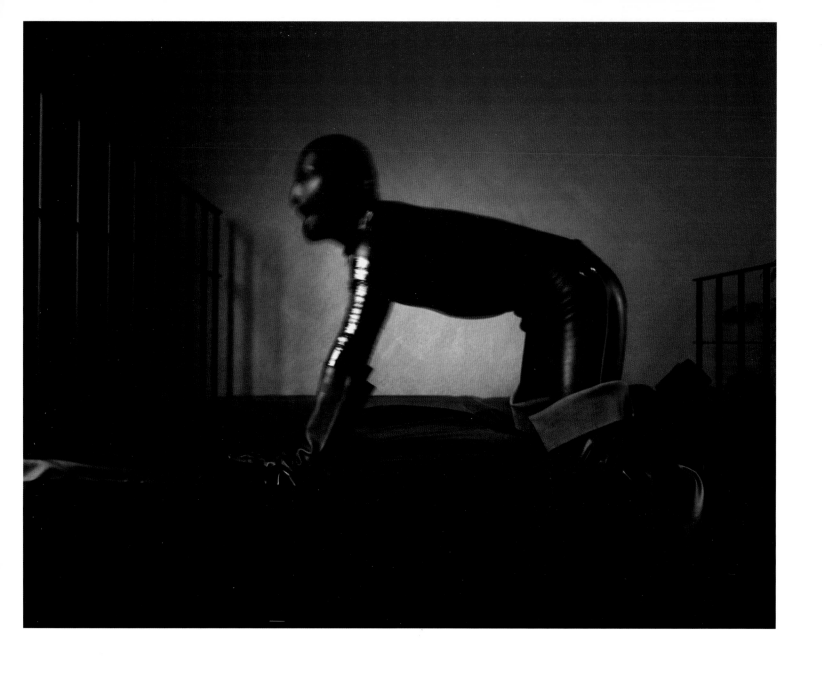

Nachtmahr, from the series *Real Indications*, 2006. C-type light-jet, dimensions variable

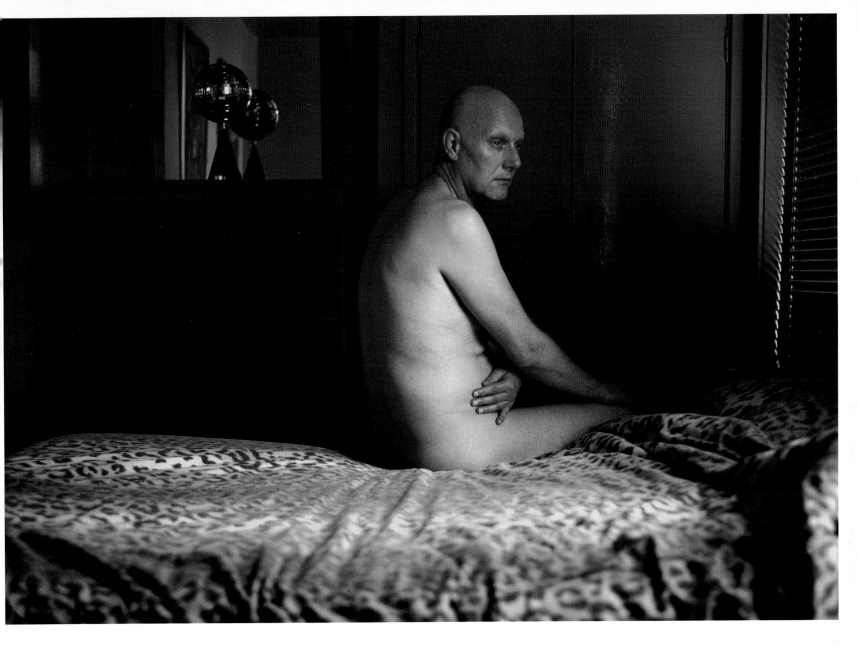

Untitled, from the series *Real Indications*, 2004. C-type light-jet, dimensions variable

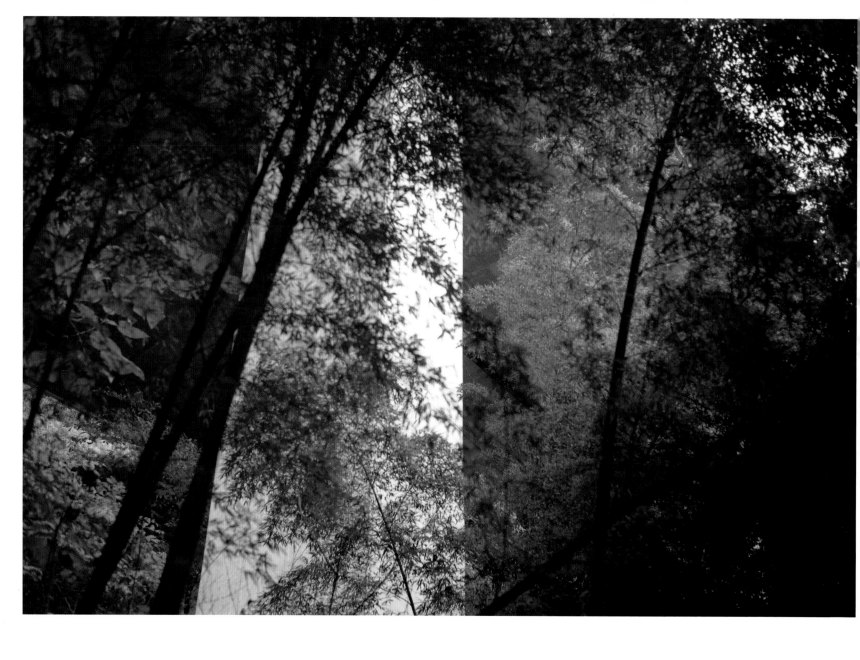

Untitled, from the series *Animism*, 2003. C-type light-jet, dimensions variable

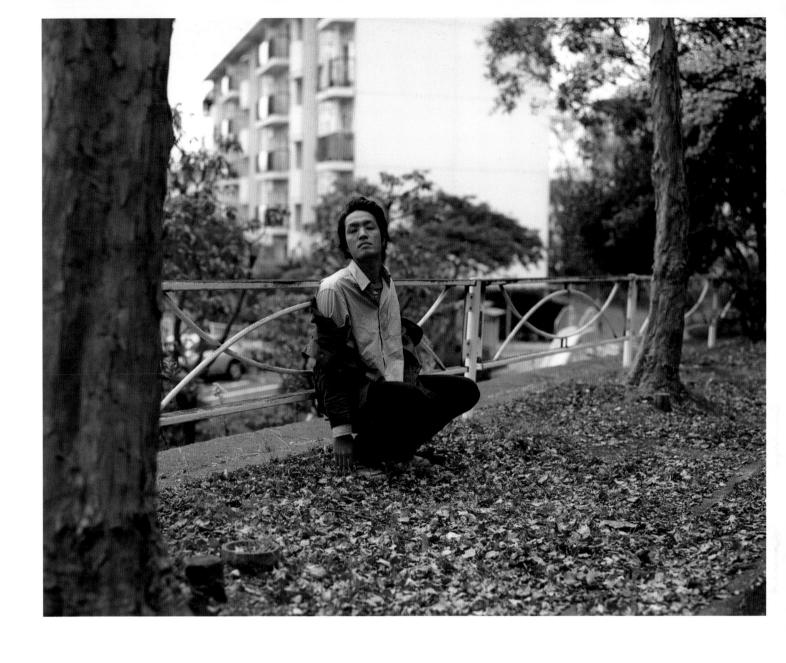

Fall, from the series *Animism*, 2003. C-type light-jet, dimensions variable

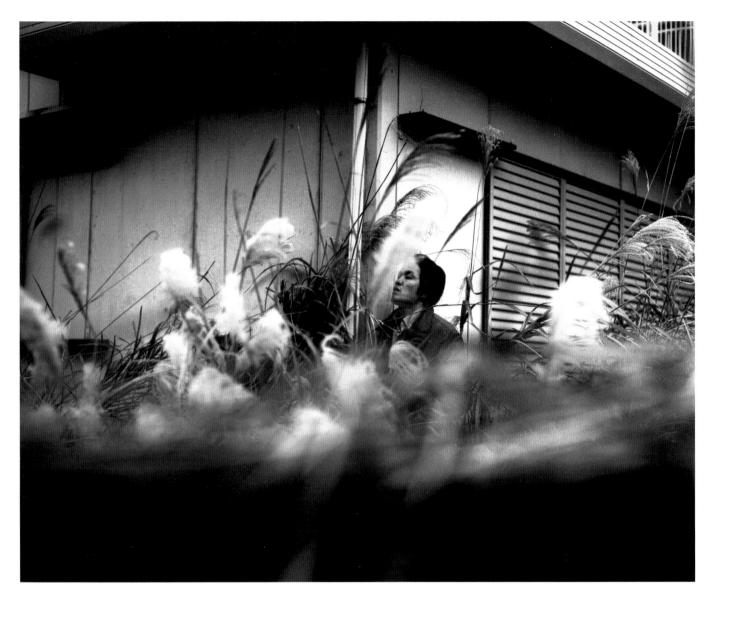

Untitled, from the series *Animism*, 2003. C-type light-jet, dimensions variable

Untitled, from the series *Animism*, 2003. C-type light-jet, dimensions variable

Danny Treacy

Born in Manchester, 1975.
Lives and works in London.

Them

What circus is this?
What strange ghosts are they that loom out of the darkest black, the last place in our dreams?
They are us and they are Them.

They are the work of Danny Treacy.
They are figments of his imagination and desire.
They are made from recovered clothes.
They are from those lonely places – the woods, the wastelands, the car parks.
They are re-stitched and re-fashioned: re-modelled into junk monsters.
They are nightmares of the catwalk, prowling around the outskirts of style's dumb extravagance.

They belonged to the unknown and the anonymous.
They are the lost, the deranged, the sexually driven and – who knows – the dead.
They are the sinister carnival playing in the street. They are the music we dread to hear.
They confront us and they defy us.
They take a chance on our presence. They take a chance on existence.
They are Danny Treacy dressed up.

They mask his identity.
They become the confined space of his transgression.
They are charged in this way.
They are the places where he is close to Them.

They are awkward. They are contorted.
They are the body harnessed, the body pinched, the body stitched up.
They have those Frankenstein, stiff-legged poses. They are B-movie cut-outs.
They are Dada and they are Pop.
They are the friends of Surrealism: shouting anarchy, whispering perversion.
They are sampled pieces, cross-dressed collages, mix-gendered melodramas: part nasty, part nice.

They are the suits, the jeans, the rubber gloves.
They are the workers and they are the dancers.
They are the porno tea-break, the sexed-up secrets.
They are rough trade. They are the soldiers.
They have the armour and the equipment.
They are medieval, the spice of old England.
They are the danger-men, the shit-kickers.
They are ready. They are tooled-up.
They are tight and they are fit.

They are soiled and stained and perfectly formed.
They are the shapes around which menace lingers.
They are intimate and they are a violation.
They are the victors and the victims.
They are the kiss and the tell.
They are true and they are false.

David Chandler

Education
2000–02
MA in Photography, Royal College of Art, London
1995–98
BA (Hons) in Editorial Photography, University of Brighton

Selected Exhibitions
2008
"In Our World: New Photography in Britain", curated by Filippo Maggia, Galleria Civica di Modena, Italy
The Photographers' Gallery, Solo show, London
2006
"Mutual Appropriations", Encosta Gallery, Lisbon
2005
"to be continued…/jaatku…", curated by Brett Rodgers and Mika Elo, Finnish Photography Festival, Helsinki
"The Instant of my Death", Galeria Dels Ángels, Barcelona
2004
"The House In The Middle", Towner Gallery, Eastbourne
"The Jerwood Photography Prize", Stills Gallery, Edinburgh
"The Jerwood Photography Prize", Impressions Gallery, York
2003
"Them", University of California, Davis, California
"You Belong to Me", Catto Contemporary, London
"Twenty White Chairs", The Wapping Project, London
"Don't You Forget About Me", Studio Voltaire, London
2002
"The Show", Royal College of Art, London
"The Red Mansion Spero Prize", London Institute Gallery, London
"Show no Mercy", The Century Gallery, London
2001
"Flip Flop", Ecole des Beaux Arts, Nantes, France

Books and Catalogues
2006
Vitamin Ph: New Perspectives in Photography, London, Phaidon
2005
To be continued…/jatkuu…, British Council/Hippolyte Gallery
2004
The House in the Middle, ed. by Gordon MacDonald, London, Photoworks

Reviews and Articles
2006
"Livraison", No 2
"Portfolio Catalogue", No 43
2004
"Camera Austria", No 88
"Blueprint", No 218
2003
"Another Magazine", Spring–Summer Edition
"Photoworks", Autumn–Winter
"Portfolio Catalogue", No 38
2002
"Art Review" (The Best of the Graduate Shows)
"Hot Shoe International", August
"i-D Magazine", Issue 224
"Tank", Vol. 3, Issue 3
2000
"Creative Review", Vol. 20, No 3

Awards
2003
The Inaugural Jerwood/Portfolio Photography Award
2002
The Photographers' Gallery Award
1998
The Nagoya University of Arts' Award (Japan)
The Tom Buckeridge Photography Prize

Collections
The British Council Collection, London
Several private collections

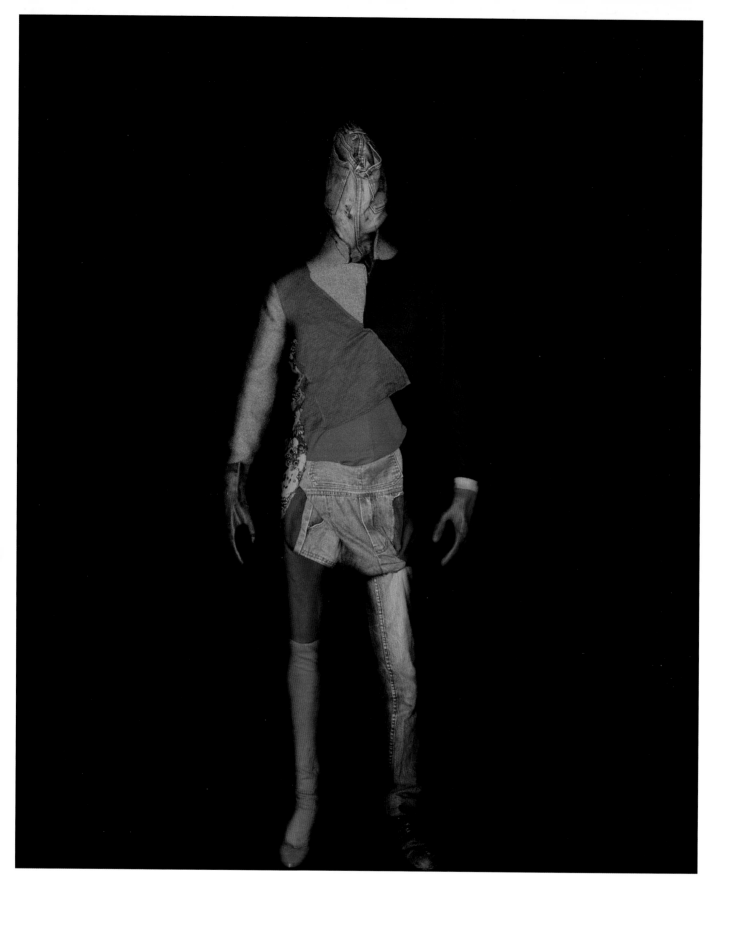

Them 1, 2002
Archival photographic print, 215 x 178 cm
Courtesy The Photographers' Gallery, London

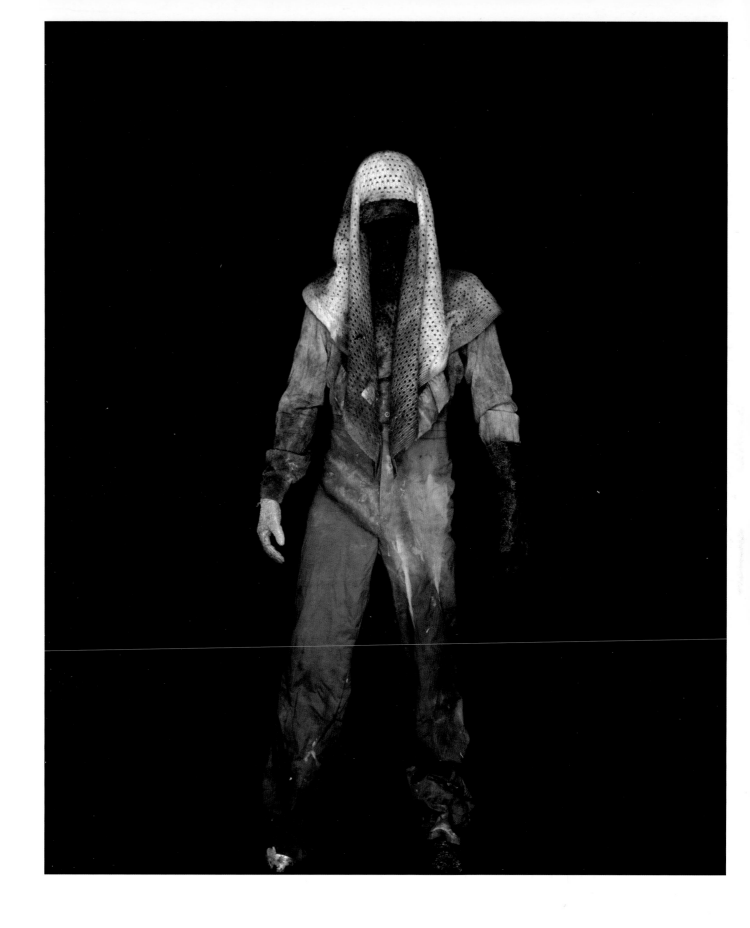

Them 12, 2005
Archival photographic print, 215 x 178 cm
Courtesy The Photographers' Gallery, London

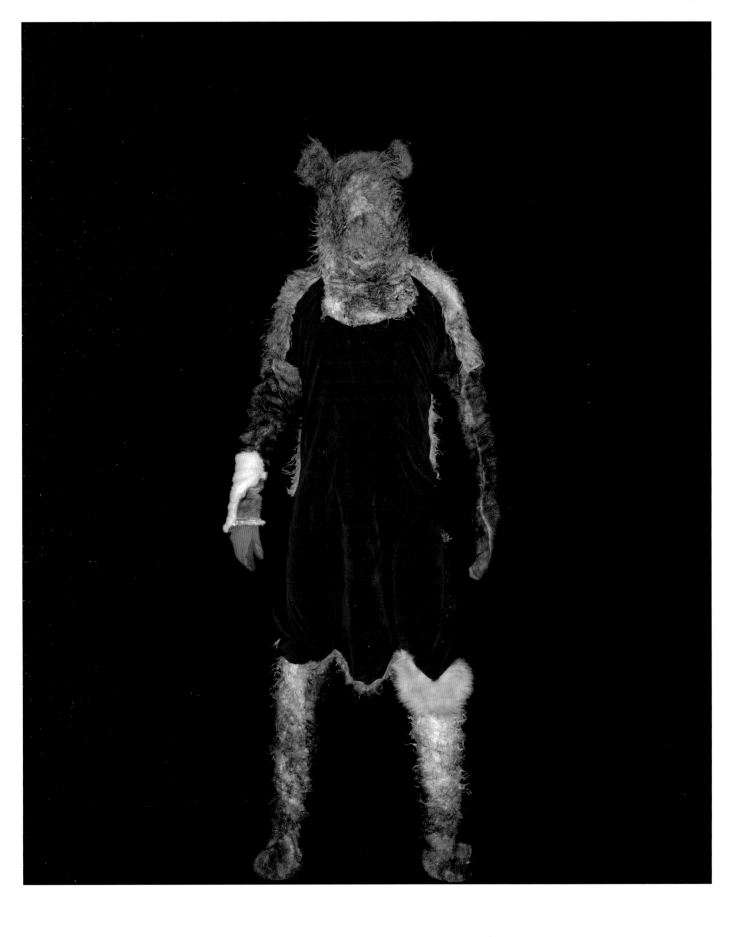

Them 15, 2005
Archival photographic print, 215 x 178 cm
Courtesy The Photographers' Gallery, London

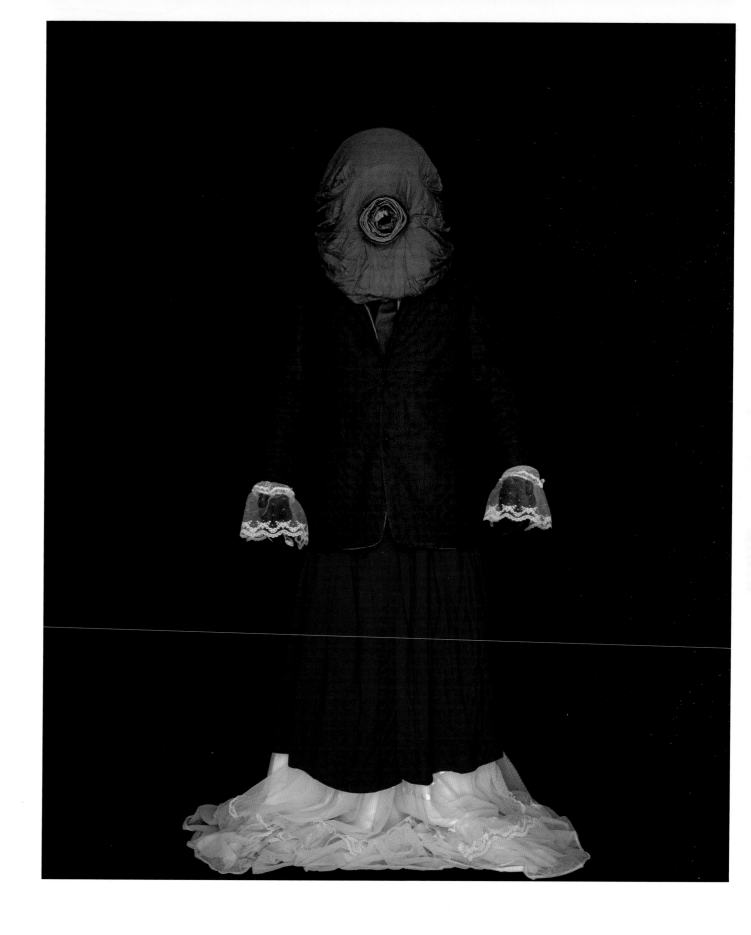

Them 8, 2005
Archival photographic print, 215 x 178 cm
Courtesy The Photographers' Gallery, London

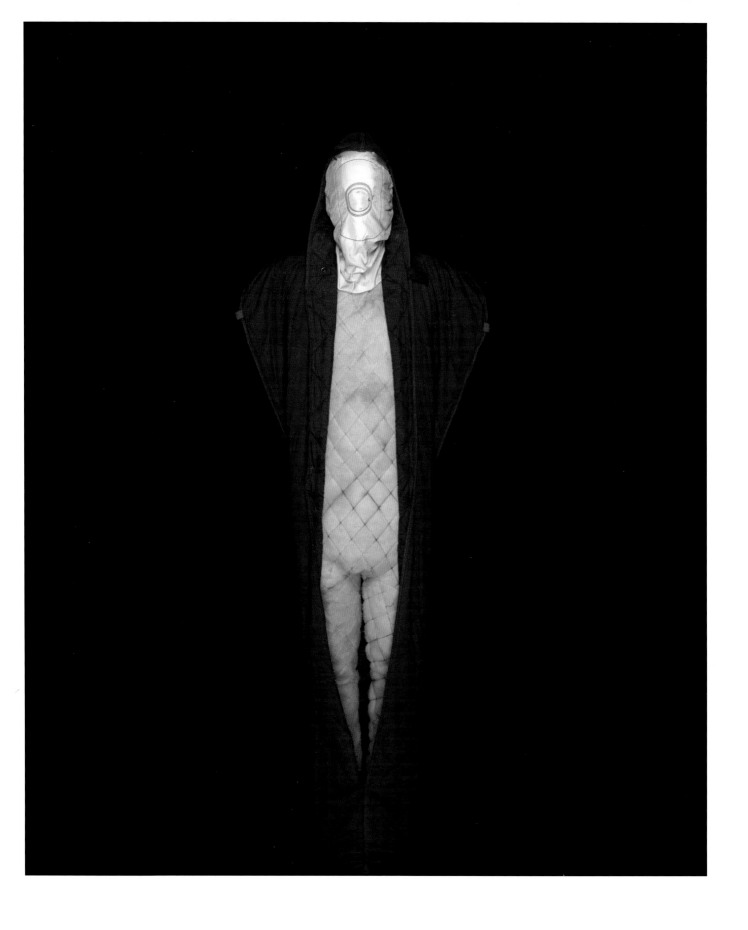

Them 17, 2007
Archival photographic print, 215 x 178 cm
Courtesy The Photographers' Gallery, London

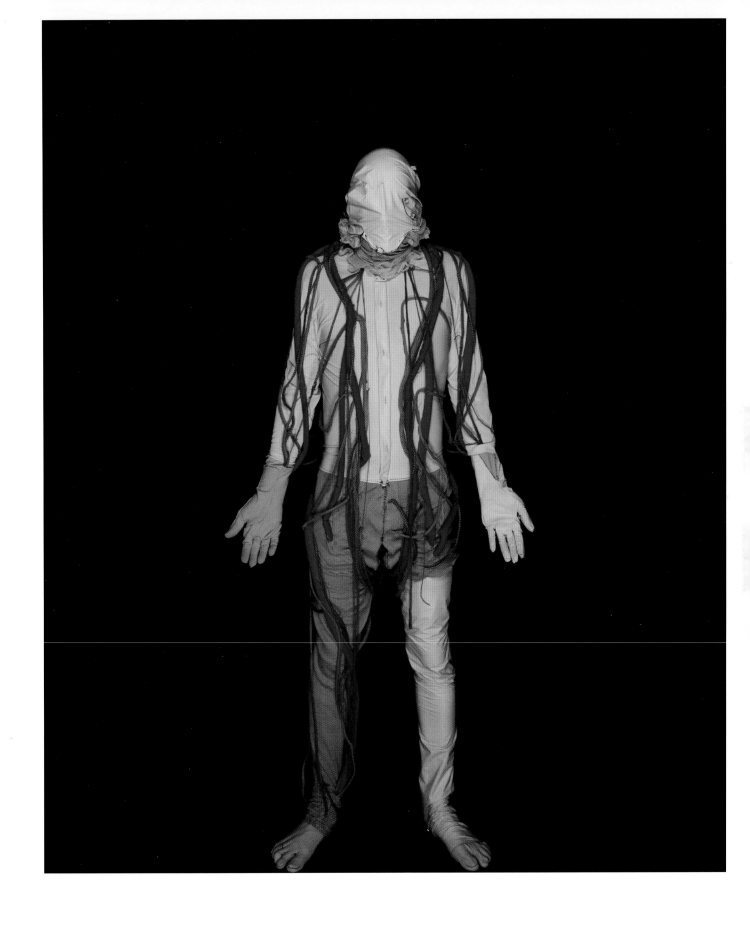

Them 19, 2007
Archival photographic print, 215 x 178 cm
Courtesy The Photographers' Gallery, London

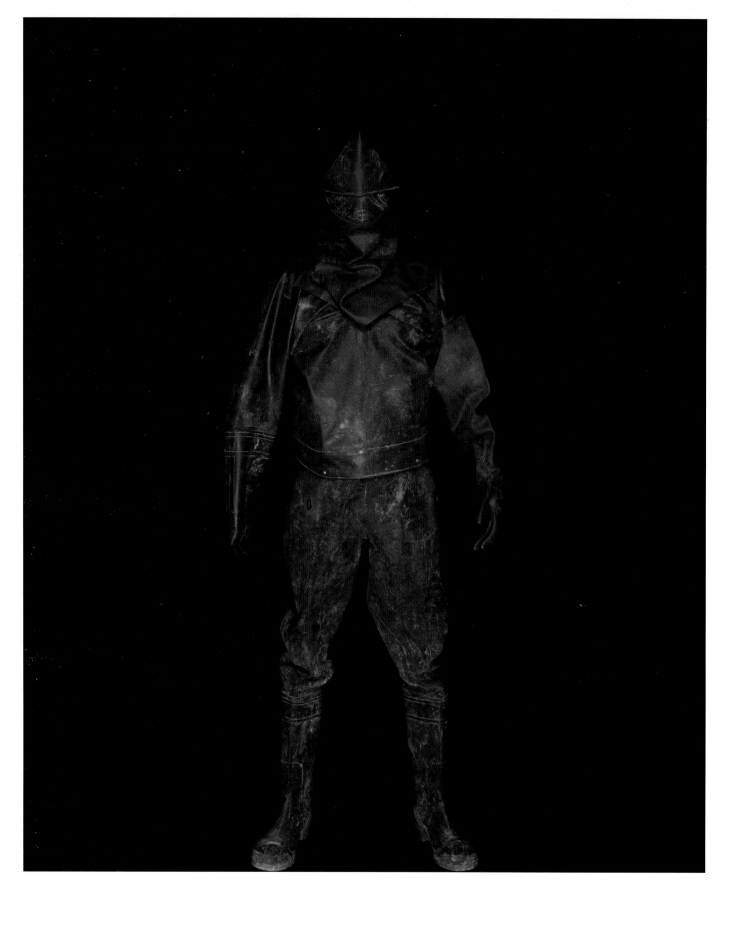

Them 18, 2007
Archival photographic print, 215 x 178 cm
Courtesy The Photographers' Gallery, London

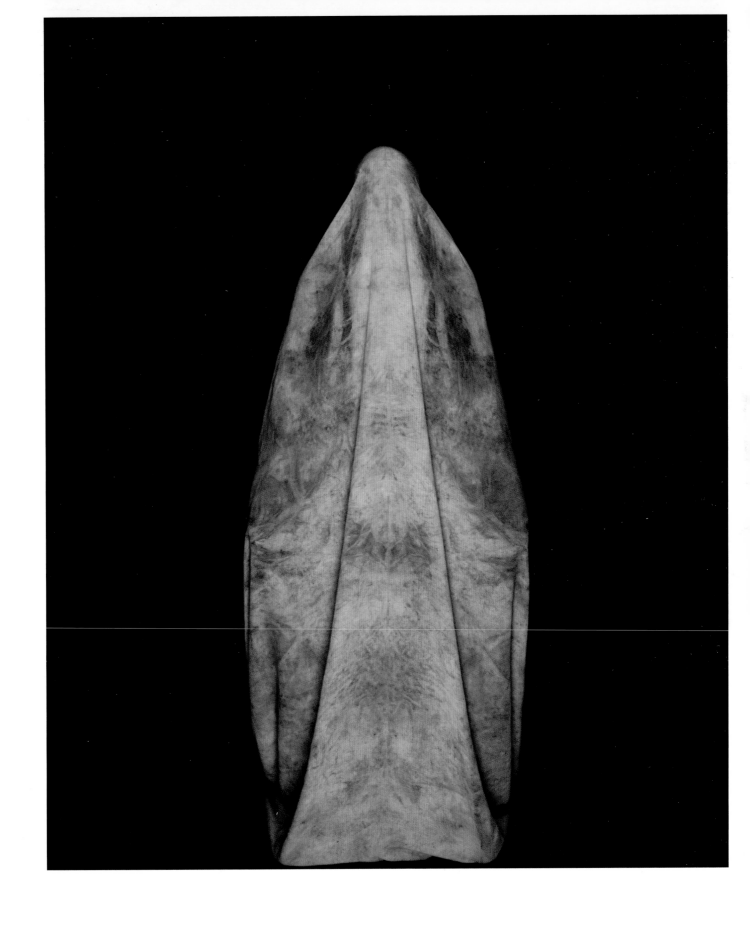

Them 20, 2007
Archival photographic print, 215 x 178 cm
Courtesy The Photographers' Gallery, London